MODERN LIVING

GRANDIFLORA

CLAIRE BINGHAM

teNeues

CONTENTS

INHALT | SOMMAIRE

P E T A L

P O W E R

B O T A N I C A L

NATURE LOVERS

One of the best things about being a journalist is being able to mingle with beyond talented types. In this chapter, I delve into the lives of some of the most inspiring tastemakers, where nature is their thing.

Eine der Schokoladenseiten des Journalistenberufs ist, dass man viele hypertalentierte Menschen kennenlernt. In dieser Rubrik befrage ich einige stilprägende Persönlichkeiten, die Pflanzen und Blumen über alles lieben.

Grâce à mon métier de journaliste, je passe mon temps à côtoyer des personnes exceptionnelles. Dans ce chapitre, je lève un coin de voile sur ces créateurs qui ont la nature dans la peau.

HOW TOS

From modern framed flowers, to naturalistic, romantic bouquets, and simple Christmas decorations—learn how to style your home with these easy-to-follow, inspirational ideas.

Von modern gepressten Blumen über naturalistisch-romantische Bouquets bis hin zu schlichter Weihnachtsdekoration: Verschönern Sie Ihr Zuhause anhand dieser inspirierenden und einfach ausführbaren Ideen.

De la peinture florale contemporaine au tableau de végétaux séchés, en passant par les bouquets naturalistes, romantiques en diable, ou les décorations de Noël toutes simples, à la scandinave. Des réalisations faciles pour styliser votre intérieur.

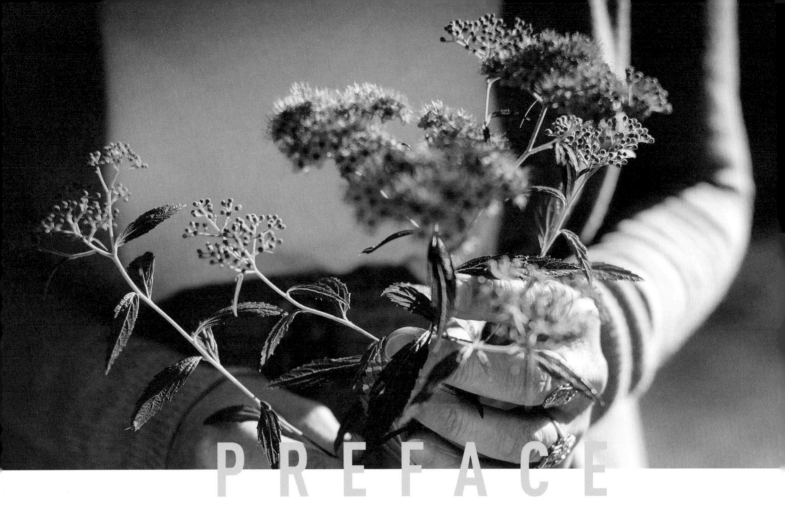

What do floral interiors mean to you? For the Dutch designer
Mariska Meijers, who creates hand-painted homewares from
her studio in Amsterdam (page 10), it's all about bold color and
uplifting prints; for globe-trotting Australian photographer
Martyn Thompson, it's toughened up in a moodily dark,
avant-garde, Old Masters still life painting kind of way (page 61).
From vintage, archetypal English chintz to retro, stylized botanical
textiles, *Grandiflora* is a lesson in the multitude ways of using
greenery in the home. There's a style to suit everyone.

Whether you're dreaming up pretty schemes using bright blooms
or are looking for inspiration on how to create a modern autumn
bouquet—in which case, the London-based florist Nik Southern
from Grace & Thorn shows you how (page 54)—this book is full of
easy ideas and all manner of decorating styles. If skipping through
meadows chasing butterflies isn't your thing, then try the vogue for
cheeseplants and succulents, which chime nicely against elegant,
modernist furniture. In polar opposite, you could go highly-stylized,
a little bit Bloomsbury, and fabulously off-beat. Whichever botanical
camp you're in, the function of a floral is to bring the party to a
room. It will always liven things up.

Was verstehen Sie unter einem floralen Interieur?
Für die holländische Designerin Mariska Meijers, die in ihrer
Amsterdamer Wohnung (ab Seite 10) handbemaltes Geschirr kreiert,
dreht sich alles um auffällige Farben und attraktive Muster.
Für den weitgereisten australischen Fotografen Martyn Thompson
hingegen ist die Stimmung dunkler und erinnert eher
an das Stillleben eines alten Meisters, wenn auch neu interpretiert (Seite 61).
Von archetypischem britischem Vintage-Chintz zu stilisierten
botanischen Retro-Stoffen: *Grandiflora* zeigt, dass man sich auf unendlich
viele verschiedene Arten natürlich einrichten kann.
Es gibt für jeden den passenden Stil.

Suchen Sie nach Inspirationen für Dekokonzepte mit bunt
leuchtenden Blüten? Oder möchten Sie eine Anleitung, wie Sie
zum Beispiel ein modernes Herbstbouquet zusammenstellen? Die Londoner
Floristin Nik Southern hilft ab Seite 54 gerne weiter.
Dieses Buch steckt voller leicht umsetzbarer Ideen und Beispiele
für sehr unterschiedliche Dekorationsstile.
Wenn eine Schmetterlings-Sommerwiese nicht so Ihr Ding ist,
dann vielleicht eher spröde-stachlige Sukkulenten, die sich apart vom
modernen Mobiliar abheben. Ein floraler Stil kann natürlich oder
hyperglamourös, künstlerisch-intellektuell oder einfach nur wunderbar
verrückt sein. Welchem botanischen Lager Sie auch angehören: Pflanzen
machen einen Raum immer lebendig.

Qu'est-ce qu'une décoration d'inspiration florale ?
Pour la designer néerlandaise Mariska Meijers, créatrice d'objets de décoration
peints à la main (p. 10), tout est dans l'audace des couleurs et le dynamisme
des motifs ; pour le photographe globe-trotter australien Martyn Thompson,
c'est une notion plus obscure et mélancolique, dans un style d'avant-garde,
qui puise aux natures mortes des maîtres anciens (p. 61). Des imprimés
à fleurs vintage à l'anglaise, aux textiles rétro à motif végétal stylisé,
Grandiflora propose un voyage à travers la multitude des interprétations
de la nature par les décorateurs d'intérieur. Chacun y trouvera son style.

Vous rêvez de jolies compositions aux couleurs vives ou cherchez l'inspiration
pour un bouquet d'automne au look moderne ? Suivez les conseils
de la fleuriste londonienne Nik Southern, de Grace & Thorn (p. 54).
Ce livre foisonne d'idées faciles à mettre en œuvre. Vous n'êtes pas
du genre à courir les prés avec un filet à papillons ? Misez sur le grand retour
des philodendrons et des plantes grasses, qui font excellent ménage avec
un élégant mobilier moderniste. Ou, à l'inverse, jouez la carte de l'hyper-style,
vaguement XVIIe siècle et merveilleusement décalé. Quel que soit le camp
botanique que vous choisirez, la fonction de l'élément floral est d'animer
l'espace – et il n'y manque jamais.

P E

P O

T A L
W E R

PETAL POWER

After what seems like decades of decorating in beige or gray head-to-toe,
revitalize your home with floral-inspired pattern and color.

DIE KRAFT DER BLÜTEN

Die Zeiten von tristem Beige und Grau sind endgültig vorbei!
Lassen Sie mit floralen Mustern und Farben einen frischen Wind
durch Ihr Zuhause wehen.

LE POUVOIR DES FLEURS

Après le long règne du beige et du gris sur la décoration,
insufflez une nouvelle vie à votre intérieur avec des motifs
et des couleurs d'inspiration florale.

*Oriental blossom prints on wallpapers or a garden of petal-colored rooms,
these vibrant interiors know how to pack a floral punch. It's pretty fabulous.*

*Ob Tapeten mit orientalischem Blütenmotiv oder in Blütenfarben gestrichene Wände:
In diesen lebendigen Interieurs fühlt man sich wie in einem Garten. Einfach herrlich!*

*Papiers peints fleuris à l'orientale ou décoration aux couleurs de jardin,
découvrez des intérieurs directement inspirés de l'univers végétal.*

MIXED BOUQUET

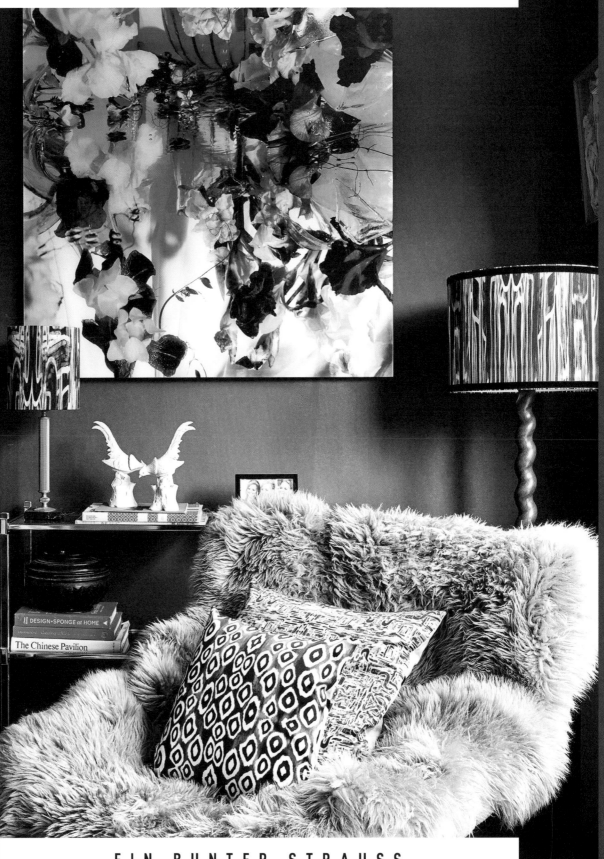

EIN BUNTER STRAUSS
UN BOUQUET COLORÉ

IMAGINE a Van Gogh still life of a vase of flowers: bright yellow sunflowers, green stems, Technicolor shades . . . and burst this out of the picture frame and into 3-D, then you get an inkling as to the interior of this soulful 1930s apartment in Amsterdam. Home to the textile designer Mariska Meijers, the look is vibrant, glamorous, and like her fabrics, works color and pattern on the right side of chaotic—her vibrant artwork perfectly set off by the dark charcoal-painted walls. "I find that dark walls do my collection the most justice," says Mariska of her living room scheme. "The apartment is located on the second floor of the building and bathed in natural light. This allowed me to create a dark interior without it feeling too somber." Describing her taste as "eclectic chic," Mariska mixes style and pattern without too much second-thought. "I fall in love with objects and somehow always find them a home," she explains. For Mariska, flowers have always been an influence in her work. "From the magnolia and cherry blossom in my Singapore garden to Vincent van Gogh's *Almond Blossom*—and also our iconic Dutch tulip fields, I have always painted flowers," she says. "No flower is ever the same, and the forms and colors continue to inspire me both in my work and in my home."

STELLEN SIE sich ein Stillleben von Van Gogh vor: eine Vase mit leuchtend gelben Sonnenblumen und sattgrünen Stängeln. Wenn Sie dieses Bild nun gedanklich aus seinem Rahmen sprengen und in 3-D und Technicolor umwandeln, bekommen Sie zumindest eine vage Vorstellung von dem Interieur dieser stimmungsvollen Amsterdamer Wohnung aus den 1930er-Jahren. Textildesignerin Mariska Meijers hat ein lebendiges und glamouröses Zuhause erschaffen und setzt Farben und Muster wie bei ihren Stoffen auf angenehm-chaotische Weise ein. Die quirlig-bunten Gemälde heben sich perfekt von den in Kohlegrau gestrichenen Wänden ab.
„Dunkle Wände bringen meine Sammlung am besten zur Geltung", sagt Mariska. „Die Wohnung befindet sich auf der zweiten Etage und ist sonnendurchflutet. Das erlaubt mir, das Interieur dunkel zu gestalten, ohne dass es zu düster wirkt."
Mariska beschreibt ihren Stil als „eklektischen Chic" und mixt Stile und Muster intuitiv, ohne viel darüber nachzudenken. „Ich verliebe mich in Dinge und finde irgendwie immer den passenden Platz dafür", erklärt sie. Blumen beeinflussen seit jeher ihre Arbeit – „von den Magnolien und Kirschblüten in meinem Garten in Singapur über Vincent van Goghs *Mandelblüte* bis hin zu unseren typisch holländischen Tulpenfeldern". „Jede Blume ist einzigartig und die Formen und Farben inspirieren mich sowohl in meiner Arbeit als auch in der Einrichtung meines Zuhauses."

IMAGINEZ une nature morte de Van Gogh : un vase de fleurs, des tournesols jaune vif au sommet de vertes tiges, des nuances en Technicolor… Extrayez la peinture du cadre et transposez-la en 3D. Vous aurez un aperçu de la décoration de l'appartement années 1930 de Mariska Meijers, designer textile à Amsterdam. Un décor au charme fou, qui vibre au diapason des créations textiles de Mariska. Et elle s'y entend à agencer couleurs et motifs aux confins du chaos, pour accoucher de créations extraordinairement vivantes, et parfaitement cadrées par la toile de fond anthracite des murs.
« Pour mettre ma collection en valeur, il fallait un mur de couleur foncée, dit Mariska. Et, comme au deuxième étage, l'appartement est inondé de lumière naturelle, j'ai pu réaliser cet intérieur sombre sans que l'atmosphère y soit pesante. »
Mariska qualifie sa décoration d' « éclectique chic ». « Je tombe amoureuse des objets, puis je me débrouille, tôt ou tard, pour leur trouver une place », explique-t-elle. Depuis toujours, l'univers floral influence le travail de Mariska. « De mon jardin à Singapour, planté de magnolias et de cerisiers en fleurs, aux *Amandiers en fleurs* de Vincent van Gogh, en passant par les champs de tulipes de Hollande, j'ai toujours aimé peindre les fleurs, se souvient-elle. Toutes sont différentes, et leurs formes et leurs teintes continuent à m'inspirer. »

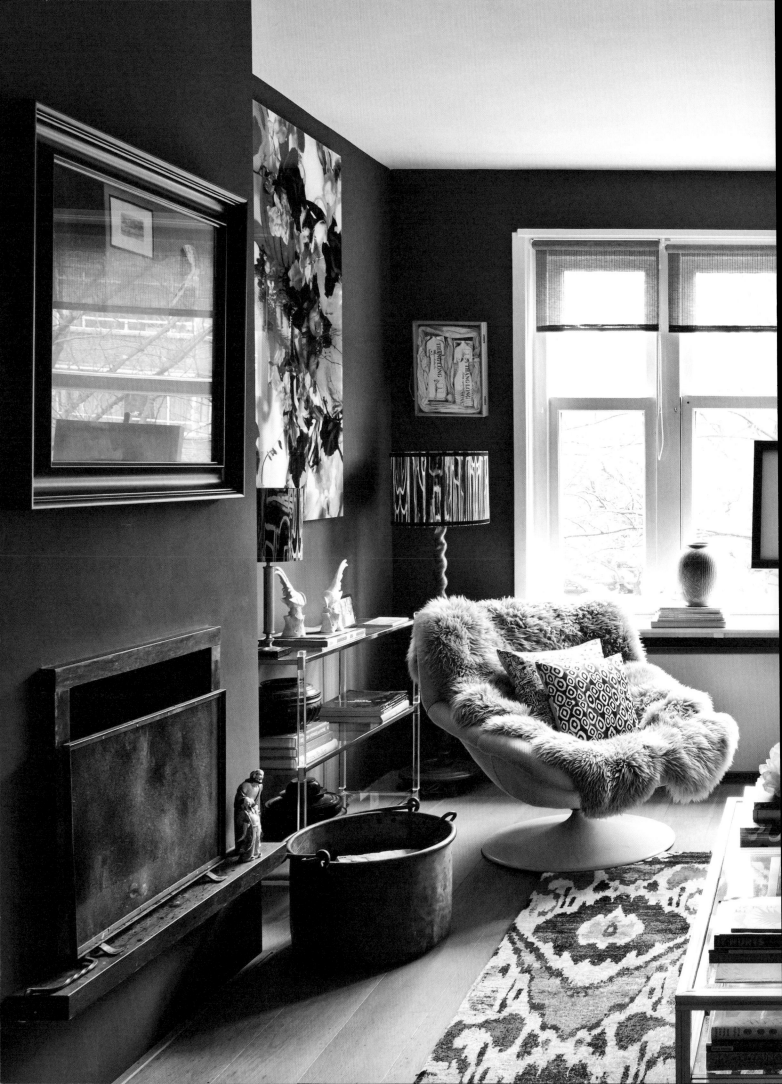

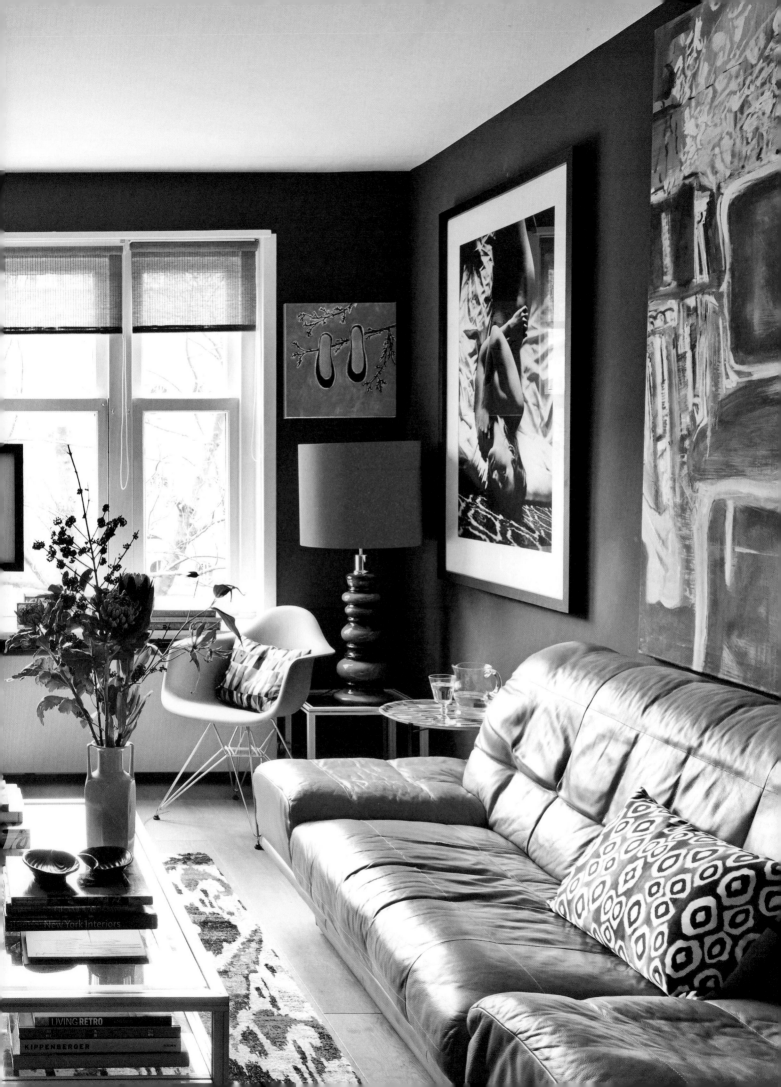

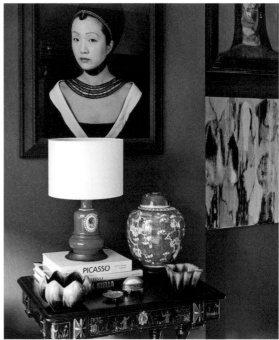

LIVING ROOM
The walls of the living room are painted charcoal-gray,
jazzed up by an Indian rug and a Rolf Benz tan leather sofa.
When you put an object against a dark wall, it has the effect of
making it stand out and giving it grandeur.

WOHNZIMMER
Die Wände in Kohlegrau werden von einem bunten
indianischen Webteppich und einem hellbraunen Ledersofa
von Rolf Benz aufgelockert. Vor einer dunklen Wand wirken
Objekte auffälliger und eleganter.

SALON
L'anthracite des murs du salon est égayé par
un tapis indien multicolore et un canapé en cuir
chamois Rolf Benz. Le fond sombre fait ressortir
les objets et les met en valeur.

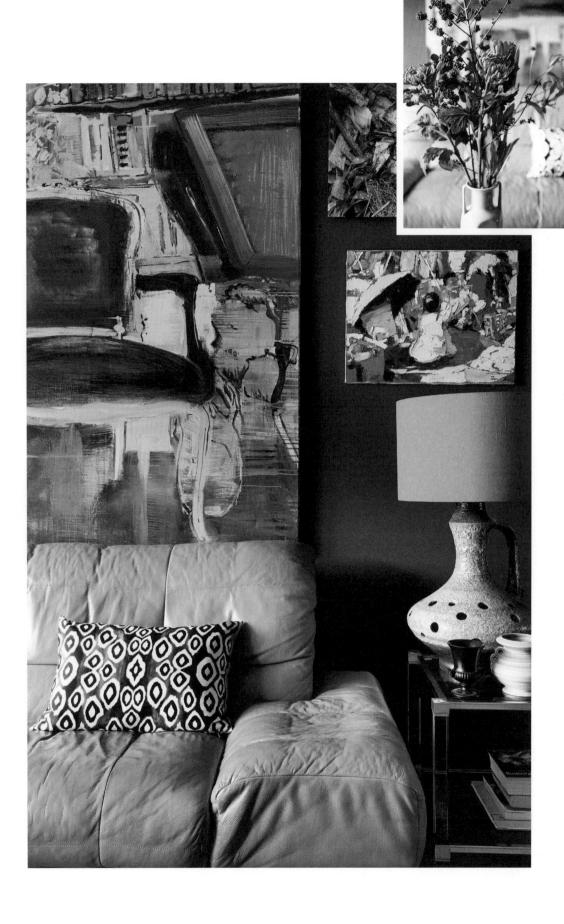

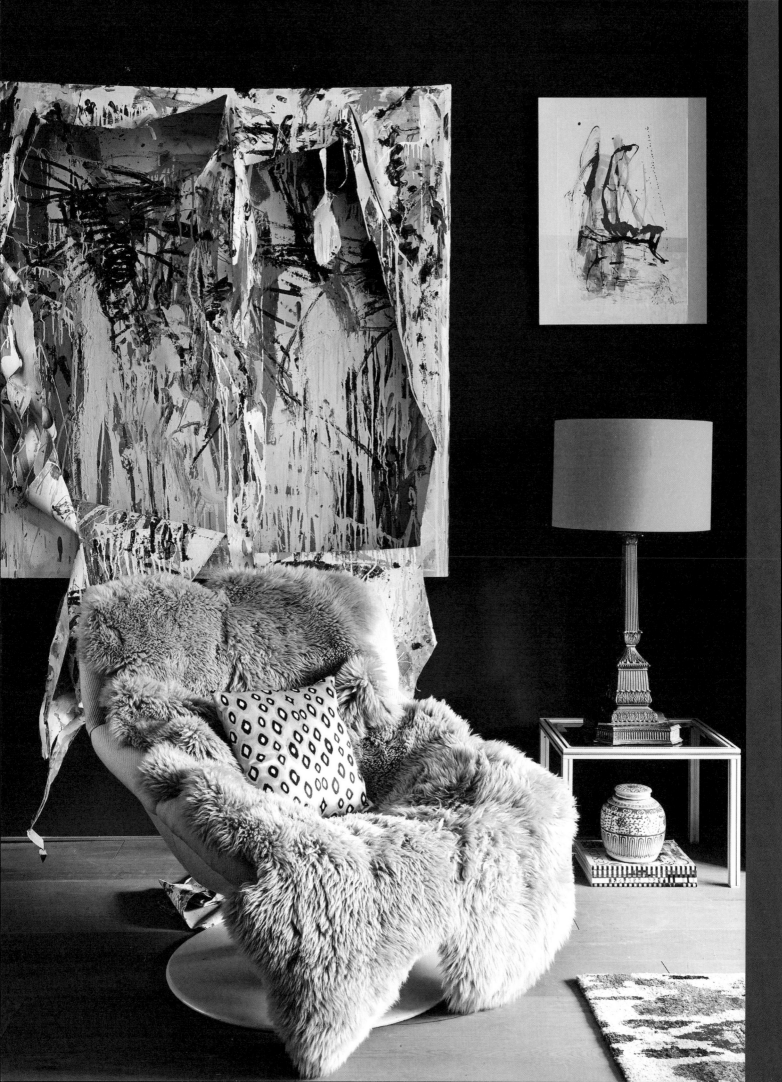

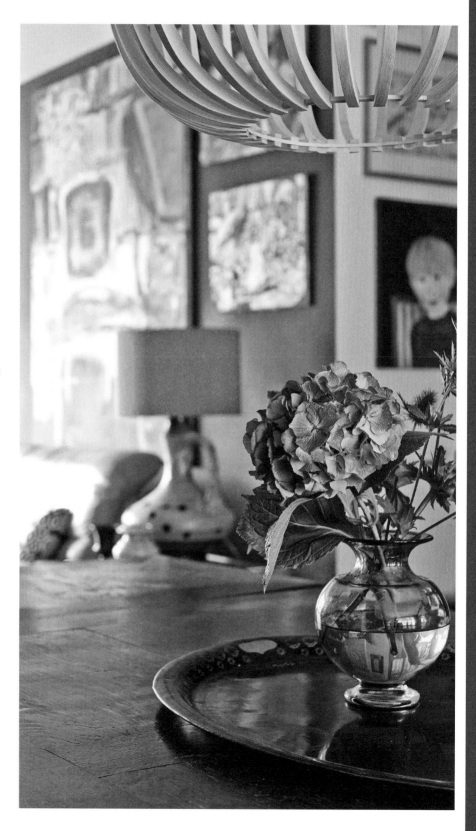

DINING AREA
Mariska's eclectic mix features Eames chairs with traditional Chinese chairs, a painting by the Dutch artist Peter de Graaff, and a simple hydrangea bouquet. Always look for pieces that give a room personality— just remember to buy what you love and not what's in trend.

ESSBEREICH
Zu Mariskas eklektischem Mix gehören sowohl Eames- als auch traditionelle chinesische Stühle, ein Bild des holländischen Künstlers Peter de Graaff und eine einzelne Hortensie in einer Vase. Einrichtungstipp: Wählen Sie Objekte aus, die dem Raum Charakter verleihen, und kaufen Sie nur das, was Sie wirklich mögen – nicht das, was gerade im Trend liegt.

SALLE À MANGER
Dans l'ensemble éclectique concocté par Mariska, une chaise Eames côtoie un fauteuil chinois, un bouquet d'hortensias un tableau de l'artiste hollandais Peter de Graaff. Comme elle, choisissez des éléments de décoration avec de la personnalité. Achetez ce que vous aimez, pas ce qui est à la mode.

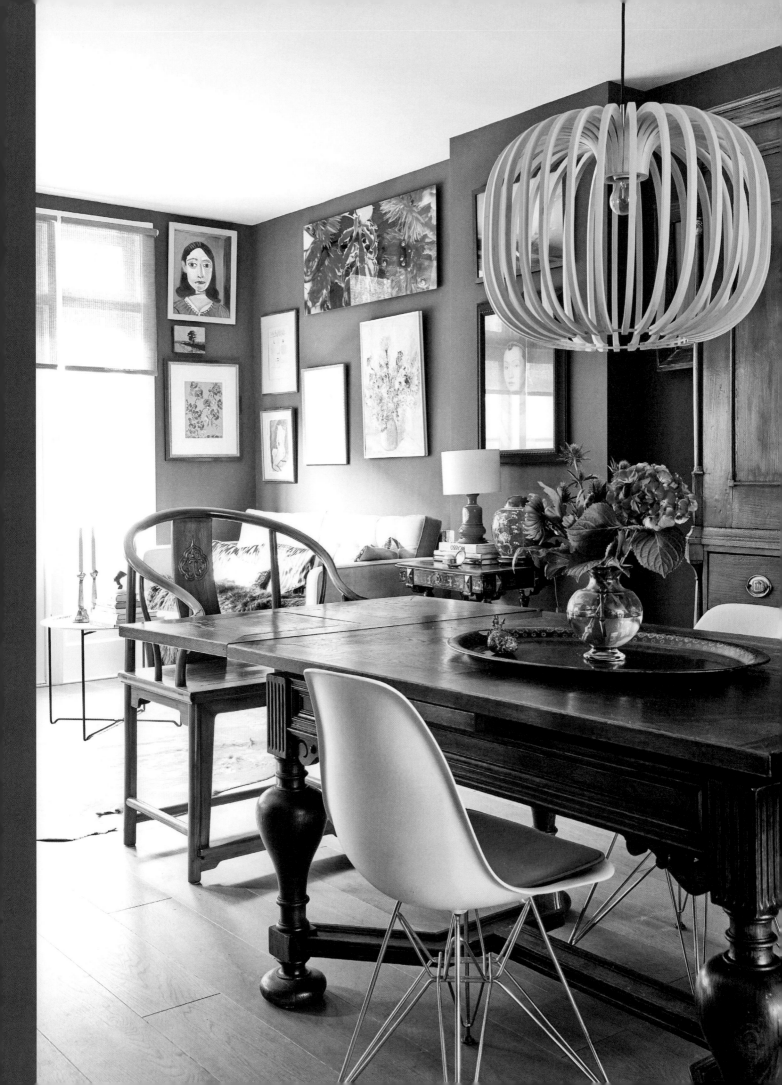

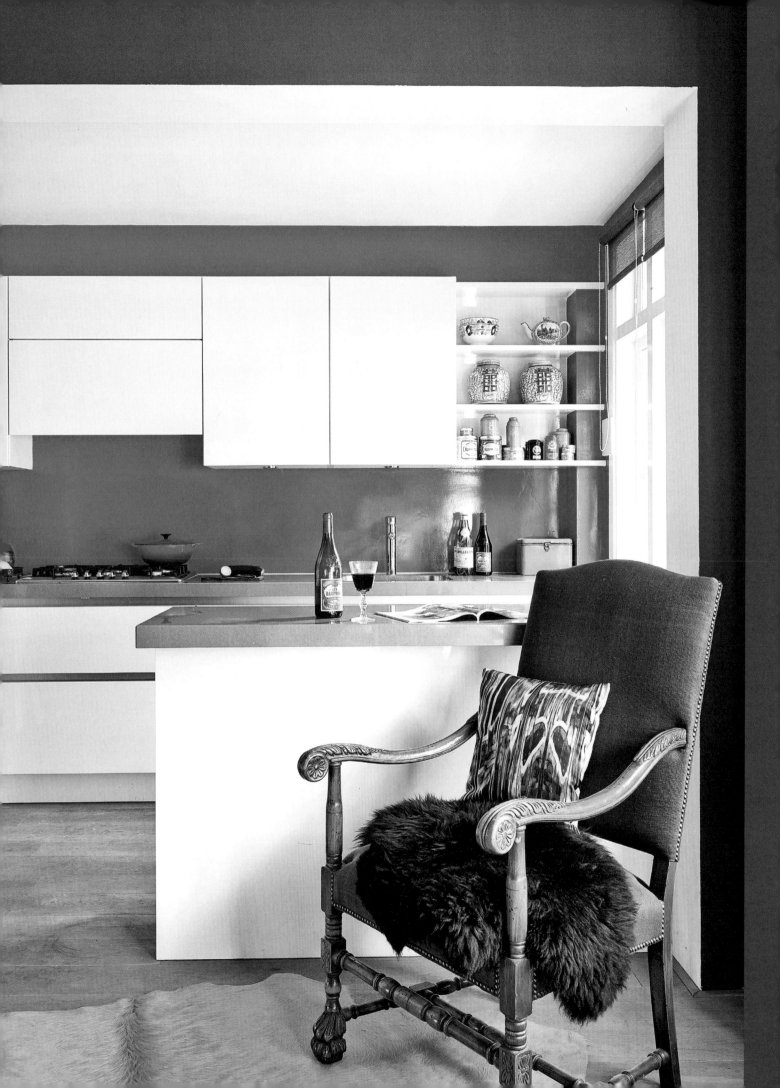

KITCHEN

With its glossy white cabinets and gray Corian worktop, the kitchen looks streamlined and modern.
This is accentuated with a bright pink wall, chosen to emphasize the kitchen as a separate zone in the living area.
"Color-blocking is a fantastic way of changing the feel of a space," says Mariska.

KÜCHE

Mit ihrer glänzend weißen Front und einer Arbeitsfläche aus grauem Corian wirkt die Küche stromlinienförmig
und modern. Akzente setzt die grellpinke Wand, die den Bereich klar vom Wohnzimmer abgrenzt.
„Colorblocking ist eine fantastische Methode, um die Atmosphäre eines Raums zu verändern", sagt Mariska.

CUISINE

Avec ses placards blancs et ses plans de travail en Corian gris, la cuisine assume son look moderne et épuré,
animé par le rose vif des murs. Cette couleur marque aussi la séparation entre cuisine et salle à manger.
« Structurer avec les couleurs est une façon efficace de modeler l'espace », confie Mariska.

BEDROOM
*Lilac and heather shades are pepped up with bright, abstract art.
The scale of the painting does away with the need of a headboard
and is the focus instead.*

SCHLAFZIMMER
*Hier setzen Lila- und Fliedertöne die farbenfrohe abstrakte Kunst
in Szene. Das große Gemälde direkt über dem Bett zieht
den Blick auf sich und macht ein Kopfteil überflüssig.*

CHAMBRE À COUCHER
*Une œuvre d'art abstrait aux couleurs vives relève
les douces nuances lilas et bruyère de la chambre.
Le tableau est le point où tout converge dans l'espace.*

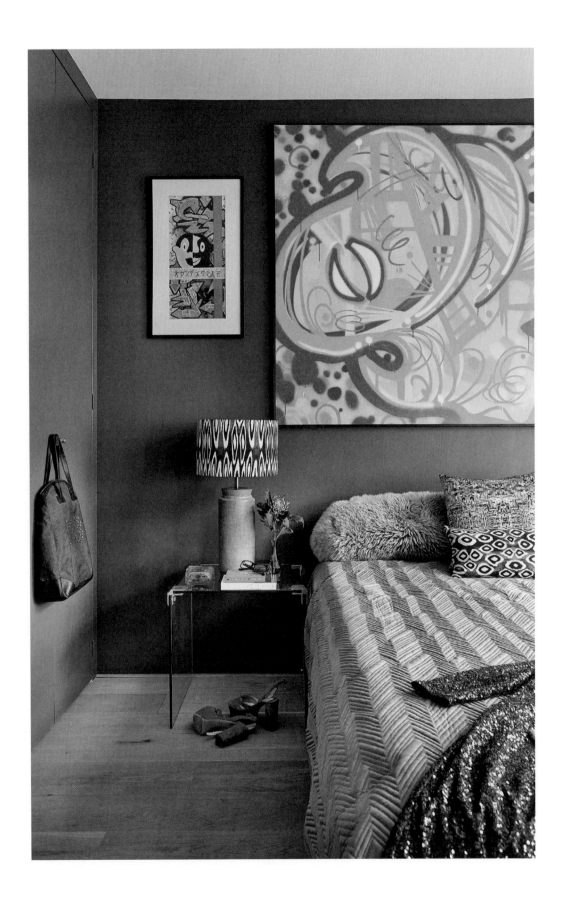

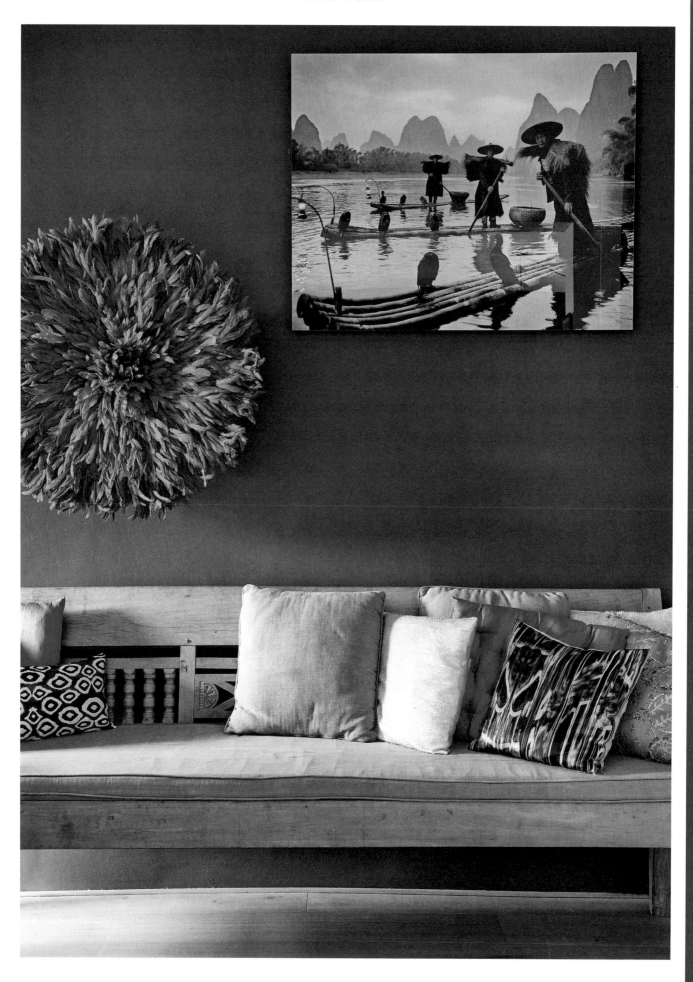

ENTRANCE HALL
A geometric wallpaper in black and white proves that smaller homes can handle a bit of pattern. Used as a transition to reach the living room, the Escher-inspired design was chosen to greet Mariska and guests with a splash of print.

EINGANGSBEREICH
Die geometrisch gemusterte Tapete in Schwarzweiß beweist, dass auch kleinere Behausungen Muster vertragen. Das von Escher inspirierte Design dient als Übergang zum Wohnzimmer und begrüßt Mariskas Besucher mit einem pulsierenden Vibe.

ENTRÉE
Ce papier géométrique en est la preuve : les petits intérieurs aussi supportent les motifs. Dans l'entrée, Mariska voulait une vaste surface imprimée. Elle a choisi cette création d'inspiration Escher pour assurer la transition vers l'espace à vivre.

MOODY BLOOMS

FROM WHITE-PAINTED FLOWERS TO GOTHIC SURROUNDS,
STYLE YOUR HOME ON THE DARK SIDE OF NATURE.

GERAHMTE BLUMEN: WEISSGESTRICHENE BLUMEN UND GOTH-ACCESSOIRES –
LASSEN SIE SICH VON DER DUNKLEREN SEITE DER NATUR INSPIRIEREN.

LE BLUES DES FLEURS : FLEURS BLAFARDES ET DÉCOR GOTHIQUE,
UN STYLE QUI EXPLORE LA FACE CACHÉE DE LA NATURE.

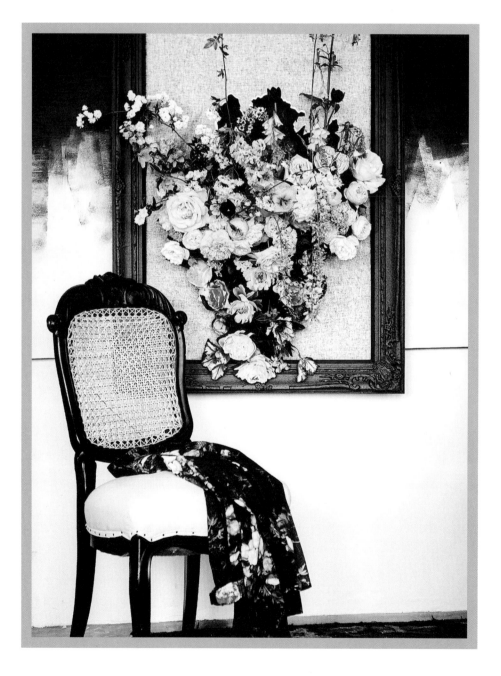

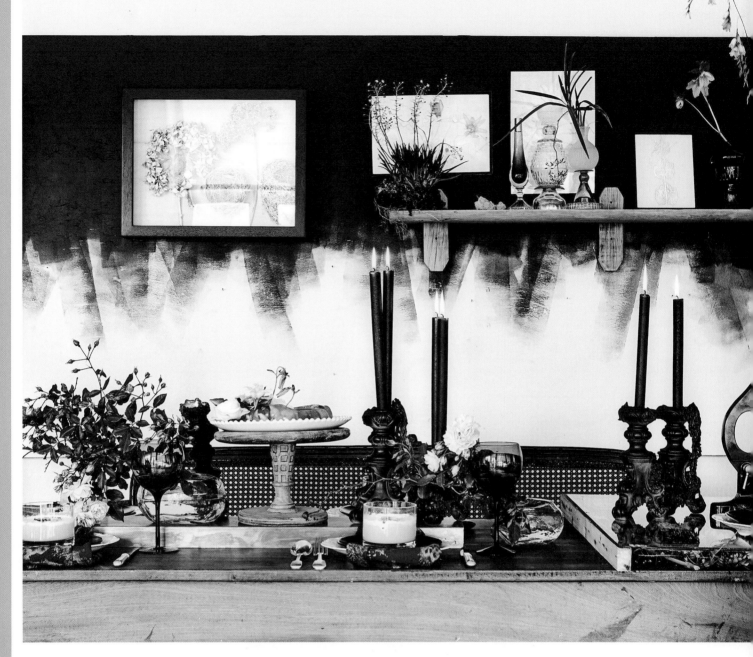

MIX FLOWERS AND A PALETTE OF BLACK-AND-WHITE FOR A VERY "NOW" TAKE ON MONOCHROME

Lush blooms spilling out of a vintage picture frame, jewel-colored glass vases scattered across a blackened wall, and ghostly white-painted flowers on a plywood wall lend this interior a dark and enigmatic glamour. A velvet-covered French sofa and a floral-bedecked rug add to the Baroque effect. The ombré wall is created using a roller brush, smudging the matt-black paint roughly into the white. For the picture frames, arrange pressed flowers and lightly spray-paint them white. Spray mount onto white paper overlapping the stems for an informal effect.

DIE KOMBINATION VON BLUMEN MIT SCHWARZWEISS VERLEIHT MONOCHROMIE EINEN BESONDEREN TOUCH

Üppige Blütenpracht, die aus einem antiken Bilderrahmen quillt, edelsteinfarbene Glasvasen vor einer schwarzen Wand und weißgestrichene Blumen auf einer Spanholz-platte verpassen diesem Interieur einen dunklen und geheimnisvollen Glam-Faktor. Ein französisches Sofa mit Samtpolster und ein Teppich mit floralem Motiv verstärken den barocken Effekt. Der Wandanstrich mit Farbverlauf entsteht, indem man die mattschwarze Farbe mit einem Farbroller grob in die weiße übergehen lässt. Für die Blumenbilder werden die gepressten Blumen mit weißer Farbe angesprüht und mit Sprühkleber auf weißem Papier fixiert. Wenn die Stängel sich überlappen, wirkt das Arrangement lockerer.

LES FLEURS SE MARIENT AU NOIR ET BLANC POUR UNE INTERPRÉTATION TENDANCE DU MONOCHROME

De grosses fleurs qui jaillissent d'un cadre ancien, des fleurs peintes d'un blanc spectral, des vases en verre aux reflets de pierres précieuses sur la toile de fond d'un mur sombre… Et voilà que votre intérieur se pare d'un charme mystérieux. Aux pieds de la banquette de velours bleu, un tapis à motif floral rehausse l'effet baroque de l'ensemble. Au mur, l'effet ombré est obtenu en empiétant grossièrement sur le blanc avec un rouleau de noir mat. Pour réaliser les tableaux végétaux, disposez des fleurs séchées sur un fond blanc, bombez légèrement de peinture blanche, puis de colle en spray.

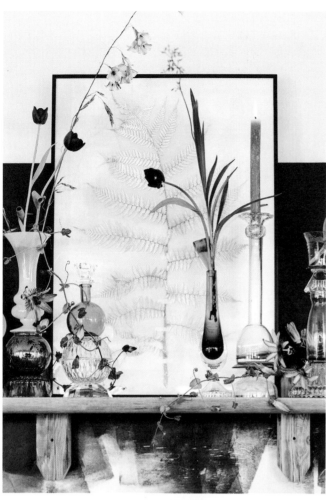

Combine a variety of different colored
and shaped vases to stand out against
a black-and-white painted wall.

*Vasen in unterschiedlichen Farben und Formen
heben sich schön von einer schwarzweiß
gestrichenen Wand ab.*

*Regroupez des vases aux silhouettes variées et
choisissez des couleurs qui tranchent sur le mur
peint en noir et blanc.*

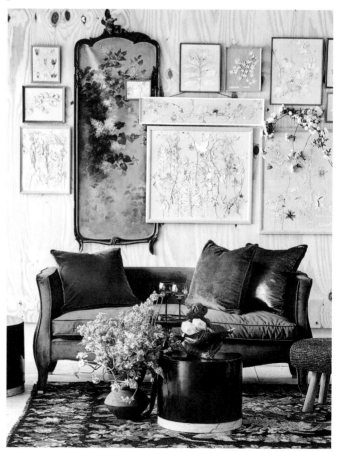

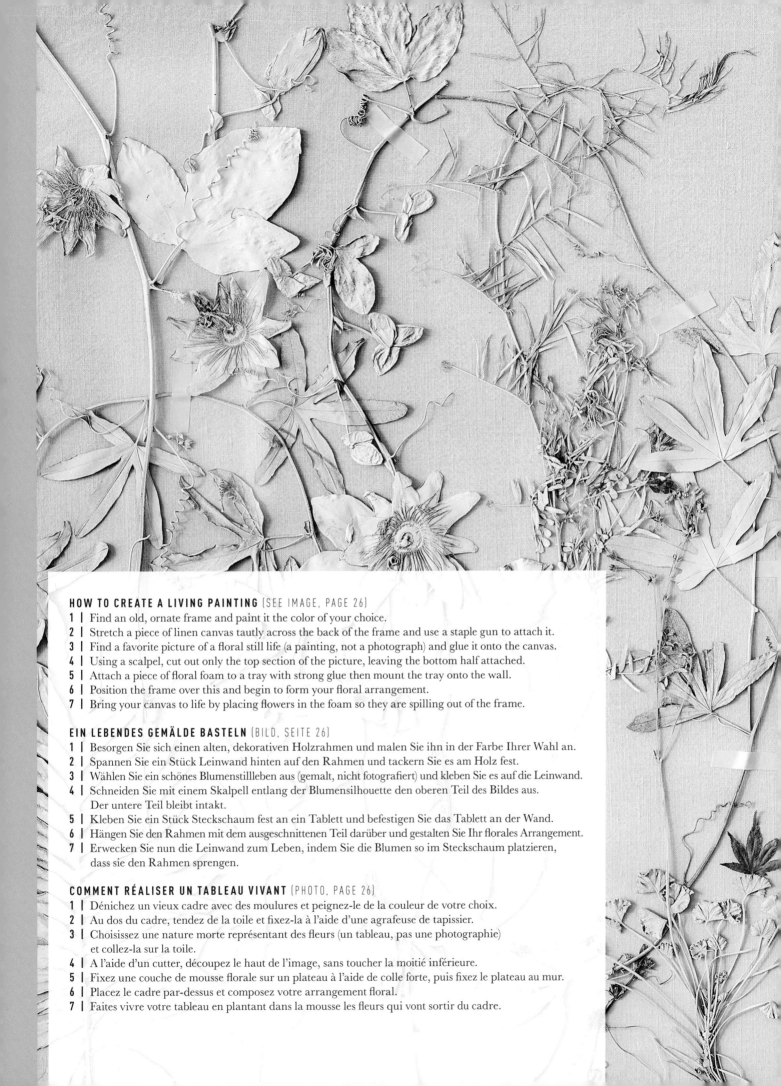

HOW TO CREATE A LIVING PAINTING [SEE IMAGE, PAGE 26]
1 | Find an old, ornate frame and paint it the color of your choice.
2 | Stretch a piece of linen canvas tautly across the back of the frame and use a staple gun to attach it.
3 | Find a favorite picture of a floral still life (a painting, not a photograph) and glue it onto the canvas.
4 | Using a scalpel, cut out only the top section of the picture, leaving the bottom half attached.
5 | Attach a piece of floral foam to a tray with strong glue then mount the tray onto the wall.
6 | Position the frame over this and begin to form your floral arrangement.
7 | Bring your canvas to life by placing flowers in the foam so they are spilling out of the frame.

EIN LEBENDES GEMÄLDE BASTELN [BILD, SEITE 26]
1 | Besorgen Sie sich einen alten, dekorativen Holzrahmen und malen Sie ihn in der Farbe Ihrer Wahl an.
2 | Spannen Sie ein Stück Leinwand hinten auf den Rahmen und tackern Sie es am Holz fest.
3 | Wählen Sie ein schönes Blumenstillleben aus (gemalt, nicht fotografiert) und kleben Sie es auf die Leinwand.
4 | Schneiden Sie mit einem Skalpell entlang der Blumensilhouette den oberen Teil des Bildes aus.
Der untere Teil bleibt intakt.
5 | Kleben Sie ein Stück Steckschaum fest an ein Tablett und befestigen Sie das Tablett an der Wand.
6 | Hängen Sie den Rahmen mit dem ausgeschnittenen Teil darüber und gestalten Sie Ihr florales Arrangement.
7 | Erwecken Sie nun die Leinwand zum Leben, indem Sie die Blumen so im Steckschaum platzieren,
dass sie den Rahmen sprengen.

COMMENT RÉALISER UN TABLEAU VIVANT [PHOTO, PAGE 26]
1 | Dénichez un vieux cadre avec des moulures et peignez-le de la couleur de votre choix.
2 | Au dos du cadre, tendez de la toile et fixez-la à l'aide d'une agrafeuse de tapissier.
3 | Choisissez une nature morte représentant des fleurs (un tableau, pas une photographie)
et collez-la sur la toile.
4 | A l'aide d'un cutter, découpez le haut de l'image, sans toucher la moitié inférieure.
5 | Fixez une couche de mousse florale sur un plateau à l'aide de colle forte, puis fixez le plateau au mur.
6 | Placez le cadre par-dessus et composez votre arrangement floral.
7 | Faites vivre votre tableau en plantant dans la mousse les fleurs qui vont sortir du cadre.

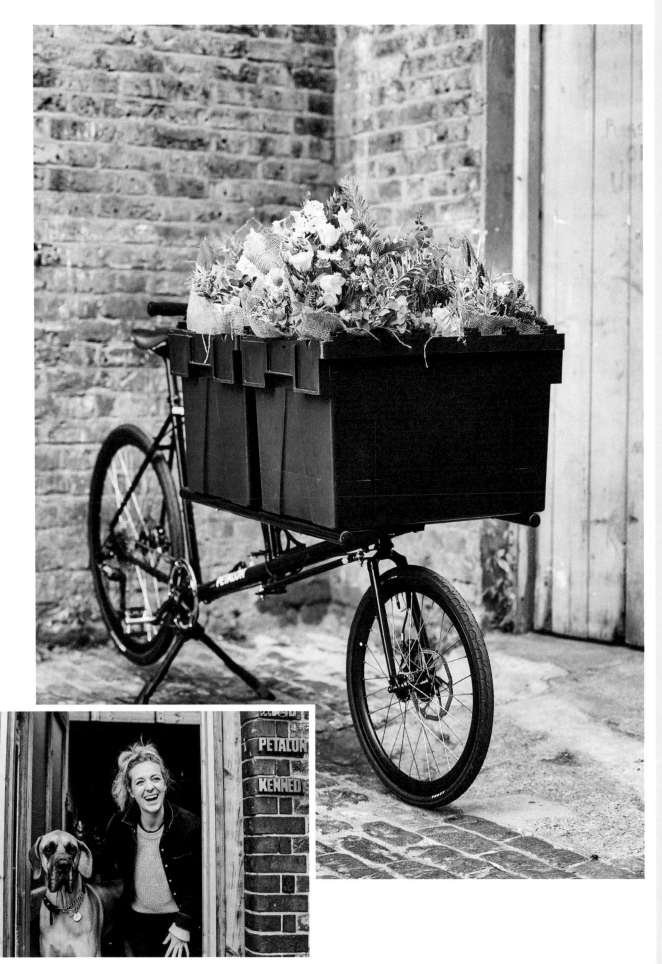

FLORENCE KENNEDY

FOUNDER OF BOUQUETS BY BICYCLE COMPANY PETALON, FLORENCE KENNEDY DELIVERS RUSTIC, HAND-TIED ARRANGEMENTS ACROSS LONDON. HER FIRST BOOK *FLOWERS EVERY DAY* SHOWS HOW TO RECREATE HER STUNNING DISPLAYS.

DIE GRÜNDERIN VON PETALON, EINEM BLUMENLIEFERDIENST PER FAHRRAD, LIEFERT IN LONDON RUSTIKALE HANDGEBUNDENE BOUQUETS AUS. IN IHREM ERSTEN BUCH *FLOWERS EVERY DAY* ZEIGT SIE, WIE IHRE WUNDERSCHÖNEN ARRANGEMENTS ENTSTEHEN.

FONDATRICE DE LA SOCIÉTÉ DE LIVRAISON DE BOUQUETS À VÉLO PETALON, FLORENCE KENNEDY DISTRIBUE SES COMPOSITIONS RUSTIQUES DANS TOUT LONDRES. DANS SON LIVRE *FLOWERS EVERY DAY*, ELLE MONTRE COMMENT REPRODUIRE SES MERVEILLEUX BOUQUETS.

MY WORK is all about letting the nature and shape of the flowers direct the arrangements rather than anything too manicured.

THE BEST THING ABOUT MY WORK is being able to create beautiful things for people.

I WOULD SUM UP MY DECORATING STYLE as overgrown and easy.

I'M INFLUENCED by colors and textures of flowers, and how they relate to each other in their environment.

MY FAVORITE COLOR COMBINATION is currently coffee tones and muted pinks, but it changes all the time.

I'M HAPPIEST when I'm playing with leftover flowers with no agenda—just making new things.

MY FAVORITE SEASON is spring. I long for it after winter and it's full of hope for all the flowers that are about to appear.

IF MONEY WAS NO OBJECT I would buy a house with a massive garden so I could grow all the flowers I loved.

IN MEINER ARBEIT GEHT ES DARUM, das Arrangement von der Natur und der Form der Blumen bestimmen zu lassen, anstatt es zu künstlich zu gestalten.

DAS BESTE DARAN: Wunderschöne Dinge für Menschen zu kreieren.

MEINEN STYLE WÜRDE ICH SO BEZEICHNEN: überwachsen und locker

MICH BEEINFLUSSEN die Farben und Texturen von Blumen und wie sie in ihrem Lebensraum miteinander in Verbindung stehen.

MEINE LIEBLINGSFARBKOMBINATION: Zurzeit Kaffeetöne und Altrosa, aber das ändert sich ständig.

AM GLÜCKLICHSTEN BIN ICH, wenn ich ohne bestimmtes Ziel mit übriggebliebenen Blumen spiele und einfach so etwas Neues entsteht.

MEINE LIEBLINGSJAHRESZEIT ist der Frühling. Nach dem Winter sehne ich mich immer danach, und er steckt voller Hoffnung für all die Blumen, die dann hervorkommen.

WENN GELD KEIN THEMA WÄRE, würde ich ein Haus mit einem riesigen Garten kaufen und darin alle Blumen wachsen lassen, die ich liebe.

MON TRAVAIL, C'EST AVANT TOUT laisser la nature et la ligne des fleurs dicter mes créations, plutôt que d'imposer une composition trop artificielle.

CE QUE J'AIME LE PLUS DANS MON TRAVAIL, c'est créer de belles choses pour les autres.

JE QUALIFIERAIS MON STYLE de facile et foisonnant.

JE SUIS INFLUENCÉE PAR les couleurs et les textures des fleurs, et par leurs interactions au sein de leur environnement.

MON ASSOCIATION DE COULEURS PRÉFÉRÉE, en ce moment, ce sont les tons café et les vieux roses, mais cela change tout le temps.

MON BONHEUR, c'est de jouer avec les fleurs restées au rebut, sans vraiment savoir où je vais, juste pour tester de nouvelles compositions.

MA SAISON PRÉFÉRÉE, c'est le printemps, que j'aspire à voir pointer après l'hiver. Il recèle l'espoir de toutes les fleurs à éclore.

SI L'ARGENT N'ÉTAIT PAS UN OBSTACLE, j'achèterais une maison avec un grand jardin pour y faire pousser toutes les fleurs que j'aime.

KATE CADBURY

BASED IN EAST LONDON, KATE IS A PRESSED FLOWER ARTIST WHO ASSEMBLES HOME-GROWN FLOWERS OVER VINTAGE PHOTOGRAPHS.

KATE IST EINE KÜNSTLERIN AUS EAST LONDON, DIE MIT GEPRESSTEN BLUMEN ARBEITET. SIE ARRANGIERT SELBSTGEZOGENE BLUMEN ÜBER ALTEN FOTOGRAFIEN.

INSTALLÉE DANS L'EST DE LONDRES, KATE EST UNE VIRTUOSE DES FLEURS SÉCHÉES QU'ELLE APPLIQUE SUR DES PHOTOS RÉTRO.

MY WORK is all about preserving the past and present. A pressed flower preserves a moment in time.

THE BEST THING ABOUT IT is growing the flowers myself and then experimenting.

MY LOVE OF FLOWERS was sparked by my garden in London and watching things grow.

IF I WERE A FLOWER, I'd be a poppy.

MY FAVORITE COLOR COMBINATION is hot yellow and lilac combinations.

MY FAVORITE DESTINATIONS include India for the color and madness, France for the markets and forests, London for going out and being with friends.

I'M HAPPIEST when I'm working in my studio and in the garden.

MY FAVORITE SEASON is late spring, when the wisteria is in bloom and the cherry blossoms are fading.

I LIKE TO COLLECT photography books. Corinne Day's *Diary* is the one I treasure most. She captures a time I feel connected to.

IF MONEY WAS NO OBJECT I would travel for a year.

MY FAVORITE QUOTE IS: "Dance first, think later. It's the natural order." —Samuel Beckett

IN MEINER ARBEIT GEHT ES DARUM, Vergangenheit und Gegenwart zu bewahren. Eine gepresste Blume hält einen Moment in der Zeit fest.

DAS BESTE DARAN: Die Blumen selber heranzuzüchten und dann damit zu experimentieren.

MEINE LIEBE ZU BLUMEN entstand durch meinen Garten in London, in dem ich den Pflanzen beim Wachsen zusehen konnte.

ALS BLUME WÄRE ICH eine Mohnblume.

MEINE LIEBLINGSFARBKOMBINATION: ein warmes Gelb und Lila

MEIN LIEBLINGSREISEZIEL: Indien, weil es so bunt und verrückt ist; Frankreich wegen seiner Märkte und Wälder; London zum Ausgehen und Abhängen mit Freunden

AM GLÜCKLICHSTEN BIN ICH, wenn ich in meinem Atelier und im Garten arbeite.

MEINE LIEBLINGSJAHRESZEIT ist der späte Frühling, wenn der Blauregen blüht und die Kirschblüten fast abgeblüht sind.

LIEBLINGSBÜCHER: Ich sammle Bücher über Fotografie. Mein Lieblingsbuch aus dieser Sammlung ist *Diary* von Corinne Day. Sie fängt eine Zeit ein, mit der ich mich verbunden fühle.

WENN GELD KEIN THEMA WÄRE, würde ich ein ganzes Jahr lang reisen.

MEIN LIEBLINGSZITAT: „Zuerst tanzen, dann denken. Das ist die natürliche Reihenfolge." Samuel Beckett

MON TRAVAIL, C'EST AVANT TOUT préserver à la fois le passé et le présent. Une fleur séchée, c'est un instant qui s'éternise.

CE QUE J'AIME LE PLUS DANS MON TRAVAIL, c'est faire des expériences créatives avec des fleurs que j'ai fait pousser moi-même.

MON AMOUR DES FLEURS me vient de mon jardin londonien, où je regarde pousser les plantes.

SI J'ÉTAIS UNE FLEUR, je serais un coquelicot.

MON ASSOCIATION DE COULEURS PRÉFÉRÉE, c'est jaune vif et lilas.

MES DESTINATIONS PRÉFÉRÉES sont l'Inde pour les couleurs et la folie, la France pour les marchés et les forêts, Londres pour sortir et pour les amis.

MON BONHEUR, c'est travailler dans mon atelier et mon jardin.

MA SAISON PRÉFÉRÉE, c'est la fin du printemps, quand fleurit la glycine et que fanent les fleurs de cerisier.

J'AIME BIEN COLLECTIONNER les livres de photos. *Diary* de Corinne Day est celui auquel je tiens le plus. Elle a su saisir une époque avec laquelle je me sens en phase.

SI L'ARGENT N'ÉTAIT PAS UN OBSTACLE, je partirais en voyage pendant un an.

MA CITATION PRÉFÉRÉE est une phrase de Samuel Beckett : « Danse d'abord, pense ensuite. C'est l'ordre naturel. »

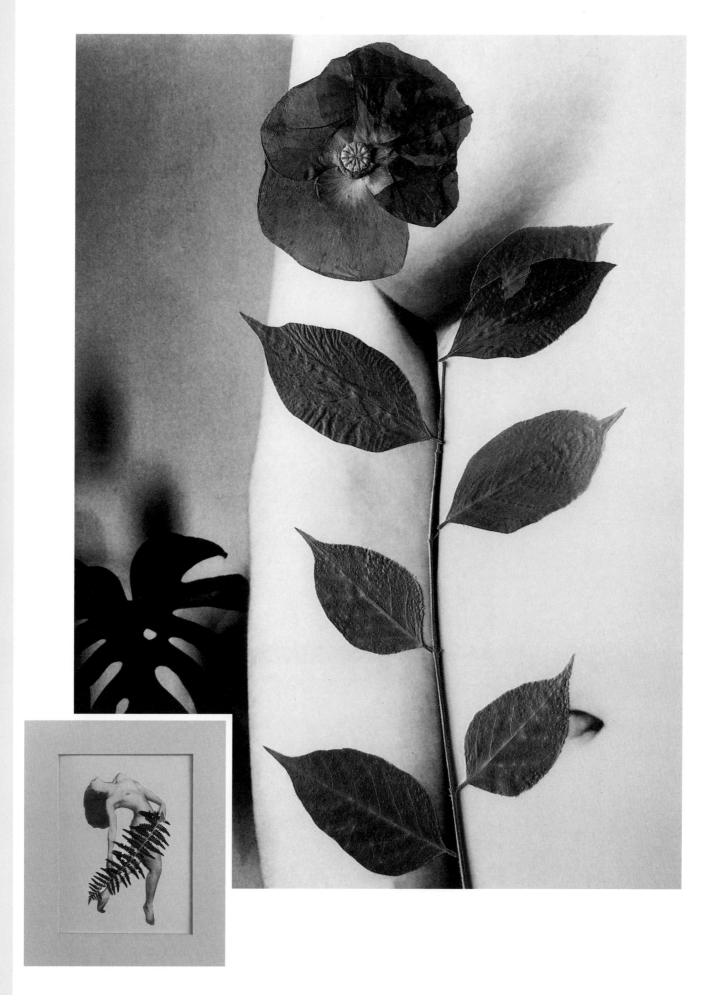

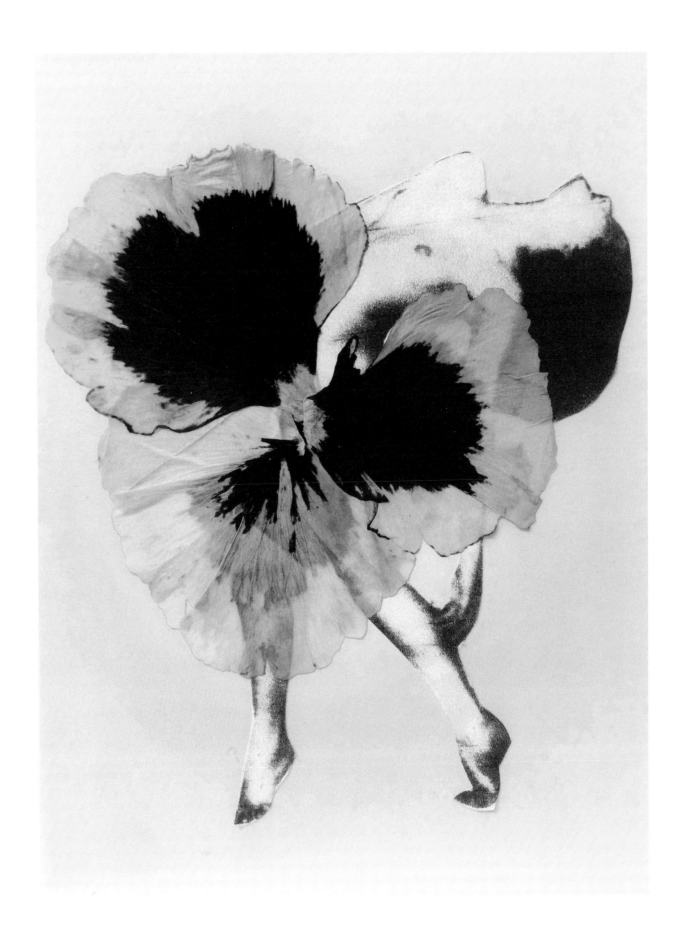

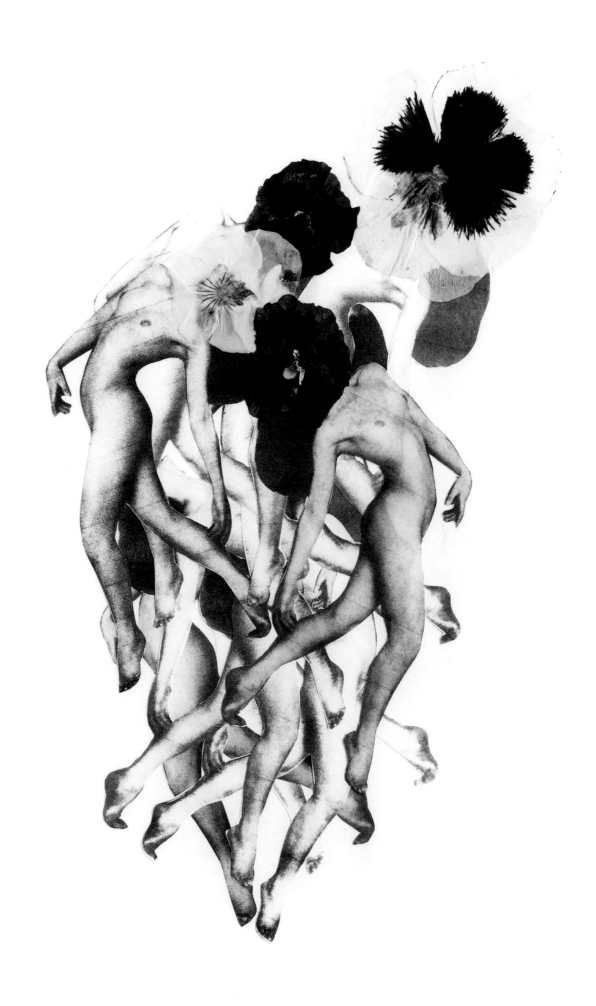

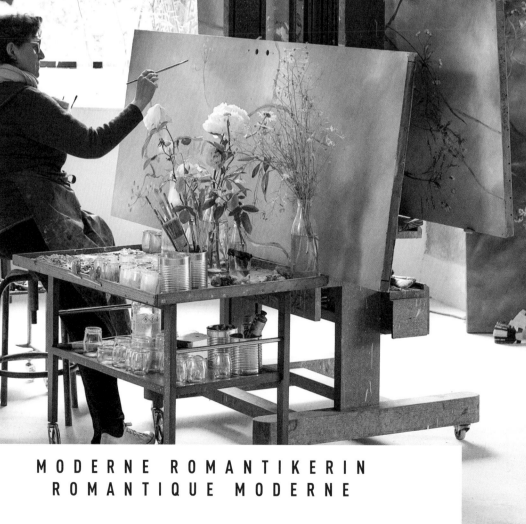

MODERN ROMANTIC

MODERNE ROMANTIKERIN
ROMANTIQUE MODERNE

THE FRENCH have always taken a higher plane when it comes to romance. Free-spirited and flamboyant, the aesthetic vision and creative impulses are second to none. Take Versailles, for example. It is fun, fashion, and power, all in one. Claire Basler's home and studio, Château de Beauvoir in Auvergne, is most definitely of La Pompadour spirit. Everything about her medieval château feels Cinderella-like and palatial. Filled with sharp, modern design as well as her ethereal paintings, here a graphic coffee table is balanced with naked plaster on the walls. Likewise contemporary lighting updates a traditional parquet floor. Taking floral to the next level, Claire adds luxury to her fifteen-bedroom country house with lush velvet sofas, glossy glass tables, and metallic accessories that glow in the light. However, the biggest personality givers are the hand-painted canvases adorning the walls. "I was attracted to the castle for its magnificent trees and great nature," says Claire. Her paintings capture a feeling of looking out over the gardens, creating an interior that is breathtakingly verdant—airy and uplifting in the bedroom, dark and dramatic in the lounge. It all makes for a wonderful visual feast. Color and nature are key—wonderfully smudgy oil paintings decorate the walls, and the play of light and shadow adds another dimension.

IN SACHEN ROMANTIK waren die Franzosen immer *magnifique*, unerreichbar in ihren freigeistigen ästhetischen Visionen und eigenwillig-kreativen Impulsen. Man nehme nur Versailles, das Spaß, Mode und Macht in einem verkörpert. Claire Baslers Zuhause und Atelier, das Château de Beauvoir in der Auvergne, verströmt definitiv den Geist der Pompadour. Das Interieur ist geprägt von modernen Designerstücken sowie Claires zarten Gemälden. Gegensätze prallen aufeinander: So steht ein eleganter Beistelltisch vor Wänden, von denen der Putz blättert, und minimalistisch-moderne Leuchten illuminieren einen alten Parkettboden. In ihrem Landsitz mit 15 Schlafzimmern hat Claire florales Design auf Luxus getrimmt: mit weichen Samtsofas, glänzenden Glastischen und Accessoires aus Metall, die im Licht schimmern. Die prägendsten Objekte sind jedoch die von Claire handbemalten Landschaftsszenerien, die viele der Wände verzieren. „Das Schloss zog mich wegen der herrlichen Bäume und der großartigen Landschaft an", sagt Claire. Ihre Gemälde lassen glauben, man würde direkt in den Garten hinausschauen, und erzeugen ein atemberaubend grünes Interieur – leicht und luftig im Schlafzimmer, dunkel und dramatisch im Wohnzimmer. Alles zusammen ergibt ein visuelles Fest, das von den Farben und Formen der Natur geleitet wird. Leicht unscharfe Ölgemälde schmücken die Wände und das Spiel von Licht und Schatten verleiht dem Ganzen eine weitere Dimension.

EN MATIÈRE DE ROMANTISME, les Français ont toujours une longueur d'avance. Pour eux, esthétique et créativité ne sont pas de vains mots. En Auvergne, le château de Beauvoir, où vit et travaille Claire Basler, assume son côté très « Pompadour ». Tout, dans ce château médiéval, évoque le palais d'une Cendrillon. Il réalise l'équilibre parfait entre les éléments de design moderne aux lignes épurées et le romantisme éthéré des tableaux peints par Claire. Ici, une table basse brille contre les murs de plâtre brut. Là, des luminaires contemporains éclairent le parquet traditionnel. L'ambiance végétale se décline aussi dans les étages de ce manoir de campagne qui compte quinze chambres. Claire a apporté une touche de luxe à chacune, à grand renfort de voluptueux canapés en velours, de tables en verre à la surface brillante et d'accessoires métalliques qui étincellent dans la lumière. Mais ce sont surtout les toiles sur les murs qui donnent à ces lieux toute leur personnalité. « Ces arbres magnifiques et l'époustouflante beauté de la nature m'ont séduite », explique Claire. Ses œuvres trompent le regard en recréant une sensation d'extérieur et de jardins, tout en composant un intérieur extraordinairement verdoyant – aéré et tonique dans la chambre, sombre et grave dans le salon. Couleurs et nature règnent en maîtres. Des huiles sur toile au flou onirique décorent les murs, tandis qu'un jeu d'ombres et de lumières ajoute une dimension féérique.

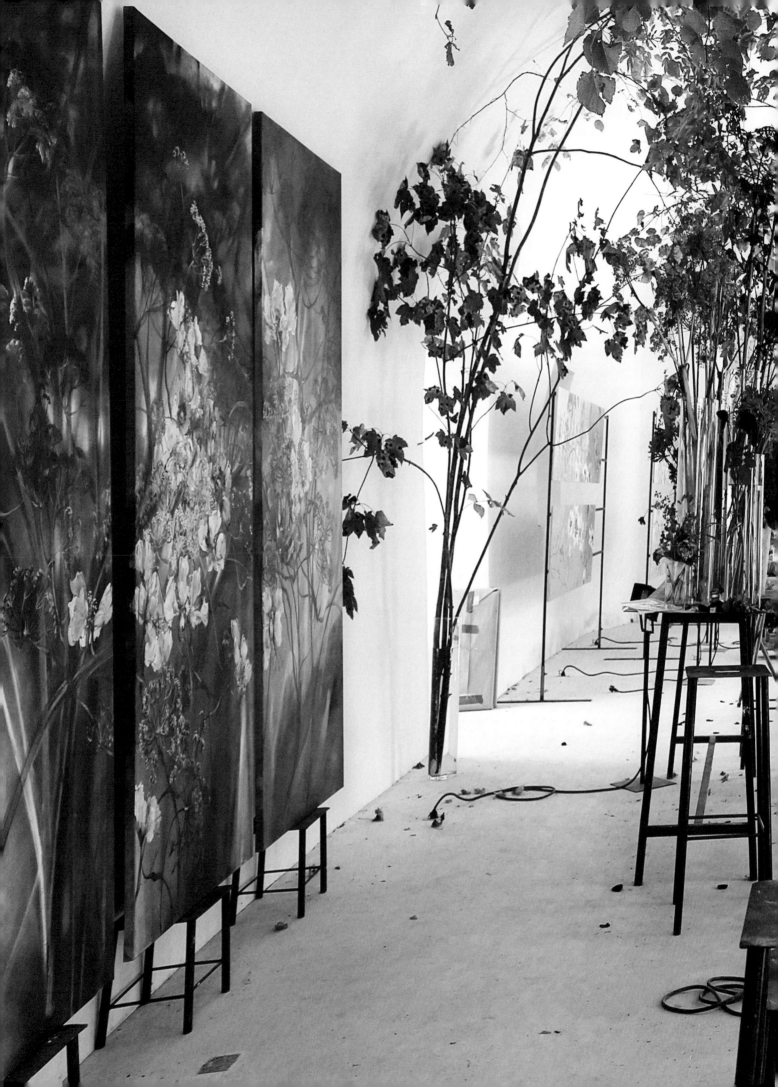

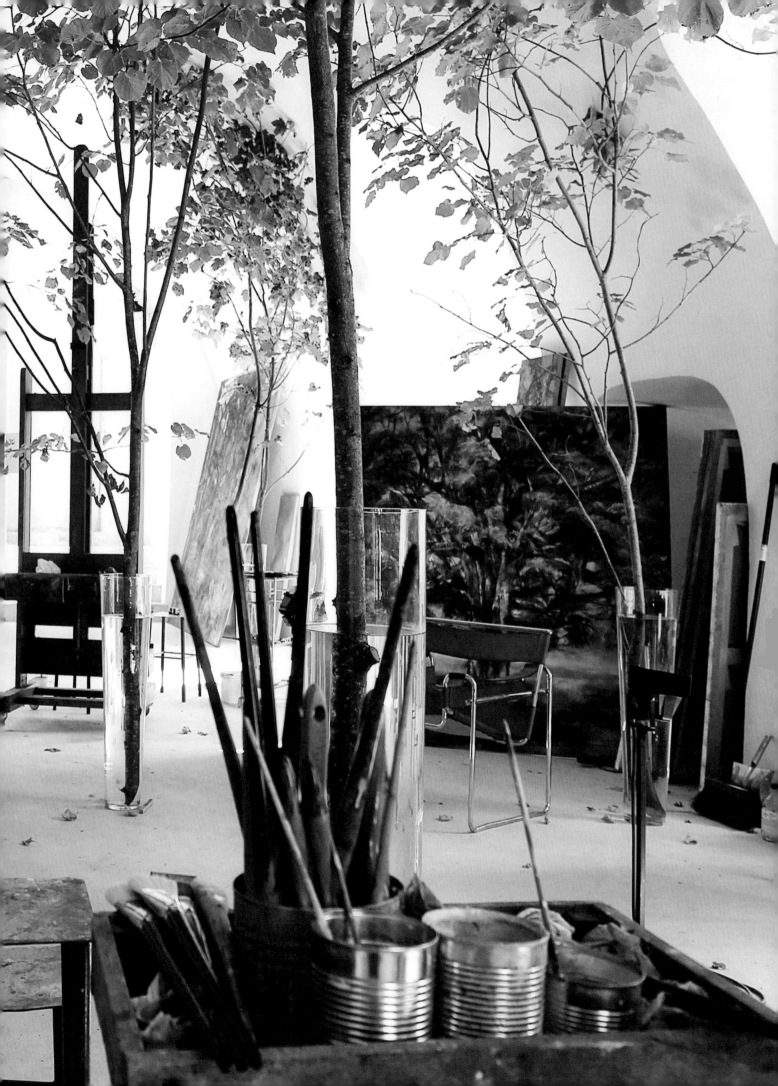

STUDIO
Fresh-from-the-garden stems and flowers are the starting point of this interior design scheme. Look for watercolor and pencil sketched patterns to summon an artsy, naturalistic vibe—mixing different scales of prints to keep things contemporary.

ATELIER
Frisch gepflückte Blumen aus dem Garten bilden den Ausgangspunkt für dieses Designkonzept. Zum Nachahmen: Suchen Sie nach mit Wasser-, Ölfarben und Bleistift skizzierten Mustern, um einen künstlerisch angehauchten, naturalistischen Vibe zu kreieren. Eine Kollektion aus Bildern in unterschiedlichen Formaten wirkt modern.

ATELIER
Au commencement de ce projet d'architecture d'intérieur, il y avait les fleurs et les feuillages du jardin fraîchement coupés. Pour recréer ces vibrations naturalistes, choisissez des motifs dessinés au fusain et peints à l'aquarelle, et jouez avec les proportions.

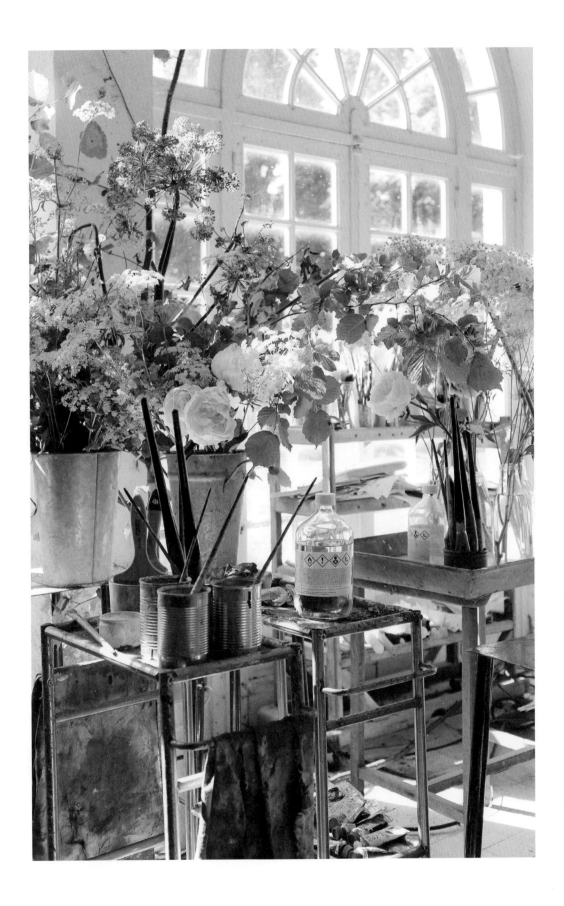



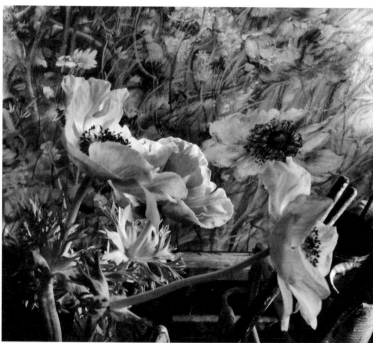

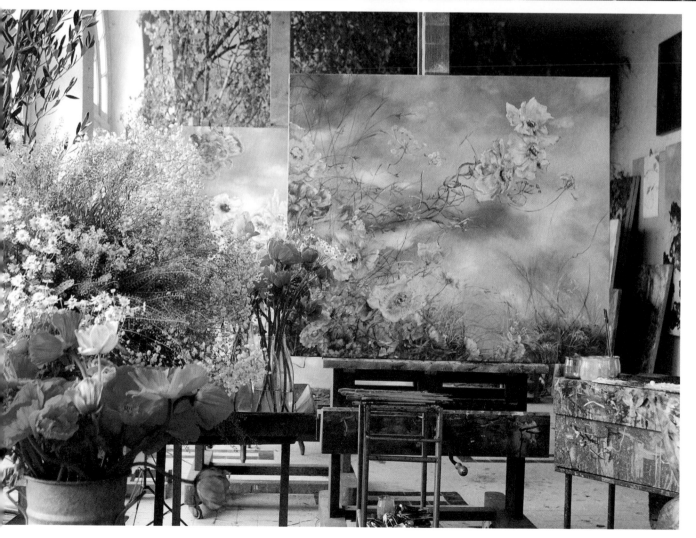

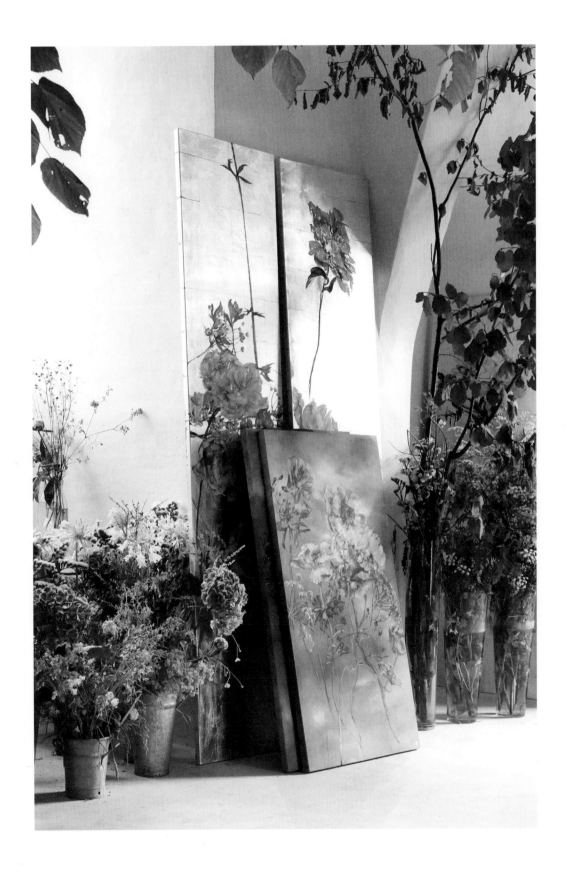

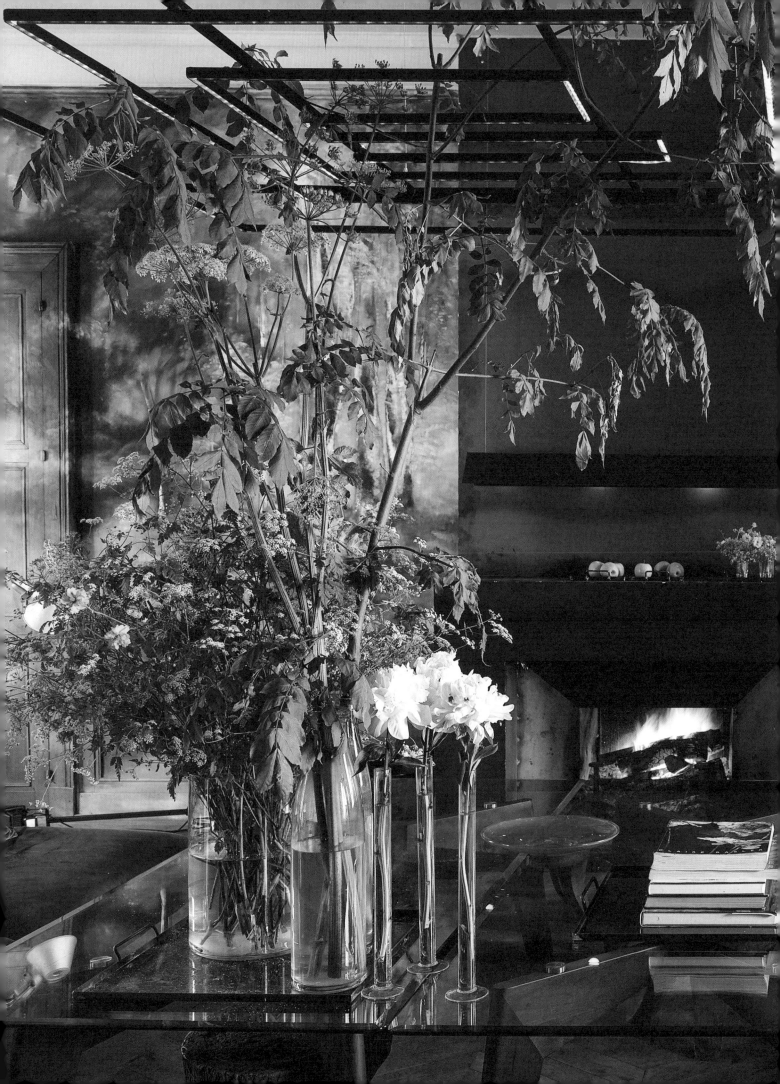

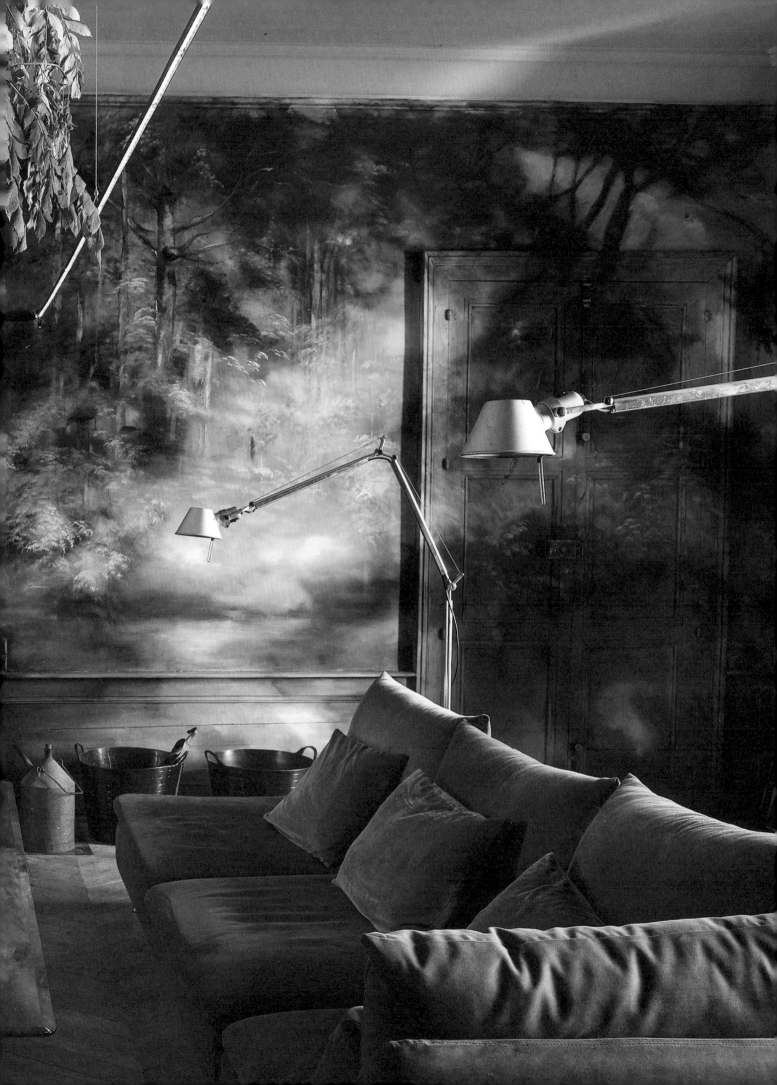

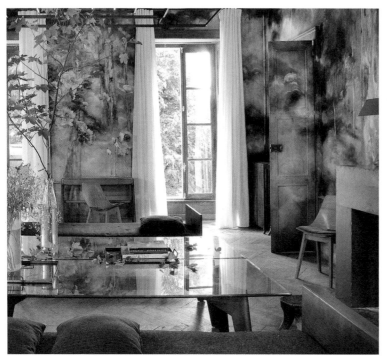
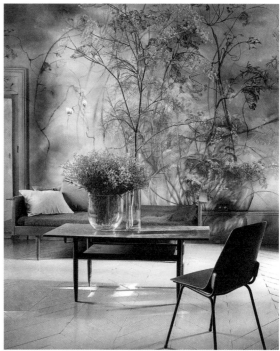

LIVING ROOM

*The floral-patterned walls of the living room are grounded
by angular-shaped furniture. A Pierre Guariche chair and Italian table
are both from the '50s and an iron mobile by Claire's brother, Jérôme Basler,
brings the ceiling to life. Sheer voiles create a soft, diffused light.*

WOHNZIMMER

*Den mit floraler Motivik verzierten Wänden wurde eher gradlinig-
schnörkelloses Mobiliar entgegengesetzt. Ein Stuhl von Pierre Guariche
und ein italienischer Tisch stammen beide aus den 1950er-Jahren,
ein Eisenmobile von Claires Bruder Jérôme belebt die Decke.
Durchscheinende Voilevorhänge erzeugen ein sanftes, diffuses Licht.*

SALON

*Les meubles aux silhouettes rectilignes donnent du corps aux motifs floraux
qui décorent les murs du salon. La chaise de Pierre Guariche
et la table italienne datent des années 1950. Un mobile en fer créé
par le frère de Claire, Jérôme Basler, anime le plafond et d'aériens voilages
tamisent l'ambiance.*

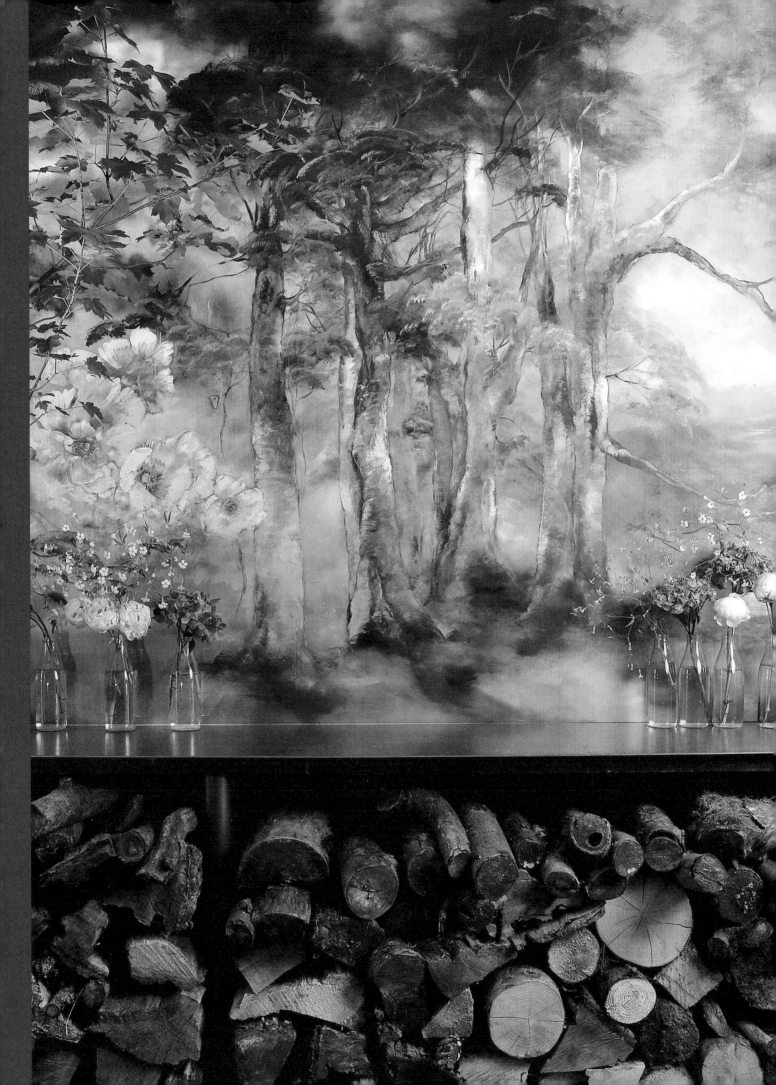

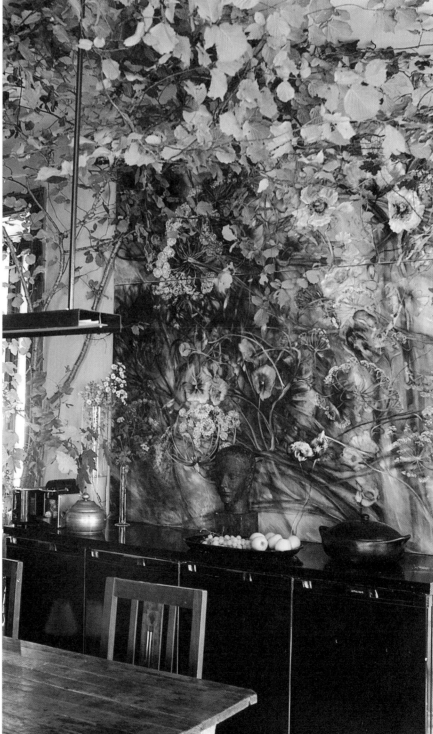

KITCHEN
In the kitchen, a painted farmhouse table and a trio of stoves add punch to the delicacy of Claire's flower art. Flos lights by Ronan & Erwan Bouroullec drape overhead and texture is in overload, courtesy of the bare plaster walls.

KÜCHE
Ein schlichter weiß lackierter alter Landhaustisch mit drei Gasbrennern bildet einen drastischen Kontrast zur Zartheit von Claires Blumenkunst. Von Ronan & Erwan Bouroullec entworfene Flos-Leuchten sind an der Decke drapiert; die nackten Wände mit abblätterndem Putz vermitteln Textur.

CUISINE
Dans la cuisine, une table de ferme repeinte et trois feux donnent du punch aux délicates fleurs de Claire. Les luminaires Flos de Ronan & Erwan Bouroullec drapent le plafond, tandis que les murs en plâtre composent une toile de fond brute à souhait.

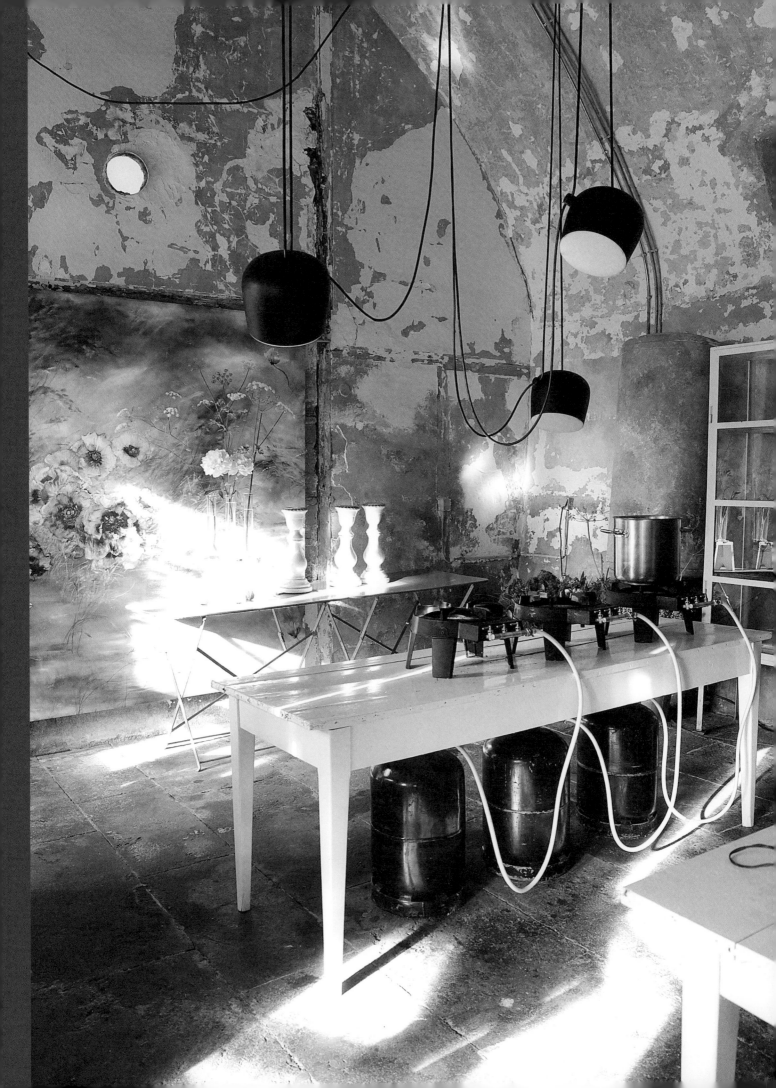

BEDROOM
Painted to resemble a spacey, botanical scene, Claire's bedroom proves that just because it's flowers, it doesn't have to be pink. Earthy shades of taupe and sage greens are crisped up with matte white pieces, such as the table light and linen.

SCHLAFZIMMER
Claires Schlafzimmer wurde so bemalt, dass eine botanische Szenerie entsteht, und beweist, dass Blumenmotive nicht immer pink sein müssen. Erdige Taupetöne und Salbeigrün werden durch das matte Weiß der Nachttischlampe und des Bettbezugs aufgefrischt.

CHAMBRE À COUCHER
Avec ses fresques, la chambre de Claire prouve que tout ce qui est fleuri n'a pas besoin d'être rose. Elle décline des nuances de taupe et de sauge, que viennent rehausser des éléments de décoration d'un blanc mat, comme la lampe et le linge de lit.

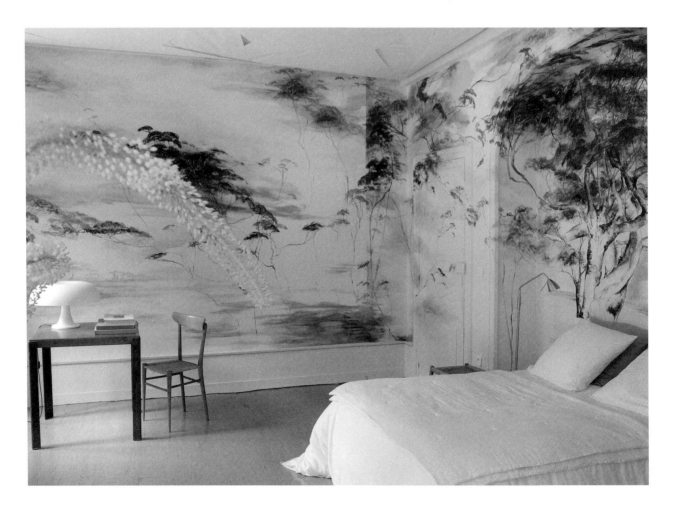

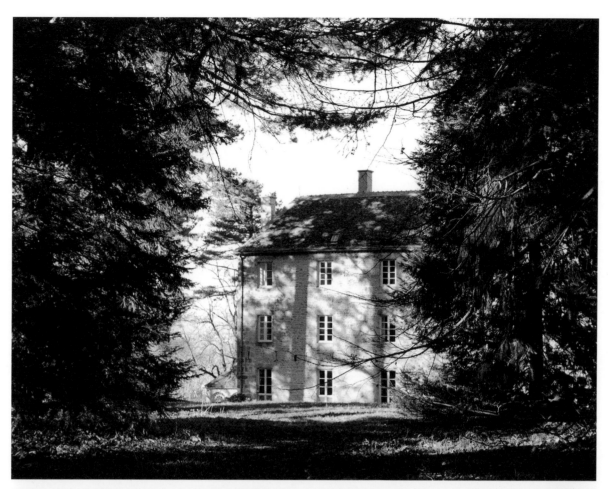

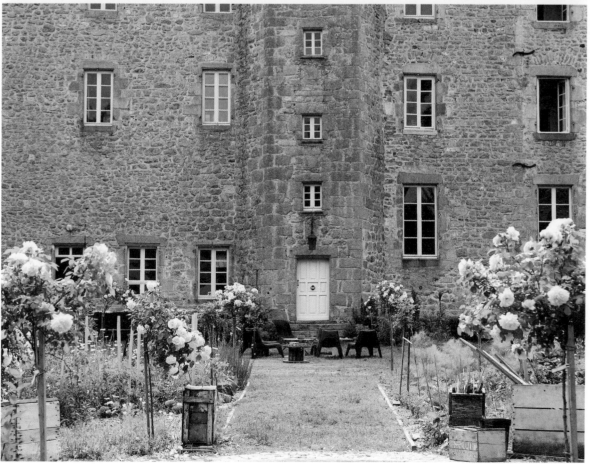

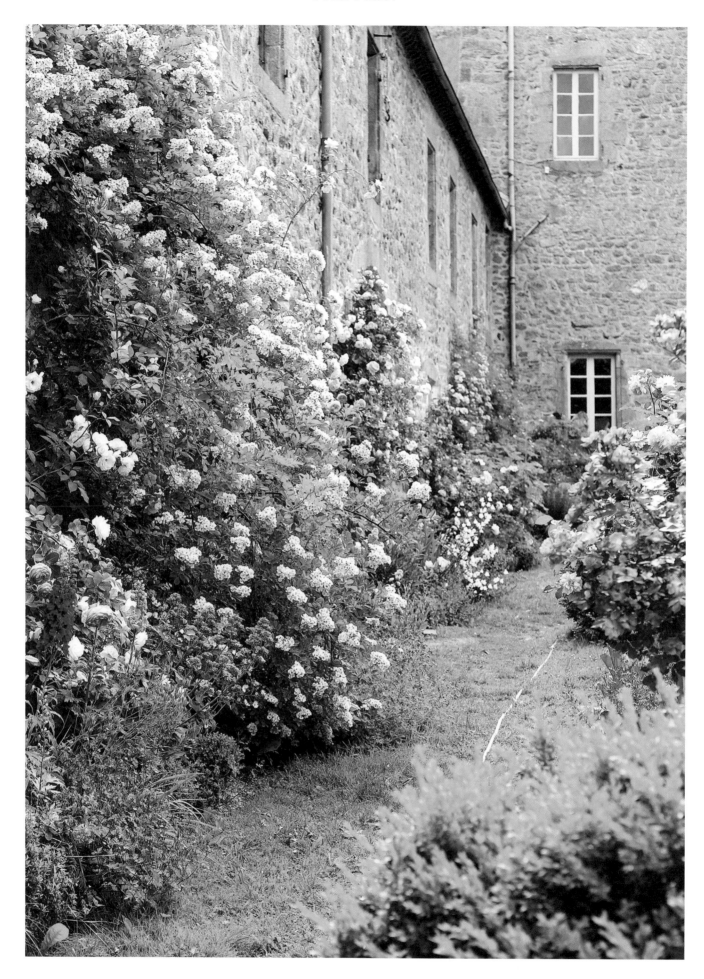

AN AUTUMN BOUQUET

TAKE THE EDGE OFF A ROMANTIC DISPLAY WITH A CONTEMPORARY
ARRANGEMENT ON THE WILD SIDE.

EIN HERBSTBOUQUET: SO WIRD FLORALE ROMANTIK
DURCH EINE WILDE KOMPONENTE ZU EINEM MODERNEN ARRANGEMENT.

BOUQUET D'AUTOMNE : À L'ÉCART DES SENTIERS BATTUS DU ROMANTISME,
UNE COMPOSITION SAUVAGE AU LOOK CONTEMPORAIN.

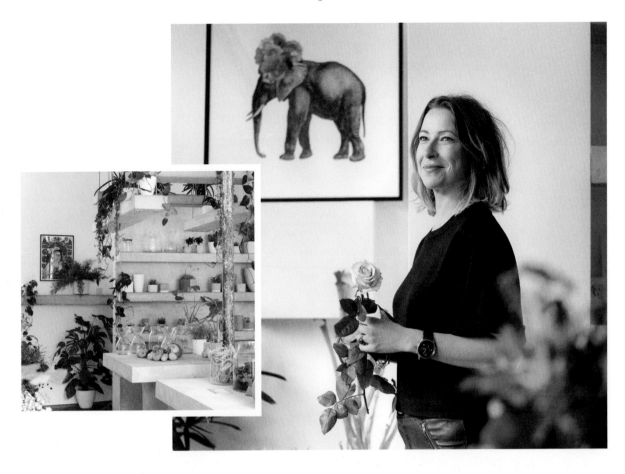

FLORIST NIK SOUTHERN has made a name for herself with whimsical and romantic arrangements. Bringing the wildness and rusticity of the English countryside to her busy London shop Grace & Thorn in Hackney, her naturalistic designs have made her one of the most in-demand florists today. Here, she shows us how to create a modern autumn bouquet.
graceandthorn.com

"First of all, choose your flowers," says Nik. "Go for a couple of large and sumptuous blooms, which will be the focus of your arrangement. Follow with smaller flowers, berries, and foliage that will create texture and interest to the display. Before you go any further, tidy up your flowers by stripping all of the leaves from the stem. This will prevent them from rotting in the water and make for a tidier finish. Only now you are ready to start. Begin by placing foliage in the jar. This will be your "skeleton"— your base of the arrangement. Next, position the largest flower and layer all the other, smaller flowers, berries, and thistles all around it. The result? A full and wild garden effect."

FLORISTIN NIK SOUTHERN hat sich mit ungewöhnlichen und romantischen Arrangements einen Namen gemacht. In ihrem immer gut besuchten Laden Grace & Thorn in Hackney findet sich die wilde Ursprünglichkeit der englischen Landschaft wieder. Hier erklärt sie, wie man einen modernen Herbststrauß zusammenstellt.
graceandthorn.com

„Wählen Sie zuerst die Blumen aus", sagt Nik. „Zwei große auffällige Blüten sollten im Mittelpunkt des Arrangements stehen. Danach folgen kleinere Blumen und Beeren sowie Blattgrün, das Textur und Fülle beisteuert. Bevor Sie mit der Zusammenstellung des Straußes beginnen, befreien Sie die Blumenstängel von Blättern, damit diese nicht im Wasser verfaulen und der Strauß ordentlicher aussieht. Erst jetzt geht es richtig los. Setzen Sie zuerst das Blattgrün in die Vase – das ist Ihr Grundgerüst. Als Nächstes ist die größte Blume an der Reihe. Die kleineren Blumen, Beeren und Disteln werden in Schichten darum herum gruppiert. Das Resultat? Ein voller und wilder Garteneffekt."

C'EST AVEC DES CRÉATIONS à la fois sages et fantasques que la fleuriste Nik Southern s'est fait un nom. Chez Grace & Thorn, sa boutique londonienne qui ne désemplit pas, en plein quartier de Hackney, elle a recréé un petit coin de campagne anglaise rustique. Nik nous explique comment réaliser un bouquet d'automne au goût du jour.
graceandthorn.com

« La première chose, c'est le choix des fleurs, dit-elle. Prenez deux ou trois belles fleurs épanouies qui formeront le cœur de la composition. Sélectionnez ensuite des fleurs plus petites, des baies et du feuillage, qui donneront du volume à votre bouquet, tout en mettant ses vedettes en valeur. Puis préparez vos fleurs, en débarrassant les tiges de toutes les feuilles, à la fois pour alléger l'ensemble et pour qu'elles ne pourrissent pas dans l'eau. Maintenant, vous pouvez vous lancer : commencez par disposer le feuillage dans le pot pour installer le "squelette", la base de l'arrangement. Positionnez ensuite les grandes fleurs, puis les petites, et enfin les baies et les chardons. Résultat ? Un effet jardin sauvage bluffant. »

1

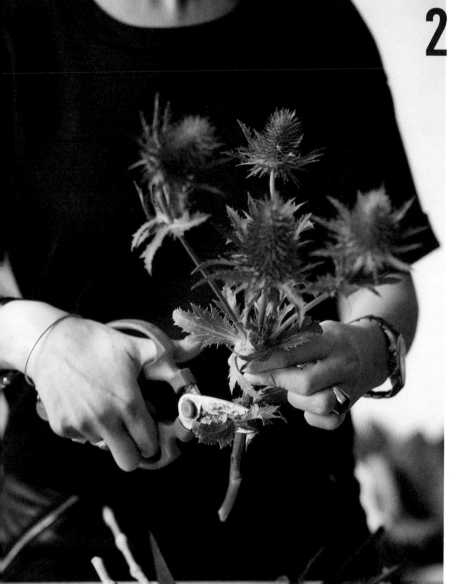

2

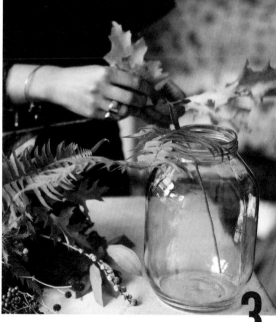

3

Contrast velvety roses with paper-
like petals of Astrantia and striking
thistles for a wild and vintage style.

Kombinieren Sie samtene Rosen
mit den papierartigen Blütenblättern
der Sterndolde und dekorativen Disteln,
um einen wilden Vintage-Stil zu erzeugen.

Jouez les contrastes en mariant
le velouté des roses à la finesse
de l'astrance et au piquant du chardon.

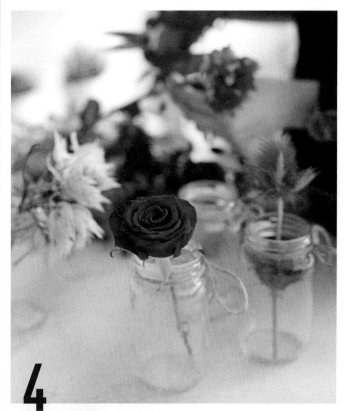

4

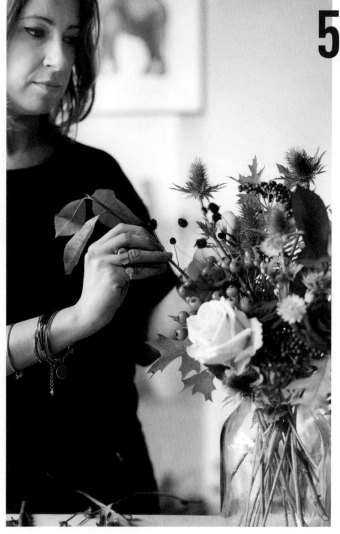

5

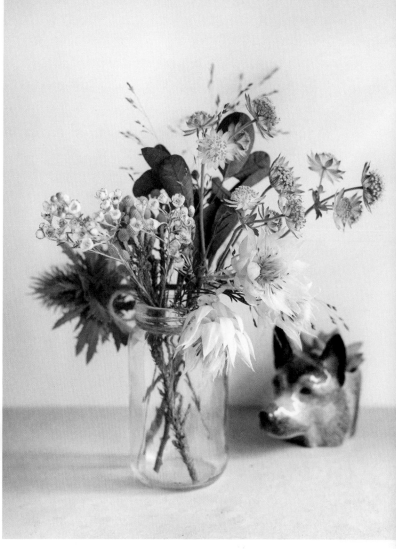

FOLLOW THESE FIVE STEPS TO CREATE A SIMPLE, MODERN DISPLAY

1 | Select contrasing flowers.
2 | Strip any leaves from the stem.
3 | Begin with foliage.
4 | Follow with the largest flower.
5 | Layer with smaller flowers, berries, and thistles.

EIN EINFACHES MODERNES BOUQUET ZUSAMMENSTELLEN

1 | Wählen Sie kontrastierende Blumen aus.
2 | Entfernen Sie die Blätter von den Stängeln.
3 | Fangen Sie mit dem Blattgrün an.
4 | Danach kommt die größte Blume.
5 | Fügen Sie die kleineren Blumen, Beeren und
 Disteln in Schichten hinzu.

COMMENT RÉALISER UNE COMPOSITION SIMPLE ET CONTEMPORAINE

1 | Sélectionnez des fleurs contrastant les unes
 avec les autres.
2 | Effeuillez les tiges.
3 | Disposez le feuillage.
4 | Dressez les grosses fleurs.
5 | Installez les petites fleurs, les baies et les chardons.

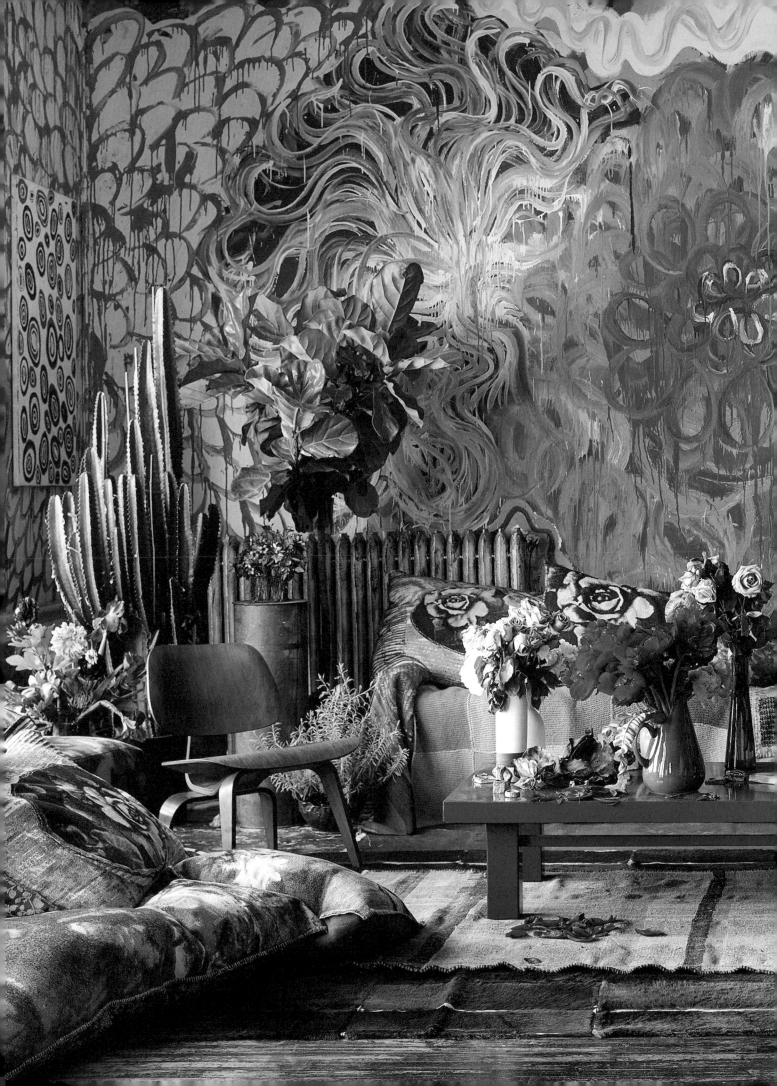

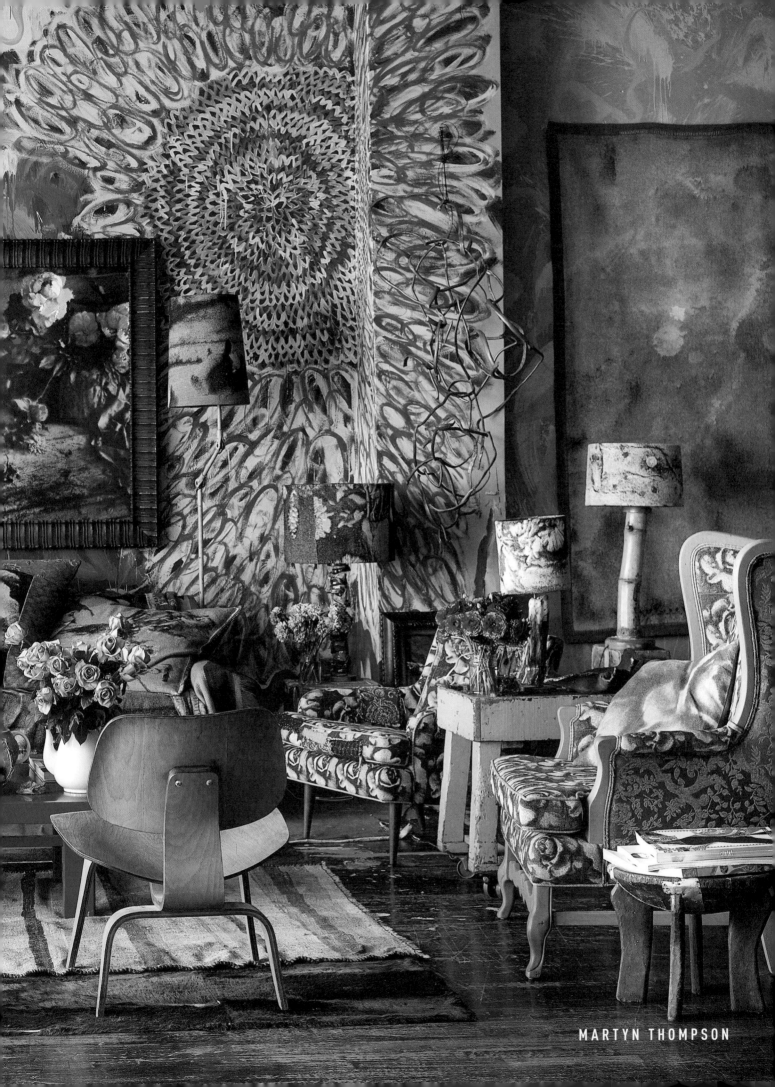

MARTYN THOMPSON

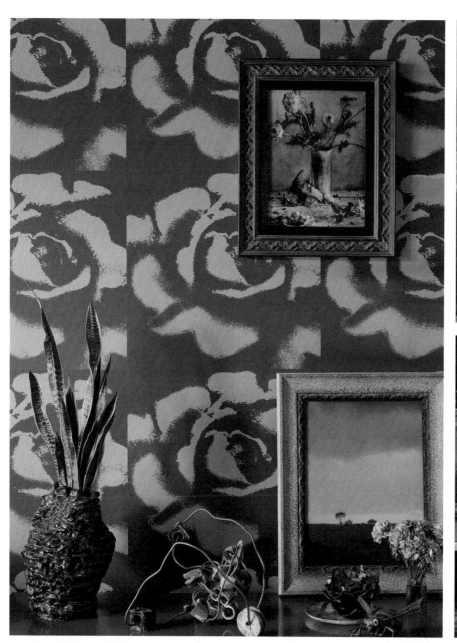

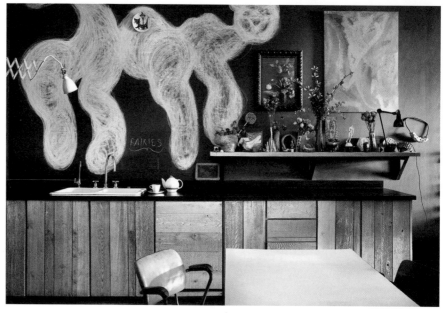

MARTYN THOMPSON

THE SYDNEY-BORN PHOTOGRAPHER IS KNOWN FOR HIS ETHEREAL IMAGES. NOW A NATIVE NEW YORKER, HE HAS TURNED HIS EYE TO DESIGNING WALLPAPERS AND TEXTILES.

DER AUS SYDNEY STAMMENDE UND IN NEW YORK LEBENDE FOTOGRAF IST FÜR SEINE ÄTHERISCHEN BILDER BEKANNT. HEUTE ENTWIRFT ER TAPETEN UND STOFFE.

NÉ À SYDNEY, CE PHOTOGRAPHE EST CONNU POUR SES IMAGES ÉTHÉRÉES. AUJOURD'HUI ANCRÉ À NEW YORK, IL S'EST TOURNÉ VERS LA CRÉATION DE TEXTILES ET DE PAPIERS PEINTS.

MY WORK is all about what I love.

I WOULD SUM UP MY STYLE as very personal, like a patina of age, all lived-in and moody. The color palette is paramount.

NATURE has influenced my work by providing the ultimate source material—light!

MY BEST FLORAL MOMENT is the smell of frangipani on the streets of Sydney in the summertime.

IF I WERE A FLOWER I'd be a ranunculus butterfly.

MY FAVORITE DESTINATION includes Iceland for the summer solstice.

I'M HAPPIEST when I'm making new things.

MY BIGGEST GUILTY PLEASURE is watching a great period drama.

THE BOOK that's influenced me most is *To the Lighthouse* by Virginia Woolf.

IF MONEY WAS NO OBJECT, I would have a lot more help around the house.

MY BEST SKILL is enthusiasm.

MY PERSONAL MOTTO is "Just do it."

IN MEINER ARBEIT GEHT ES UM das, was ich liebe.

MEINEN STYLE WÜRDE ICH SO BEZEICHNEN: sehr persönlich, wie eine Alterspatina, eingelebt und launisch. Die Farbpalette steht an erster Stelle.

DIE NATUR HAT MEINE ARBEIT BEEINFLUSST, weil sie das ultimative Material bereitstellt: Licht!

MEIN BESTER FLORALER MOMENT: Der Geruch von Frangipani auf den Straßen von Sydney im Sommer.

ALS BLUME WÄRE ICH eine Ranunkel der Sorte „Butterfly".

MEIN LIEBLINGSREISEZIEL: Island zur Sommersonnenwende

AM GLÜCKLICHSTEN BIN ICH, wenn ich neue Dinge kreiere.

MEIN GRÖSSTES HEIMLICHES VERGNÜGEN: Kostümfilme

DAS BUCH, DAS MICH AM MEISTEN BEEINFLUSST HAT: *Zum Leuchtturm* von Virginia Woolf

WENN GELD KEIN THEMA WÄRE, hätte ich viel mehr Hilfe im Haushalt.

MEINE BESTE EIGENSCHAFT: Enthusiasmus

MEIN PERSÖNLICHES MOTTO: Just do it!

MON TRAVAIL, C'EST AVANT TOUT la synthèse de tout ce que j'aime.

JE QUALIFIERAIS MON STYLE de très personnel, une patine de l'âge, un style à vivre, versatile. La gamme de couleurs joue un rôle essentiel.

JE SUIS INFLUENCÉ PAR LA NATURE, car elle fournit une matière première essentielle à mon travail : la lumière !

MON PLUS BEL INSTANT FLORAL, c'est le parfum des frangipaniers dans les rues de Sydney, l'été.

SI J'ÉTAIS UNE FLEUR, je serais une renoncule butterfly.

MA DESTINATION PRÉFÉRÉE est l'Islande, entre autres, pour le solstice d'été.

MON BONHEUR, c'est la nouveauté.

MON PETIT PLAISIR COUPABLE, c'est de regarder un grand film d'époque.

LE LIVRE QUI M'A LE PLUS MARQUÉ est *La Promenade au phare* de Virginia Woolf.

SI L'ARGENT N'ÉTAIT PAS UN OBSTACLE, je me ferais davantage aider à la maison.

MA QUALITÉ PREMIÈRE est l'enthousiasme.

MA DEVISE est « Just do it. »

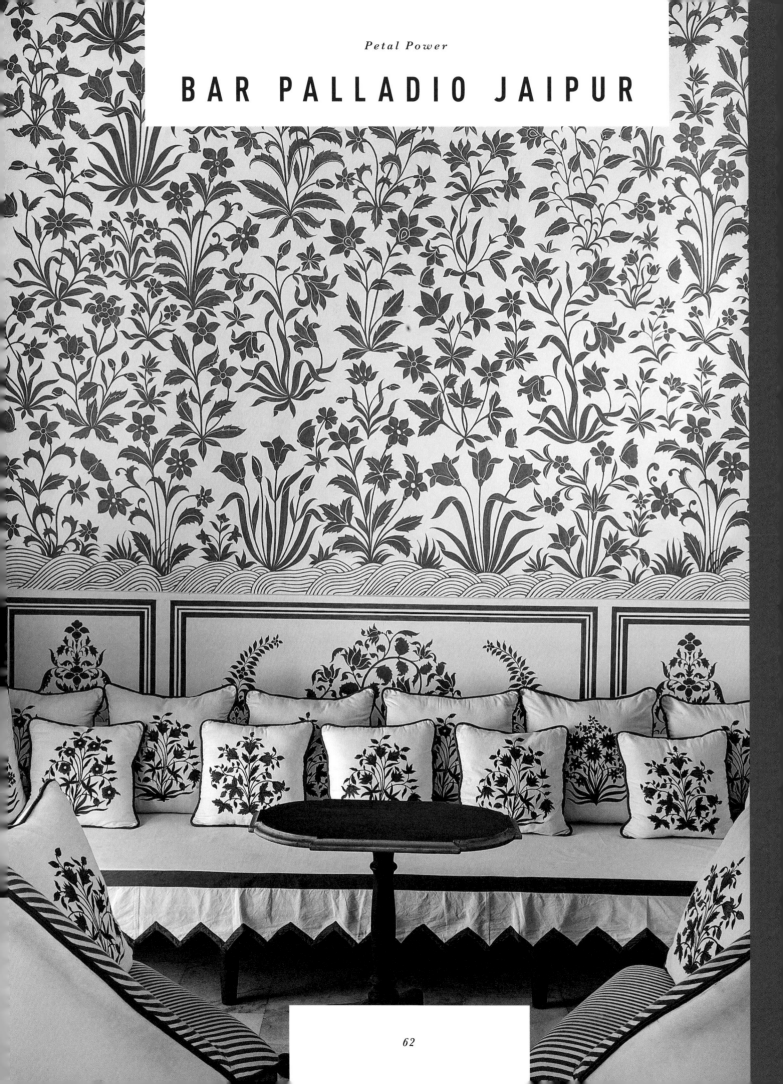

BLUE WONDER

A blue oasis in the heart of Jaipur, Bar Palladio is a jewel box of a restaurant that mixes Italian and Indian décor. Designer Marie-Anne Oudejans brings together Empire-style chairs block-printed with traditional Indian florals, while the Venetian-inspired black and white–tiled floor contrasts with intricate brass lanterns.

BLAUES WUNDER

Diese blaue Oase im Herzen Jaipurs ist ein richtiges Schatzkästchen, das italienisches und indisches Dekor kombiniert. Das von Marie-Anne Oudejans gestaltete Restaurant, ist u. a. mit Stühlen im Empire-Stil ausgestattet, die mit traditionellen, handbedruckten Stoffen mit indischem Blumenmuster bezogen sind. Die schwarzweißen Bodenfliesen im venezianischen Stil kontrastieren mit den fein ziselierten Messinglaternen.

MIRACLE BLEU

Serti dans l'écrin d'un jardin à l'écart du brouhaha de la ville indienne de Jaipur, Bar Palladio est une oasis de bleus – un décor un peu italianisant, un peu rajput et moghol. Conçu par Marie-Anne Oudejans, ce bijou de restaurant est meublé de fauteuils Empire tapissés d'imprimés aux motifs floraux indiens, tandis que le sol carrelé d'inspiration vénitienne contraste avec les lanternes en cuivre finement ouvragées.

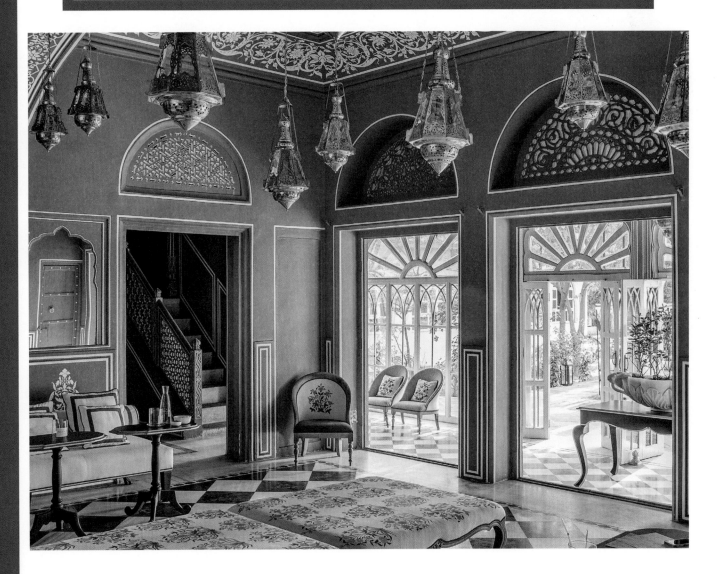

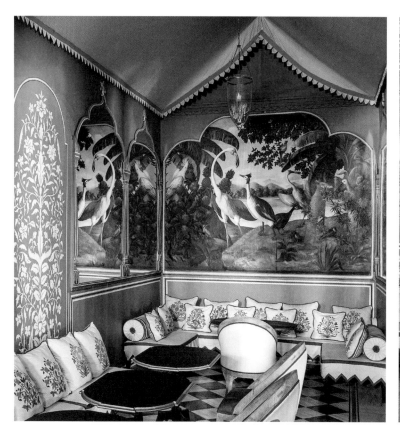
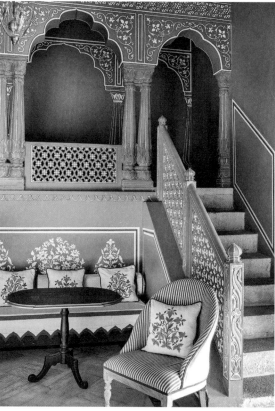

INTO THE EXOTIC
*The vision of Italian owner Barbara Miolini, tented ceilings, scallop-edged fabrics,
symmetrical layouts and fantasy landscapes all lend to the Italian/Indian vibe.
The style may be traditional, but updated with neon colors
it is far from dull.*

EXOTISCHES AMBIENTE
*Zeltdecken, Stoffe mit Muschelrand, symmetrische Layouts und
Fantasielandschaften tragen zum italienisch-indischen Vibe bei, den die
italienische Besitzerin Barbara Miolini erreichen wollte.
Der Stil mag traditionell sein, wirkt aber in seiner neonfarbenen
Reinkarnation alles andere als langweilig.*

AMBIANCE EXOTIQUE
*Plafonds en toile de tente, étoffes festonnées, agencements symétriques,
paysages oniriques… Tout concourt à entretenir l'ambiance italienne
et indienne que recherchait la propriétaire italienne, Barbara Miolini.
Un style traditionnel revisité dans des couleurs lumineuses.*

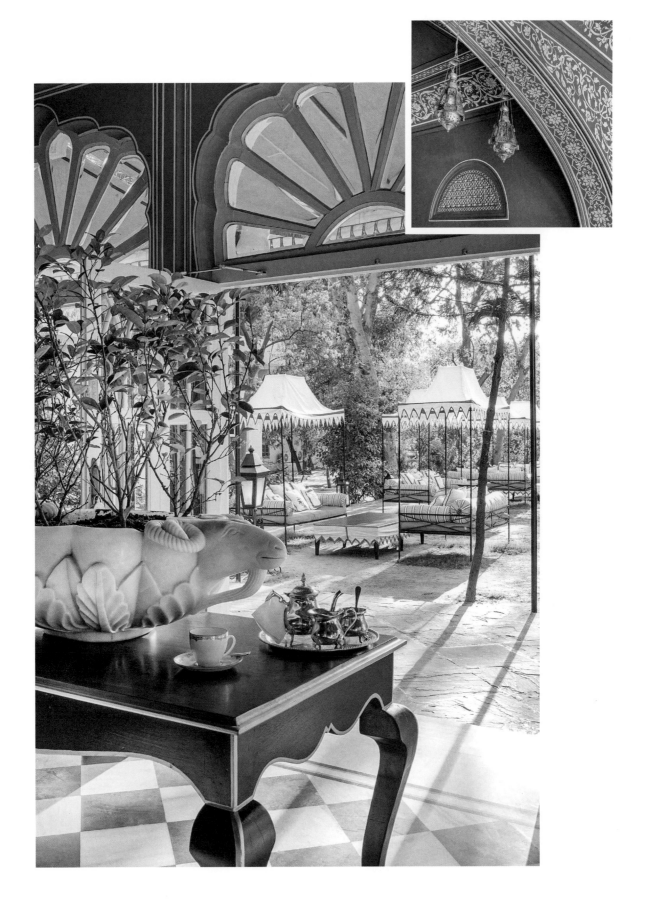

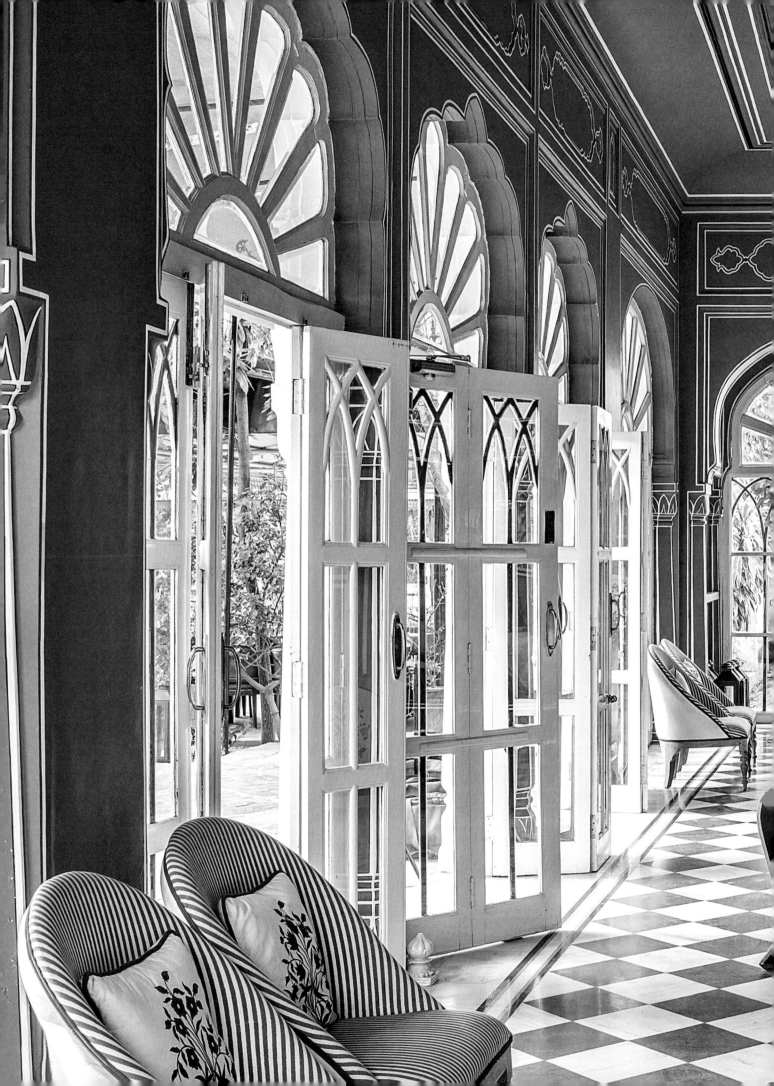

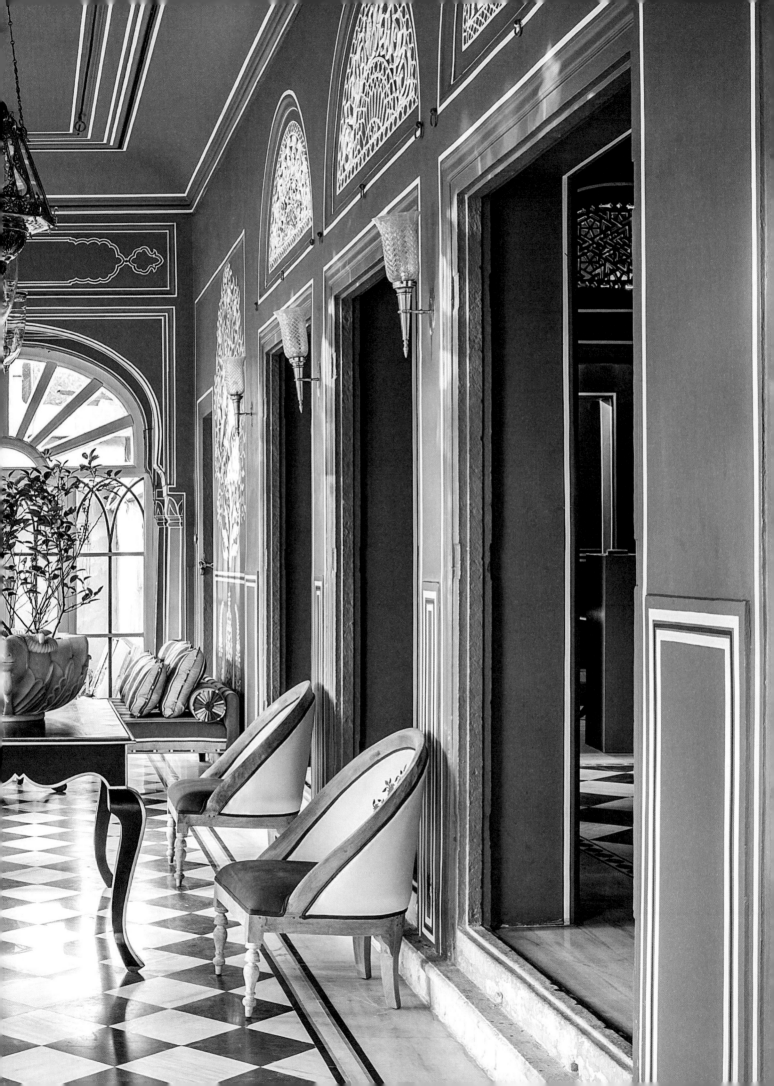

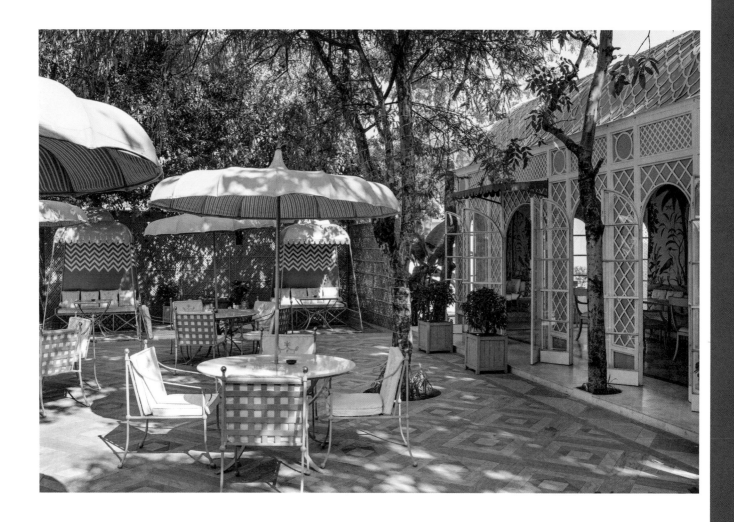

CAFFÉ PALLADIO JAIPUR

*Inspired by the palaces and gardens of Sicily, the fresh and cheerful
Caffé Palladio mixes an apricot and mint color combo with inlaid marble floors,
exotic garden frescoes, and party-ready striped parasols.*

CAFFÉ PALLADIO JAIPUR

*Inspiriert von den Palästen und Gärten Siziliens, verbindet das einladende
Caffé Palladio die Farbkombination Apricot und Mint mit eleganten Marmorböden,
exotischen Gartenfresken und fröhlich-gestreiften Sonnenschirmen.*

CAFFÉ PALLADIO JAIPUR

*Inspiré par les palais et les jardins de Sicile, le Caffé Palladio est frais et
accueillant. Tons menthe et abricot, sols en marqueterie de marbre,
fresques représentant un jardin exotique et parasols rayés.*

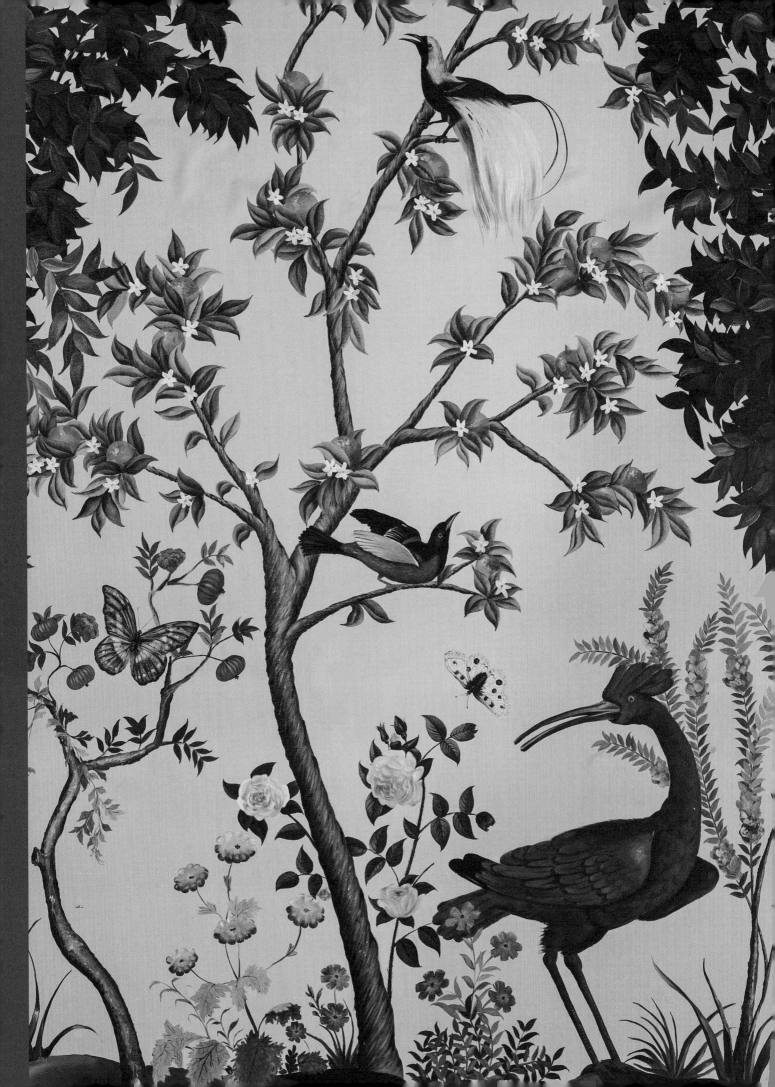

NATHALIE LÉTÉ

STEP INSIDE THE FANTASTICAL FLORAL-INSPIRED WORLD OF THE PARISIAN CERAMICIST, ARTIST, AND TEXTILE DESIGNER.

TRETEN SIE EIN IN DIE FANTASTISCHE FLORALE WELT DER PARISER KÜNSTLERIN, TÖPFERIN UND STOFFDESIGNERIN.

BIENVENUE DANS LE FANTASTIQUE UNIVERS D'INSPIRATION FLORALE DE L'ARTISTE PARISIENNE, CÉRAMISTE ET CRÉATRICE TEXTILE.

MY WORK is all about the dreams I had when I was a child. It is a mix of fairy tales and folk art.

THE BEST THING ABOUT IT is that it gives as much joy to others as it does to myself.

I WOULD SUM UP MY STYLE as poetic, colorful, nostalgic, dreamy, naïve, and joyful—also sometimes dark.

MY LOVE OF FLOWERS is sparked by my origins. I'm half Chinese and it feels that painting flowers is in my blood.

MY BEST FLORAL MOMENT is when I spray on my orange blossom flower water in the morning.

IF I WERE A FLOWER, I would be a dahlia. My Chinese name is Ly Ly, which means "beautiful flower."

MY FAVORITE DESTINATIONS are zoos and botanical gardens.

MY FAVORITE FILM when I was growing up was *Donkey Skin* with Catherine Deneuve.

THE BOOK that has influenced me most is Stefan Zweig's *Letter from an Unknown Woman.*

I WOULD SPEND MY LAST DOLLAR on a Pierre Bonnard painting.

MY PERSONAL MOTTO is "I will reach my dreams that I had when I was a kid."

IN MEINER ARBEIT GEHT ES UM die Träume, die ich als Kind hatte – einer Mischung aus Märchen und Folklore.

DAS BESTE DARAN: Meine Arbeit erfreut andere genauso wie mich selbst.

MEINEN STIL WÜRDE ICH SO BEZEICHNEN: poetisch, farbenfroh, nostalgisch, verträumt, naiv und voller Freude – manchmal aber auch düster

MEINE LIEBE ZU BLUMEN entspringt meiner Herkunft. Ich bin halb Chinesin und habe das Gefühl, dass das Malen von Blumen mir im Blut liegt.

MEIN BESTER FLORALER MOMENT: Wenn ich morgens meinen Orangenblütenduft auflege.

ALS BLUME WÄRE ICH eine Dahlie. Mein chinesischer Name lautet Ly Ly, was „schöne Blume" bedeutet.

MEIN LIEBLINGSREISEZIEL: Zoos und botanische Gärten

MEIN LIEBLINGFILM als Kind war *Eselshaut* mit Catherine Deneuve.

DAS BUCH, DAS MICH AM MEISTEN BEEINFLUSST HAT: *Brief einer Unbekannten* von Stefan Zweig

MEINEN LETZTEN CENT würde ich für ein Gemälde von Pierre Bonnard ausgeben.

MEIN PERSÖNLICHES MOTTO: Ich werde mir meine Kindheitsträume erfüllen.

MON TRAVAIL, C'EST AVANT TOUT mes rêves d'enfant transposés dans la réalité. Un mélange de contes de fées et d'art populaire.

CE QUE J'AIME LE PLUS DANS MON TRAVAIL, c'est qu'il m'apporte autant de plaisir qu'il en apporte aux autres.

JE QUALIFIERAIS MON STYLE de poétique, haut en couleur, nostalgique, rêveur, naïf et joyeux — mais aussi sombre, parfois.

MON AMOUR DES FLEURS est ancré dans mes origines. Je suis à moitié Chinoise, et j'ai l'impression que j'ai les fleurs et la peinture dans le sang.

MON PLUS BEL INSTANT FLORAL, c'est le matin, quand je me parfume à l'eau de fleur d'oranger.

SI J'ÉTAIS UNE FLEUR, je serais un dahlia. Mon nom chinois est Ly Ly, ce qui signifie « belle fleur ».

MES DESTINATIONS PRÉFÉRÉES restent les zoos et les jardins botaniques.

MON FILM PRÉFÉRÉ, quand j'étais petite, était *Peau d'âne* avec Catherine Deneuve.

LE LIVRE QUI M'A LE PLUS MARQUÉE est *Lettre d'une inconnue* de Stefan Zweig.

JE DÉPENSERAIS MON DERNIER DOLLAR pour un tableau signé Pierre Bonnard.

MA DEVISE est « Je réaliserai mes rêves d'enfant. »

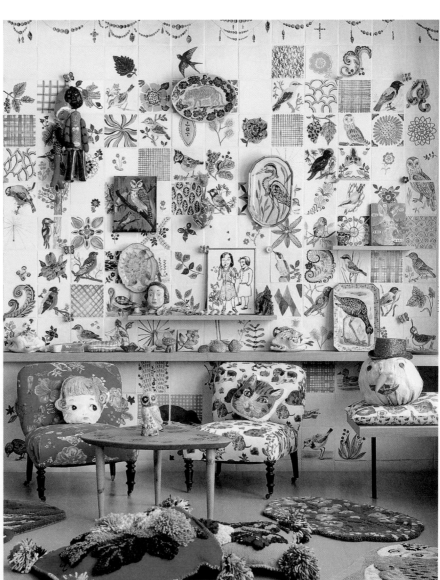

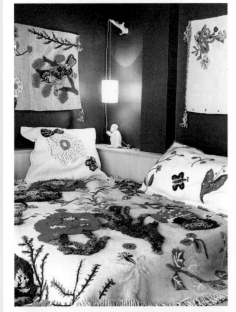

GLAMOURAMA

THIS MANHATTAN APARTMENT
designed by architect Iain Halliday's firm,
Burley Katon Halliday, is a lesson in sexy,
uptown style. In the living room, huge
floor-to-ceiling windows flood the room
in light. Its color cues come from nature:
lettuce-green and geranium-pink upholstery,
deliciously layered with hand-painted
chinoiserie walls, patterned Beauvais rugs,
and billowy silk curtains. The floral arrange-
ments dotted throughout complement the
lavish mise-en-scène.
Designed for an Australian expat,
Kiane von Mueffling and her New Yorker
husband, this Madison Square Park home
delivers on an exuberant brief. "Kiane wanted
to create a glamorous, rather than grungy
or high-tech, loft," recalls Iain. "She loved
the work of designer Kelly Wearstler and
wanted a youthful interpretation of a spacious
NYC apartment."
Bringing the antipodean sense of open space
to New York's metropolis, Iain started with
the black and gold hand-painted wallpaper
in the entrance hall. "Kiane was very fond
of using the de Gournay wallpaper in
the foyer," Iain says. Together, the intricate
chinoiserie pattern combined with the
vibrant textiles and glitzy metallic acces-
sories make for a feminine yet handsome
home. It also proves that floral wallpaper
works just as well in urban spaces as it does
in country homes. Halliday says layering is
key. "New York has a highly evolved design
aesthetic. Domestic interiors have to hold up."

DIESES APARTMENT in Manhattan
wurde von Burley Katon Halliday, der
Firma des Innenarchitekten Iain Halliday,
eingerichtet. Im Wohnzimmer flutet
Sonnenlicht den Raum durch hohe Fenster.
Die Farbpalette richtet sich nach der
Natur: Polster in Salatgrün und Geranien-
pink köstlich kombiniert mit handbemalten
Chinoiserie-Tapeten, gemusterten
Teppichen von Beauvais und luftigen
Seidengardinen. Die floralen Arrangements,
mit denen die ganze Wohnung gespickt ist,
ergänzen die opulente Szenerie.
Dem für die Australierin Kiane von Mueffling
und ihren New Yorker Mann gestalteten
Domizil am Madison Square Park lag ein
überschwängliches Briefing zugrunde:
„Kiane wollte eher ein glamouröses Loft
als eines im Grunge- oder Hightech-Stil",
erinnert sich Iain. „Sie liebt die Arbeit von
Designerin Kelly Wearstler und wünschte
sich ein geräumiges New Yorker Apartment
mit jugendlichem Flair."
Iain machte sich daran, das Gefühl der
Weite aus Down Under in die Metropole
New York zu übertragen. Er fing mit der
schwarzgoldenen handbemalten Tapete
im Eingangsbereich an. „Kiane wollte
für den Flur unbedingt die Tapete von de
Gournay", sagt Iain. Das feingesponnene
Chinoiserie-Muster bildet zusammen mit
den bunten Textilien und glitzernden
metallischen Accessoires ein feminines und
elegantes Entree – und liefert den Beweis,
dass Blumentapeten genauso gut in einer
Stadtwohnung funktionieren wie auf dem
Land. Laut Halliday ist Layering der
Schlüssel zum Erfolg. „New York besitzt
eine hochentwickelte Designästhetik,
der die Interieurs gerecht werden müssen."

IMAGINÉ PAR L'ARCHITECTE
Iain Halliday et son cabinet, Burley Katon
Halliday, cet appartement de Manhattan
est une magistrale démonstration de déco
urbaine et sexy. D'immenses baies vitrées
laissent entrer des flots de lumière dans
le salon. Toute la palette des couleurs est
d'inspiration naturelle : fauteuils et canapés
vert printemps ou rose géranium, murs
délicieusement habillés de chinoiseries faites
main, tapis à motifs géométriques issus des
manufactures de Beauvais ou délicats rideaux
de soie qui se gonflent à chaque souffle d'air.
Des compositions florales ponctuent l'espace
et complètent la mise en scène.
Destiné à Kiane von Mueffling, une expatriée
australienne, et à son époux new-yorkais, cet
intérieur qui s'ouvre sur Madison Square Park
est une ode à l'opulence. « Kiane voulait un loft
plus glamour que grunge ou high-tech, se
souvient Iain. Fan du design de Kelly Wearstler,
elle souhaitait une interprétation rajeunie du
grand appartement new-yorkais classique. »
Transposant au cœur de New York le sens
des grands espaces inné aux Australiens,
Iain a commencé, dans l'entrée, avec
un papier mural noir et or peint à la main.
« Kiane avait très envie de cette tapisserie
de Gournay », explique Iain. Alliés à la gaieté
des textiles et à l'éclat métallique des meubles
et accessoires, les motifs intriqués à l'orientale
annoncent un intérieur à la fois viril et
féminin. Comme dit Iain, tout est dans
la superposition. « New York se caractérise
par une esthétique du design très sophisti-
quée. Les intérieurs doivent suivre. »

ENTRANCE HALL

The recessive walls, combined with a dark timber floor, rug, and table create a glamorous '30s feel. "My advice for using floral patterns in the home is to stick to a scale that works well in the space," says Iain. "Don't use small arrangements in large spaces unless you really know what you are doing. Better to work with less color and species in a bold way."

· EINGANGSBEREICH

Die tapezierten Wände erzeugen in Kombination mit dem dunklen Holzboden, dem Teppich und dem Abstelltisch einen Hauch von 1930er-Jahre-Glamour. „Ich rate allen, die bei sich zu Hause florale Elemente einführen wollen, auf das passende Größenverhältnis zu achten", sagt Iain. „Vermeiden Sie zum Beispiel kleine Arrangements in großen Räumen, es sei denn, Sie wissen genau, was Sie tun. Besser ist es, mit üppigen Blumen und wenigen Farben ein richtiges Statement zu setzen."

ENTRÉE

Alliés au plancher de bois sombre et à la table ronde d'un noir laqué, les murs au look rétro composent une ambiance résolument 1930. « Pour réussir l'intégration d'un motif floral dans l'espace intérieur, respectez les proportions, explique Iain. Évitez les petites compositions dans une pièce spacieuse. Mieux vaut un arrangement audacieux de quelques couleurs et variétés seulement. »

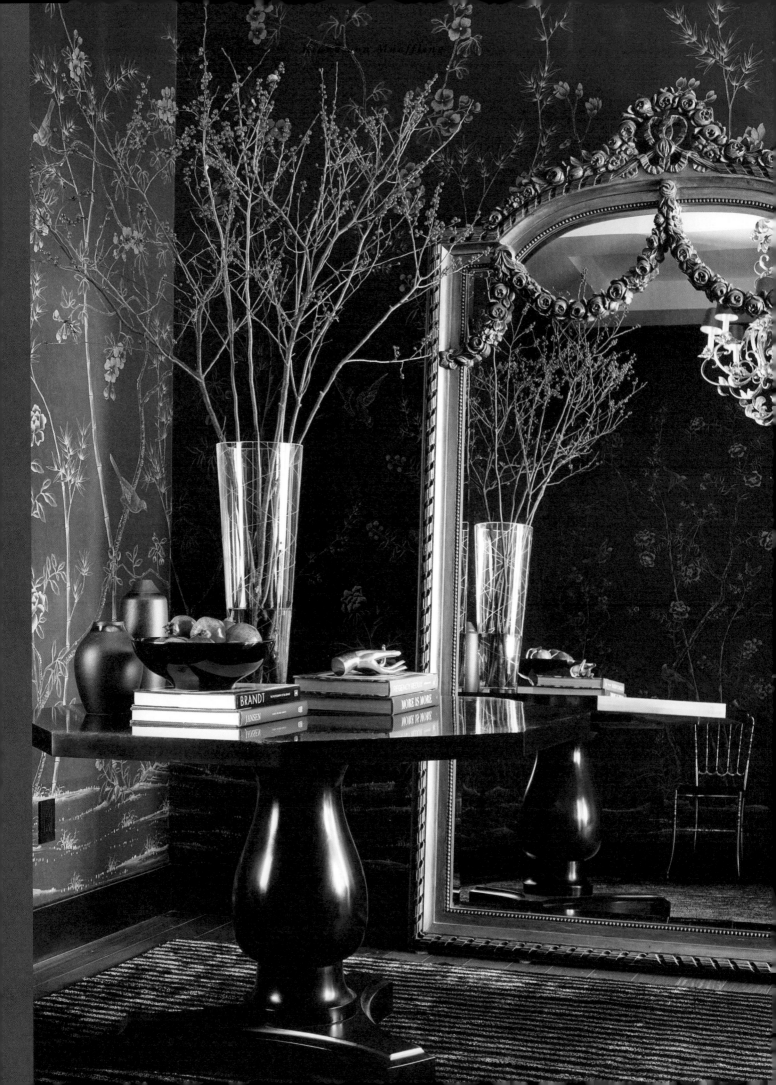

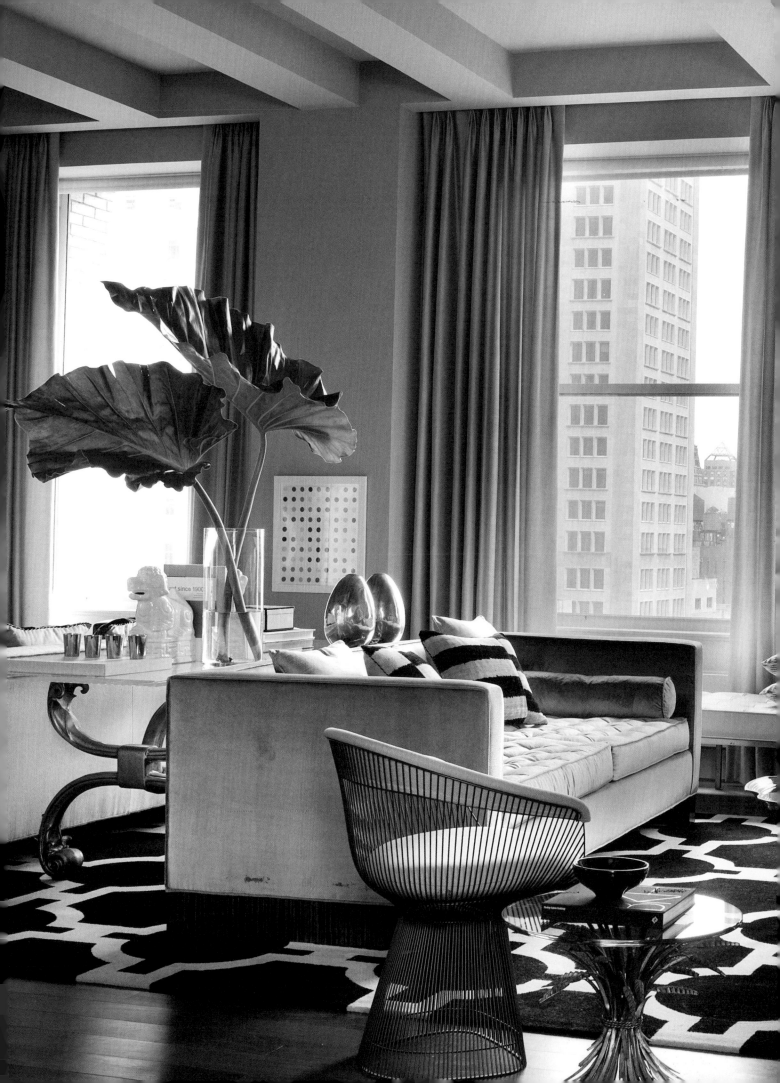

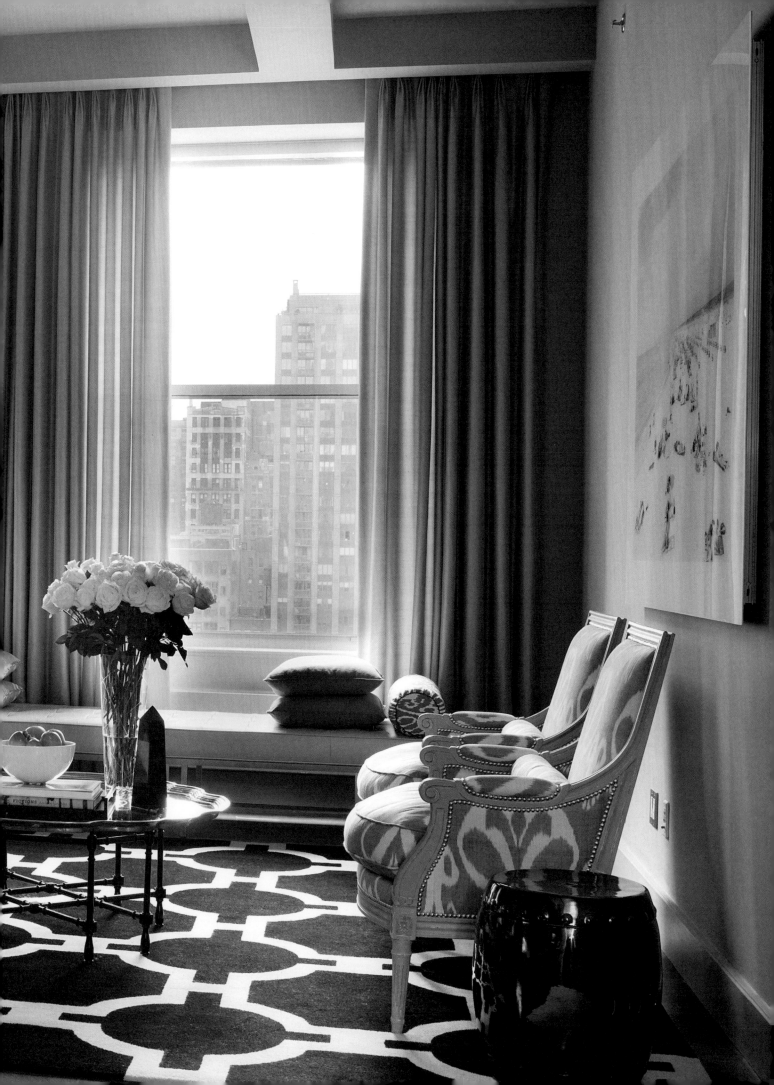

 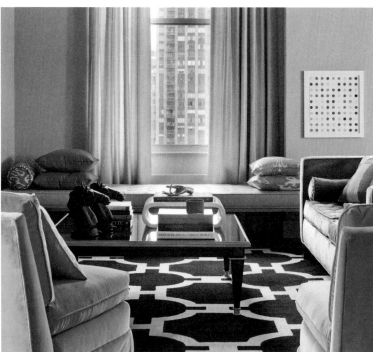

LIVING ROOM

It's worth spending the extra cash for an investment piece that will last, and a great rug will stand the test of time. Here, the bold pattern draws the eye and makes it an anchor to everything else going on in the room. Warm metallic such as copper, brass, or gold are great for adding that bit of sheen that brings a room to life.

WOHNZIMMER

Es lohnt sich, etwas mehr in ein besonderes Stück zu investieren, das ewig hält – wie zum Beispiel einen Teppich. Das auffällige Muster dieses Teppichs zieht die Blicke auf sich und verankert alle anderen Elemente im Zimmer. Warme Metalle wie Kupfer, Bronze oder Gold verströmen diesen gewissen Glanz, der einen Raum lebendig macht.

SALON

Si votre budget le permet, investir dans un bel élément de décoration destiné à durer, comme un beau tapis par exemple, est une bonne idée. Ce motif audacieux attire le regard, tel un point de mire autour duquel s'organise l'agencement de la pièce. Des éléments métalliques de couleur chaude, comme le cuivre, le bronze ou l'or, ajoutent le petit supplément d'âme.

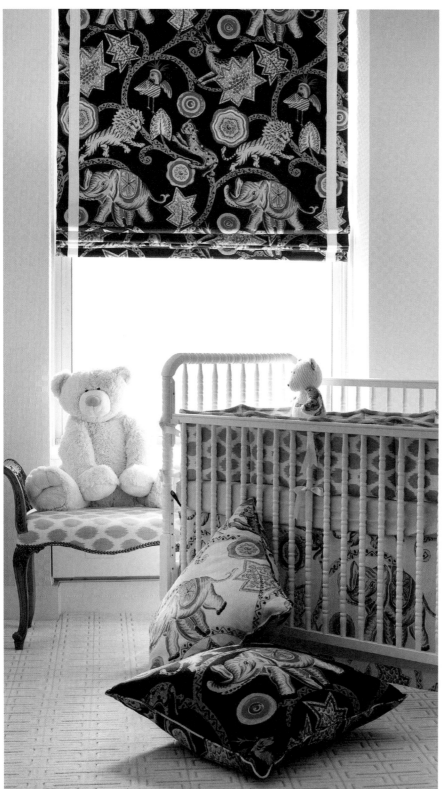

DINING ROOM & NURSERY

A Massimo Vitali beachscape and
voluptuous hydrangea pompoms deck
the black resin and bronze dining table.
The pendants are vintage Swedish.
In the nursery, the Indian-inspired
blind adds vibrancy and color to
the scheme.

ESSZIMMER & KINDERZIMMER

Eine Strandfotografie von Massimo
Vitali hängt an einem Ende des
mit üppigen Hortensienarrangements
dekorierten Esstischs aus schwarzem
Harz und Bronze. Die Vintage-
Hängeleuchten sind schwedisch.
Das Kinderzimmer wirkt durch
das farbenfrohe indisch anmutende
Rollo lebendiger.

SALLE À MANGER
& CHAMBRE D'ENFANT

Une plage photographiée par
Massimo Vitali et de généreux
hortensias animent la table en bronze
et résine noire. Les suspensions
vintage sont suédoises. La chambre
d'enfant est animée par un store
d'inspiration indienne.

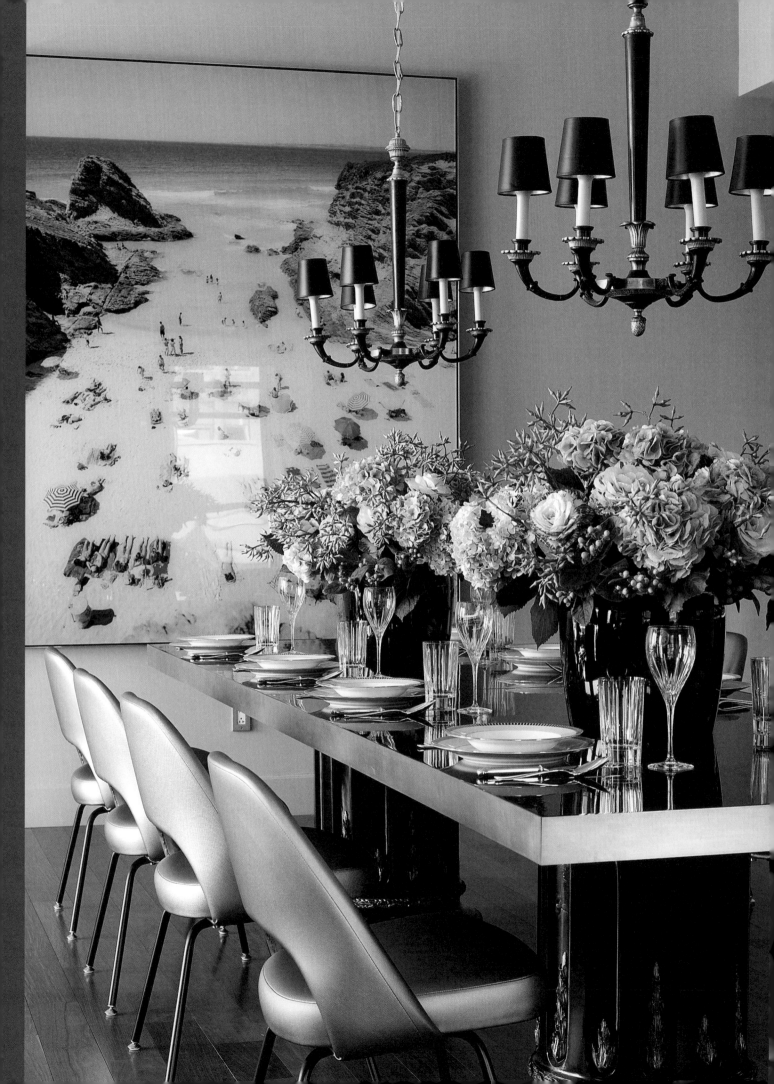

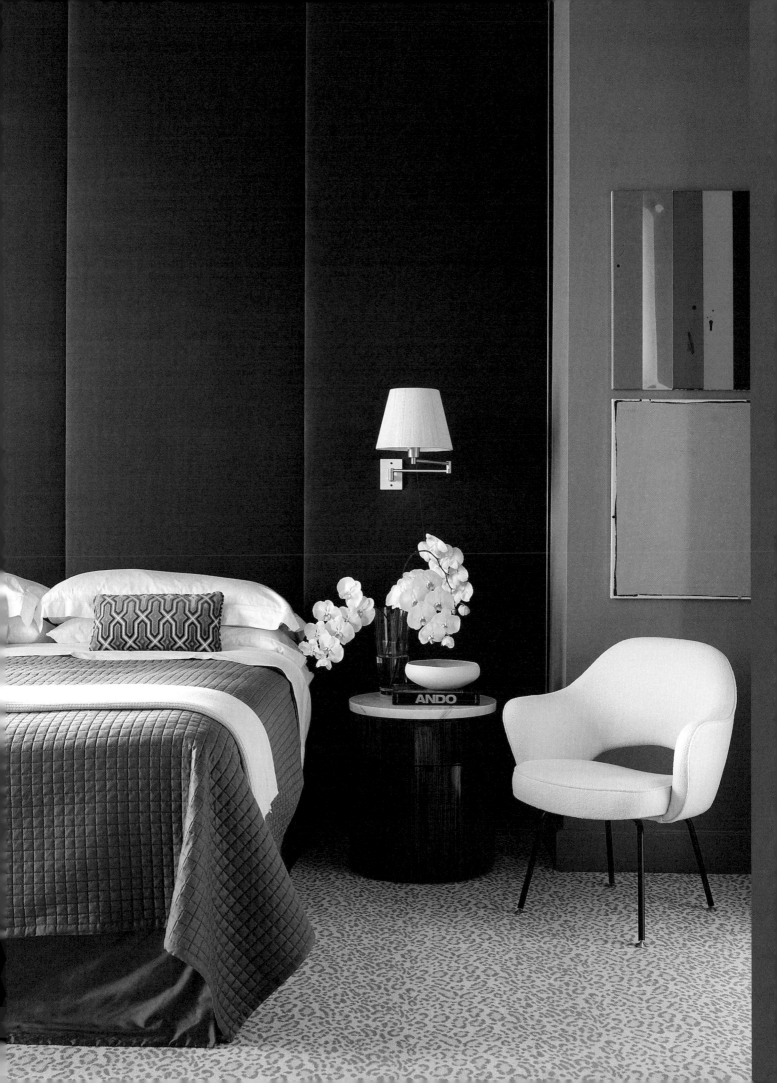

BEDROOM
*This purple silk upholstered wall provides a dramatic backdrop
for the white orchids and chic bedside lamps to stand out.*

SCHLAFZIMMER
*Die mit lila Seide verkleidete Wand bildet einen
dramatischen Hintergrund für die weißen Orchideen
und die schicken Nachttischlampen.*

CHAMBRE À COUCHER
*Ce mur capitonné de soie d'un beau violet dense offre
une spectaculaire toile de fond aux orchidées et
aux élégantes lampes de chevet.*

URBAN FLORALS

EMBRACE THE CONTRAST OF SMOOTH CONCRETE WITH
THE NATURAL BEAUTY OF FLOWERS.

URBANE FLORISTIK: EIN SPANNENDER KONTRAST –
NATÜRLICHE FLORALE SCHÖNHEIT TRIFFT AUF GLATTEN BETON.

FLEURS URBAINES : LORSQUE LA BEAUTÉ NATURELLE DES FLEURS CONTRASTE
AVEC L'ASPECT BRUT DU BÉTON.

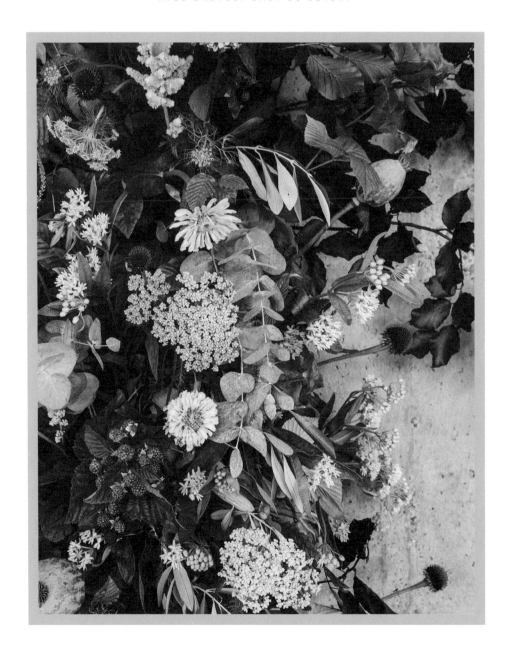

JUXTAPOSING concrete, grays, and hardness with green and floral, Anna Potter of florist Swallows & Damsons often displays her romantic, sumptuous blooms in unexpected ways. "We love mixing beautiful blousy blooms with scrappy, foraged foliage and berries in our work," says Anna. Smitten with the smooth, chalky surface and cool gray tones of concrete, here she shows how to transform a concrete wall into a botanical haven, where the plants create the environment instead.
swallowsanddamsons.com

"I created the base for the structure out of florists' foam and chicken wire," says Anna. "First, I built a layer of foliage using muted, end-of-summer, urban hedgerow leaves and vines. This created the rambling shape and disguised the frame. I chose raspberry leaves and turned them around so the pale silver underside of the leaf was facing out—this complements the cool gray of the concrete. I then paired this with dark and golden beech leaves for a contrasting, almost autumnal feel. Blackberries were used to add texture and depth in tone. Next, I added the largest flowers, such as aclepsia, dille, astilbe, and scented tuberose in shades of gold, apricot, and blush. To finish, I filled the gaps with the smaller, wispy flowers and seed heads."

HARTER BETON und Grautöne treffen auf Blumen und Grünpflanzen: Anna Potter, Floristin bei Swallows & Damsons, stellt ihre üppig-romantischen Blumen oft auf unerwartete Weise zur Schau. „Wir mixen gerne wunderschöne bauschige Blüten mit zerzausten Blättern und Beeren", sagt Anna. Sie ist von der glatt-kalkigen Oberfläche und den kühlen Grauschattierungen des Materials Beton fasziniert und zeigt hier, wie man eine Betonwand in ein botanisches Kleinod verwandelt.
swallowsanddamsons.com

„Die Grundstruktur habe ich aus Steckschaum und Maschendraht gebaut", sagt Anna. „Zuerst legte ich eine Schicht aus urbanen Heckenblättern und Ranken, die die unregelmäßige Form vorgab und das Grundgerüst verbarg. Ich nahm Himbeerblätter und drehte sie um, sodass die silbrigen Blattunterseiten nach oben zeigten – sie komplimentieren das kühle Grau des Betons. Dazu platzierte ich als Kontrast dunkle und goldene Buchenblätter, um eine herbstliche Komponente einzubringen. Brombeeren gaben dem Ganzen Textur und Farbtiefe. Als Nächstes fügte ich die größten Blumen hinzu, z. B. Sterndolden, Prachtspiere und duftende Tuberosen in Gold-, Apricot- und Rosétönen. Zum Schluss füllte ich die Lücken mit kleineren zarten Blumen und Samenkapseln auf."

JUXTAPOSANT le béton à la verdure et à la douceur des fleurs, Anna Potter, chez le fleuriste Swallows & Damsons, a le don de mettre en valeur des végétaux aux somptueuses silhouettes romantiques dans des compositions inattendues. « Nous aimons allier de belles fleurs épanouies à de simples baies et à du feuillage sans prétention », explique Anna. Fascinée par la surface lisse et crayeuse du béton et par ses froids tons de gris, elle montre ici comment transformer un mur brut en un éden botanique.
swallowsanddamsons.com

« Pour la base de la structure, je prends du grillage et de la mousse à fleurs, explique Anna. Je commence par bâtir une armature de feuillage avec des sarments et des branches de feuillus aux couleurs sourdes de fin d'été. Voilà qui définit grossièrement la silhouette de la composition et habille le support. J'ai choisi des branches de framboisier, que je place à l'envers, de façon à mettre en évidence la face argentée des feuilles, qui font écho au gris froid du béton. J'ajoute du feuillage de hêtre, sombre et mordoré, pour créer un contraste. Le mûrier donne du corps et de la profondeur de ton. Ensuite, j'installe les fleurs qui ont le plus de présence : asclépias, fleurs d'aneth, astilbes et tubéreuses dans les nuances dorées, roses et abricot. Enfin, je comble les vides avec de petites fleurs plus modestes et des capsules de graines. »

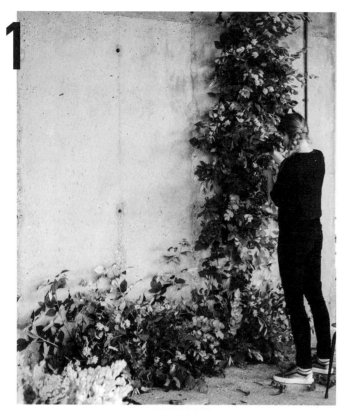

1 | Build the shape using foliage.
2 | Next, add the statement blooms.
3 | Fill the gaps with smaller flowers.

1 | Bauen Sie die Form mit Blattwerk auf.
2 | Fügen Sie Statement-Blumen hinzu.
3 | Füllen Sie die Lücken mit kleineren Blumen.

1 | Bâtissez la silhouette avec du feuillage.
2 | Disposez les fleurs « de caractère ».
3 | Comblez les vides avec de petites fleurs.

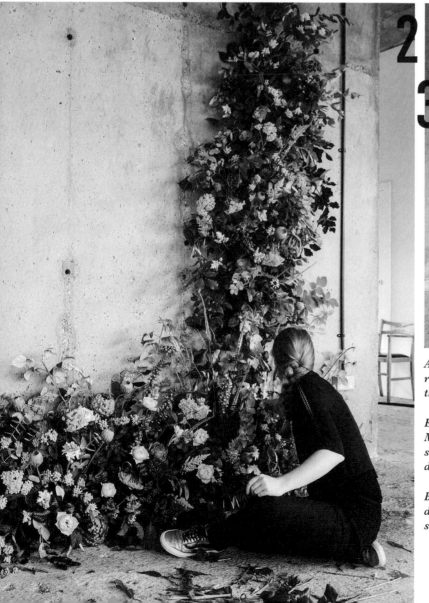

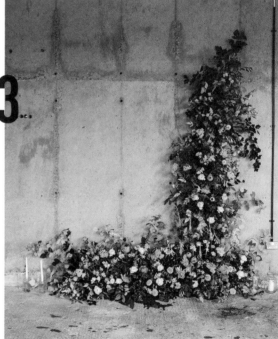

*A wild variety of copper beech, poppy seed heads,
raspberry leaves, brambles, and eucalyptus evoke
the seasonal shift of summer into autumn.*

*Eine bunte Mischung aus Rotbuchenblüten,
Mohnsamenkapseln, Himbeerblättern, Brombeer-
strauchzweigen und Eukalyptusblättern signalisiert
den Übergang vom Sommer zum Herbst.*

*Branches de hêtre et d'eucalyptus, capsules de graines
de coquelicot, ronces de framboisier et de mûrier
sauvage annoncent le passage de l'été à l'automne.*

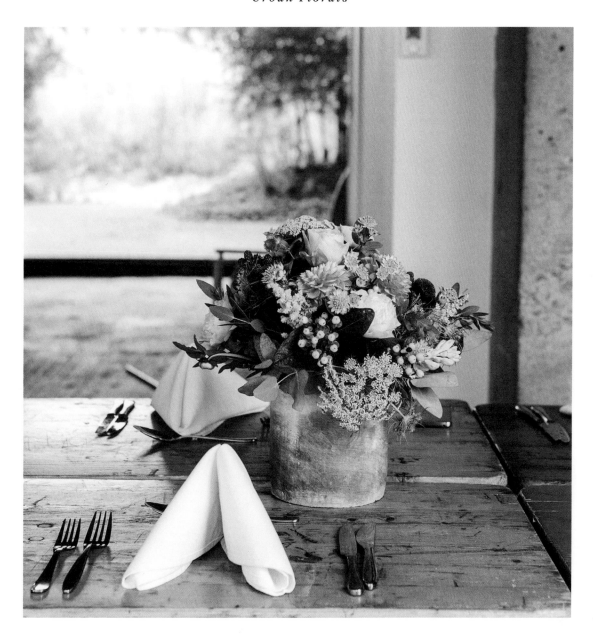

HOW TO STYLE PLANTS
IN A MODERN, URBAN WAY

1 | Start an arrangement with the choice of color. This sets the tone.
2 | Look for opposites. Romantic, blousy flowers look great in minimal concrete pots. Likewise, wild scrappy brambles and wasteland weeds contrast with beautiful ornate vases.
3 | Industrial metal cabinets filled with potted house plants and succulents make a fabulous, industrial-inspired display.
4 | Old metal dustbins with holes drilled in the bottom make unusual outdoor planters.
5 | Hang oversized floral arrangements from old warehouse beams in industrial spaces. Alternatively, single stems hung upside-down make great impact.

PFLANZEN URBAN
IN SZENE SETZEN

1 | Beginnen Sie mit der Farbwahl. Das bestimmt die Grundstimmung.
2 | Setzen Sie auf starke Kontraste. Blumen mit romantisch-bauschigen Blüten machen sich in minimalistischen Betontöpfen gut, struppige Brombeer- zweige und wildes Unkraut hingegen in hübsch verzierten Vasen.
3 | Metallschränke im Industrial-Stil sind fabelhafte Aufstellmöbel für Topf- pflanzen und Sukkulenten.
4 | Aus alten Metall-Mülleimern, in die Löcher gebohrt wurden, entstehen ungewöhnliche Blumenkübel.
5 | Hängen Sie in ehemaligen Industrie- gebäuden Blumenarrangements in XXL von den Deckenbalken. Auch einzelne kopfüber hängende Blüten können eine enorme Wirkung entfalten.

COMMENT INTÉGRER UN BOUQUET
À UN DECOR URBAIN MODERNE

1 | Commencez par choisir les couleurs.
2 | Les opposés s'attirent : les fleurs épanouies et romantiques sont mieux mises en valeur dans un pot en béton minimaliste, les herbacées sauvages et les ronces à la silhouette torturée dans un beau vase richement décoré.
3 | Les meubles industriels en métal, garnis de plantes d'intérieur et de plantes grasses, composent une superbe décoration.
4 | Les vieilles poubelles en métal, au fond percé de trous de drainage, font des pots d'extérieur originaux.
5 | Vous pouvez accrocher des arrangements floraux surdimensionnés aux vieilles poutres dans les espaces industriels ou des fleurs isolées suspendues tête en bas.

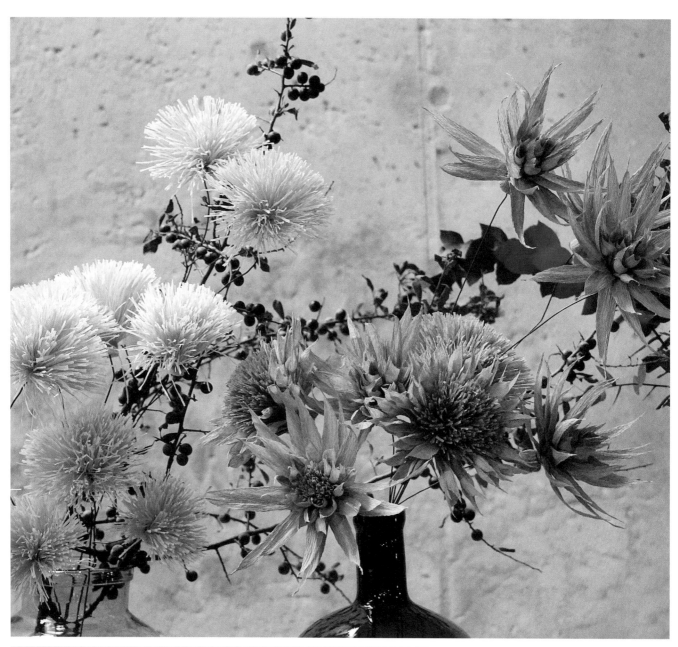

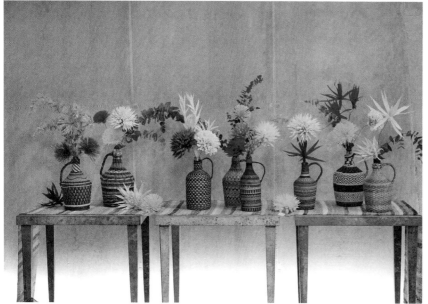

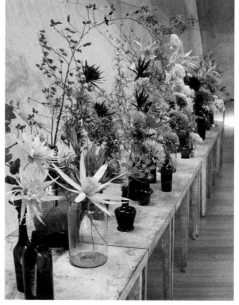

ANDREA MERENDI

BRINGING A COOL, NEW TAKE ON ARTIFICIAL FLOWERS, THE ITALIAN ARTIST CREATES COLORFUL BLOSSOMS MADE ENTIRELY OUT OF CREPE PAPER.

DER ITALIENISCHE KÜNSTLER MACHT KUNSTBLUMEN COOL. SEINE FARBENFROHEN BLÜTEN BESTEHEN AUSSCHLIESSLICH AUS KREPPPAPIER.

L'ARTISTE ITALIEN IMAGINE DES COMPOSITIONS DE TOUTES LES COULEURS, ENTIÈREMENT FAITES DE PAPIER CRÉPON, ET REND LES FLEURS ARTIFICIELLES TENDANCE.

MY WORK is all about flower design.

THE BEST THING ABOUT IT is the diversity between each piece.

I WOULD SUM UP MY STYLE as contemporary. It's an interpretation of real flowers.

MY LATEST CREATION combined yellow, pink, and gray. The most interesting part for me is the gray, as it makes it more contemporary.

MY LOVE OF FLOWERS was sparked by growing up in the countryside near Faenza in Emilia-Romagna.

IF I WERE A FLOWER, I'd be a peony. I love its delicacy and perfume.

I'M HAPPIEST when I'm surrounded by the people I love.

MY FAVORITE FILMS include all movies by Federico Fellini, especially *Amarcord*. It's set in Romagna and reminds me of the good old times.

THE BOOK that's influenced me most is *Memoirs of Hadrian* by Marguerite Yourcenar.

I'D SPEND MY LAST DECORATIVE DOLLAR on art. I would take a small Vermeer from the Frick Collection in New York City.

MY BEST SKILL is combining different colors and using my imagination.

IN MEINER ARBEIT GEHT ES UM Blumendesign.

DAS BESTE DARAN: Wie verschieden jedes Stück ist.

MEINEN STIL WÜRDE ICH SO BEZEICHNEN: Modern und zeitgemäß. Als eine Interpretation echter Blumen.

MEINE JÜNGSTE KREATION kombiniert Gelb, Pink und Grau. Der interessanteste Teil für mich ist das Grau, weil es das Ganze modern macht.

MEINE LIEBE ZU BLUMEN hat ihren Ursprung in meiner Kindheit. Ich bin auf dem Lande, in der Nähe von Faenza in der Emilia-Romagna aufgewachsen.

ALS BLUME WÄRE ICH ein Stiefmütterchen. Ich liebe ihre Zartheit und ihren Duft.

AM GLÜCKLICHSTEN BIN ICH, wenn ich von den Menschen umgeben bin, die ich liebe.

MEINE LIEBLINGSFILME: Alle Filme von Federico Fellini, vor allem *Amarcord*. Er spielt in der Romagna und erinnert mich an die guten alten Zeiten.

DAS BUCH, DAS MICH AM MEISTEN BEEINFLUSST HAT: *Ich zähmte die Wölfin* von Marguerite Yourcenar

MEINEN LETZTEN CENT würde ich für Kunst ausgeben. Ich würde mich für einen kleinen Vermeer aus der Frick Collection in New York entscheiden.

MEINE BESTE FÄHIGKEIT: Unterschiedliche Farben kombinieren und meine Fantasie einsetzen.

MON TRAVAIL, C'EST AVANT TOUT le design floral.

CE QUE J'AIME LE PLUS DANS MON TRAVAIL, c'est la diversité des éléments.

JE QUALIFIERAIS MON STYLE de contemporain. Une interprétation de ce que sont les fleurs au naturel.

MA DERNIÈRE CRÉATION se décline en jaune, rose et gris. C'est le gris qui m'intéresse le plus, pour la touche contemporaine qu'il insuffle.

MON AMOUR DES FLEURS me vient de mon enfance à la campagne, près de Faenza en Émilie-Romagne.

SI J'ÉTAIS UNE FLEUR, je serais une pivoine. J'adore son parfum et sa délicatesse.

MON BONHEUR, je le trouve avec ceux que j'aime.

MON FILM PRÉFÉRÉ est un film de Federico Fellini. Tous ses films, à vrai dire, à commencer par *Amarcord*. Il se joue en Romagne et me rappelle le bon vieux temps.

LE LIVRE QUI M'A LE PLUS MARQUÉ est un livre de Marguerite Yourcenar : *Mémoires d'Hadrien*.

JE DÉPENSERAIS MON DERNIER DOLLAR pour une œuvre d'art. Je choisirais un petit Vermeer de la Frick Collection, à New York.

MA QUALITÉ PREMIÈRE est d'oser des combinaisons de couleurs différentes en faisant appel à mon imagination.

HATTIE FOX

THE FASHIONABLE FORCE BEHIND THE SHOREDITCH-BASED FLORIST THAT FLOWER SHOP, HATTIE IS KNOWN FOR HER NATURALISTIC APPROACH, CREATING COOL ARRANGEMENTS FOR THE LIKES OF THE FASHION BRANDS ERDEM AND HERMÈS.

HATTIE IST DIE TREIBENDE KREATIVKRAFT VON THAT FLOWER SHOP IM LONDONER SHOREDITCH. SIE IST FÜR IHREN NATURALISTISCHEN ANSATZ UND IHRE COOLEN ARRANGEMENTS BEKANNT, DIE SIE U. A. FÜR DIE MODEMARKEN ERDEM UND HERMÈS KREIERT HAT.

HATTIE EST LA CRÉATRICE DE THAT FLOWER SHOP, UN FLEURISTE DE SHOREDITCH, À LONDRES. CONNUE POUR SON APPROCHE NATURALISTE, ELLE CRÉE DES COMPOSITIONS ORIGINALES POUR LES ENSEIGNES DE MODE, COMME ERDEM ET HERMÈS.

MY WORK is all about being big into colors. I'm always getting color crushes.

THE BEST THING ABOUT IT is the not knowing what flowers you are going to get on the day.

I WOULD SUM UP MY DECORATION as inspired by life memories or what I find on the street.

IF I WERE A FLOWER, I'd be a blossom, so a fruit tree I guess.

MY FAVORITE COLOR COMBINATION is currently pink and orange.

I'M HAPPIEST early in the morning, when I'm in the studio on my own.

MY BIGGEST GUILTY PLEASURE is running. I would run every day if I could.

MY FAVORITE SEASON is autumn before we start incubating over the winter months.

MY FAVORITE FILM is *Submarine*.

IF MONEY WAS NO OBJECT I would buy a house by the sea.

MY BEST SKILL is resilience.

MY PERSONAL MOTTO is "From great darkness comes great light."

IN MEINER ARBEIT geht es vor allem um Farben. Ich bin geradezu ständig von irgendeiner neuen Farbe besessen.

DAS BESTE DARAN: Nicht zu wissen, welche Blumen man jeden Tag bekommt.

MEINEN STYLE WÜRDE ICH SO BEZEICHNEN: Von Lebenserinnerungen inspiriert oder von dem, was ich auf der Straße finde.

ALS BLUME WÄRE ICH wahrscheinlich ein Obstbaum in voller Blüte.

MEINE LIEBLINGSFARBKOMBINATION: momentan Pink und Orange

AM GLÜCKLICHSTEN BIN ICH frühmorgens, wenn ich ganz allein im Atelier bin.

MEIN GRÖSSTES HEIMLICHES VERGNÜGEN: Laufen. Das würde ich jeden Tag machen, wenn ich könnte.

MEINE LIEBLINGSJAHRESZEIT: Der Herbst – die Zeit, bevor wir Winterschlaf halten.

MEIN LIEBLINGSFILM: *Submarine*

WENN GELD KEIN THEMA WÄRE, würde ich mir ein Haus am Meer kaufen.

MEINE BESTE EIGENSCHAFT: Widerstandsfähigkeit

MEIN PERSÖNLICHES MOTTO: Aus großer Dunkelheit erwächst viel Licht.

MON TRAVAIL, c'est avant tout la couleur. J'ai tout le temps des coups de cœur pour les couleurs.

CE QUE J'AIME LE PLUS DANS MON TRAVAIL, c'est découvrir de nouvelles fleurs chaque jour.

JE QUALIFIERAIS MON STYLE d'inspiré par des souvenirs vécus, ou par ce que je trouve dans la rue.

SI J'ÉTAIS UNE FLEUR, je serais un fruit en devenir. Une fleur de verger, donc.

MON ASSOCIATION DE COULEURS PRÉFÉRÉE, en ce moment, c'est le rose et l'orange.

MON BONHEUR, c'est quand, le matin, je me retrouve seule dans mon atelier.

MON PETIT PLAISIR COUPABLE, c'est la course. Je courrais tous les jours si je le pouvais.

MA SAISON PRÉFÉRÉE, c'est l'automne, avant la période de latence hivernale.

MON FILM PRÉFÉRÉ est *Submarine*.

SI L'ARGENT N'ÉTAIT PAS UN OBSTACLE, j'achèterais une maison à la mer.

MA QUALITÉ PREMIÈRE est la résilience.

MA DEVISE est « Des ténèbres émergent la lumière. »

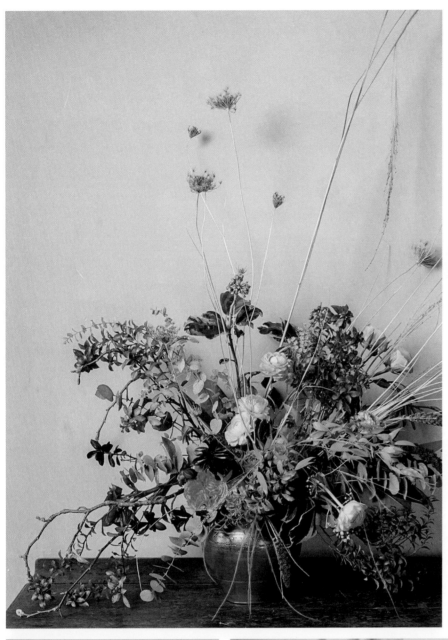

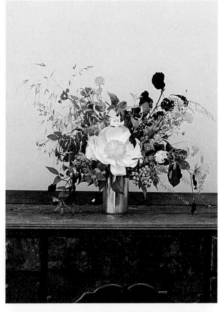

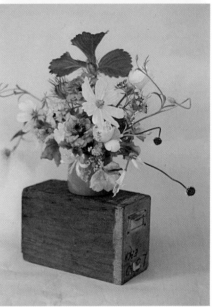

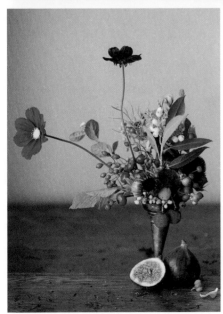

BOTA

NICAL

BOTANICAL

Nature features highly in the contemporary family home, with revamps
of a modern country look or a lush, tropical oasis a major interiors trend.

PFLANZENLIEBE

Ob moderner Landhauslook oder üppig blühende tropische Oase:
Natur steht bei den angesagtesten Inneneinrichtern hoch im Kurs.

LE CHARME DU VÉGÉTAL

La nature fait une entrée remarquée dans la maison contemporaine,
à l'heure où le look campagnard moderne revisité et l'oasis tropicale
luxuriante s'imposent parmi les tendances déco.

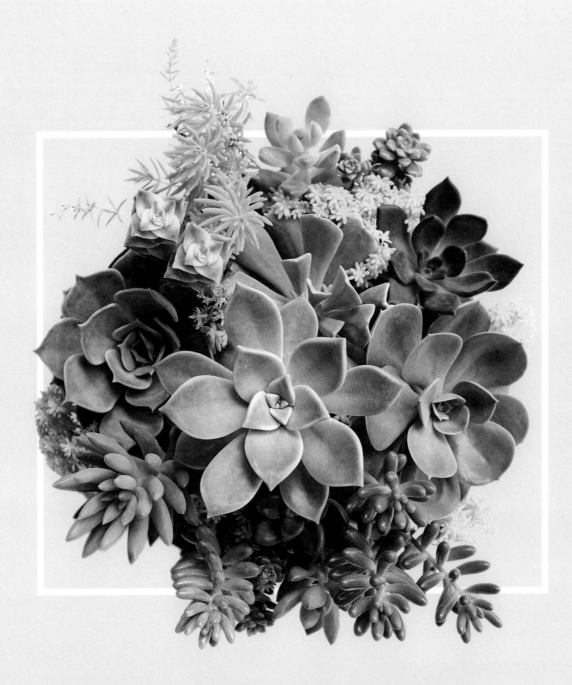

Decorated using plants, organic shapes, and natural materials,
these homes show how to create a fresh, comfortable take on urban
or country style. Find your Eden.

Diese mit Pflanzen, organischen Formen und Naturmaterialien dekorierten Domizile
demonstrieren, wie man einen urbanen oder ländlichen Stil unter floristischen Vorzeichen
neu interpretiert. Vielleicht ist Ihr persönlicher Garten Eden zwischen vier Wänden ja dabei.

Décorés de plantes, de silhouettes végétales et de matières naturelles,
ces intérieurs en sont autant d'exemples. Trouvez votre éden.

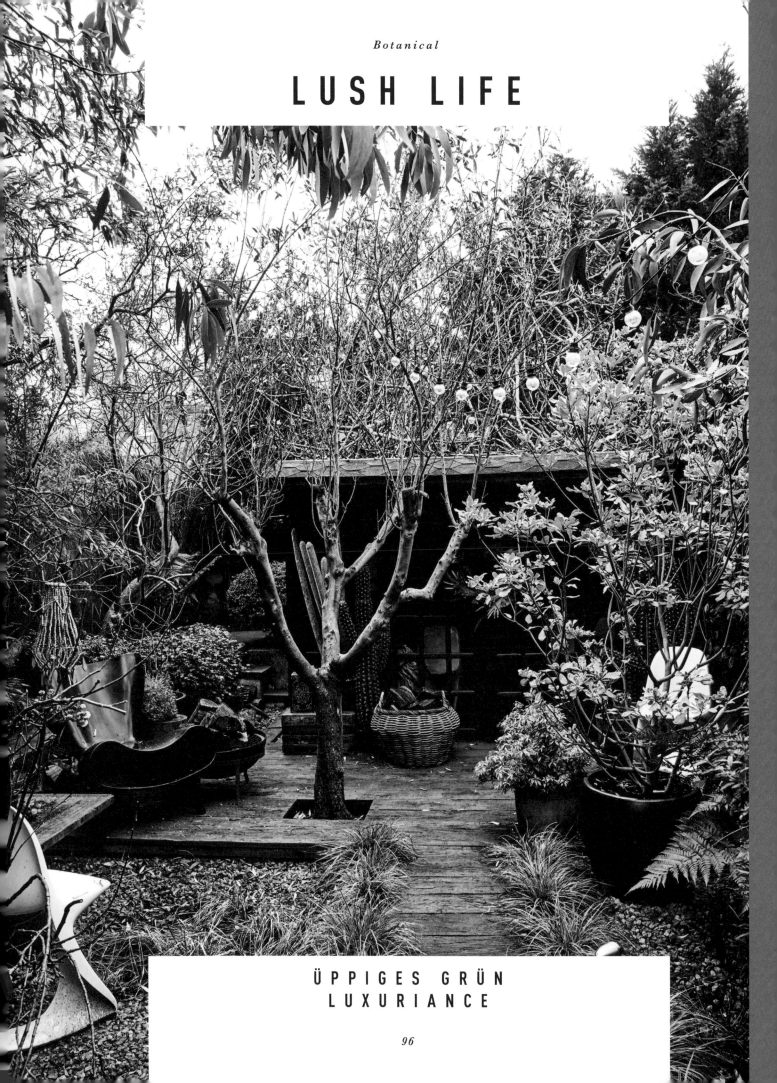

LUSH LIFE

ÜPPIGES GRÜN
LUXURIANCE

Abigail Ahern

THE HOME of the British Queen Bee of decorating, Abigail Ahern, and her husband, Graham Scott, is dark, inviting, and effortlessly glamorous. Maximalism at its best, Abigail knows how to pile on the panache, combining a sense of old-world charm, natural materials, and a slight retro feel in her fabulous East London townhouse. Mixing sensuality, grandeur—and giant cacti—on an epic scale, her mood du jour is lush. "As I've gotten older I've pulled back on all the bright colors and gone down a much more muted route," Abigail says. "I love inky colors of gray, green, caramel, and black. They feel so glam—I am a little obsessed."

Large artworks and groaning lights give each room of this large, four-story home a focus. A lighting devotee, Abigail is well aware that a cut-glass chandelier will never fail to thrill when you catch sight of it glistening in the dark. The plants bring the decor to life. "I was totally influenced by nature," explains Abigail. "I have botanicals (faux of course) everywhere and I like to merge the inside and out. The back of my house has been replaced with glass, so I am looking at the garden all year round. This has totally influenced my scheme as I want the two to merge seamlessly. My big piece of advice is to use different textures and colors, that way it will look super-cool."

Every corner has something wonderful to look at but it's the dark drama of the decor that dominates the space. The color experience doesn't feel somber. How could it with all the shimmer, tassels, and greenery dotted throughout?

DAS ZUHAUSE der britischen Einrichtungs-Queen Abigail Ahern und ihres Mannes Graham Scott ist dunkel, einladend und mühelos glamourös. Maximalismus-Fan Abigail weiß, wie man stilbildend einrichtet: In ihrem Stadthaus in East London kombiniert sie den Charme der guten alten Zeit mit natürlichen Materialien und einem leichten Retro-Flair. Die Mischung aus Sinnlichkeit und Pracht (und Riesenkakteen) in epischen Ausmaßen besagt vor allem eines: Opulenz ist hier Trumpf. „Als ich älter wurde, habe ich grellen Farben abgeschworen und stehe nun eher auf gedämpfte Töne", sagt Abigail. „Ich liebe Grau, Grün, Karamell und Schwarz. Diese Farbpalette fühlt sich so glamourös an – ich bin ein bisschen süchtig danach."

Große Gemälde und üppige Kronleuchter verleihen jedem Raum in diesem weitläufigen vierstöckigen Haus einen Fokus. Abigail weiß, dass ein im Dunkeln glitzernder Kristalllüster immer verzaubert. Die Pflanzen erwecken das Dekor zum Leben. „Ich war völlig von der Natur inspiriert", erklärt Abigail. „Überall stehen Pflanzen (natürlich künstliche) – ich mag es, wenn die Grenzen zwischen Innen- und Außenbereich verschwimmen. Die Rückseite meines Hauses wurde voll verglast, sodass ich immer in den Garten blicke. Ich möchte, dass beide Bereiche nahtlos ineinander übergehen. Mein Einrichtungstipp: Verwenden Sie unterschiedliche Materialien und Farben. Das sieht supercool aus."

Hier gibt es in jeder Ecke etwas Wundervolles zu entdecken, doch das dunkle Drama des Dekors dominiert den Raum. Trübsinn kommt dennoch nicht auf. Wie auch – bei dem ganzen Glitzer, den vielen Troddeln und Pflanzen?

EN ANGLETERRE, Abigail Ahern fait figure de reine des abeilles dans l'univers de la décoration. Avec son époux, elle partage un intérieur sombre, accueillant et glamour sans en avoir l'air. Dans sa sublime maison de ville des quartiers Est de Londres, en virtuose de l'opulence, Abigail accumule avec panache, alliant son penchant pour le charme vieille Europe à des matériaux naturels, le tout mâtiné d'une touche rétro. « Au fil des années, j'ai laissé tomber toutes les couleurs vives au profit d'une gamme de nuances plus subtiles, explique Abigail. J'aime la profondeur de certains tons de gris, de vert, de caramel et de noir. »

Chacune des pièces de cette vaste demeure agencée sur quatre niveaux s'organise autour d'immenses luminaires, d'œuvres d'art et de cactus géants. Abigail sait l'émerveillement produit par les pampilles d'un lustre en verre taillé scintillant dans le noir. Et puis il y a les plantes, qui donnent vie au décor. « Je suis sous l'influence de la nature, explique Abigail. J'ai des reproductions de planches botaniques dans toutes les pièces, et j'adore quand intérieur et extérieur ne font qu'un. Tout l'arrière de la maison a été remplacé par des baies vitrées, de sorte que j'ai vue sur le jardin en toutes saisons. Cela a changé ma vision des choses, et maintenant je voudrais que l'un et l'autre fusionnent. Si je n'ai qu'un conseil à donner, ce serait de varier les textures et les couleurs. » Le moindre recoin recèle un trésor, mais c'est surtout le décor aux allures théâtrales qui domine l'espace. Pourtant, l'ambiance n'est pas sombre. Comment le serait-elle, avec tout ce scintillement, cette verdure et ces colifichets ?

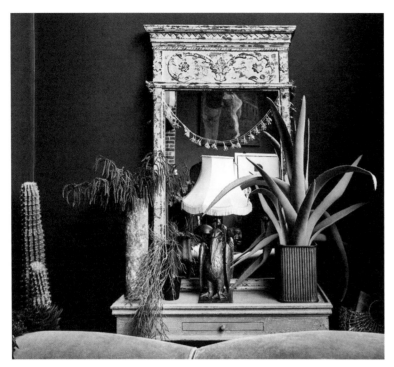

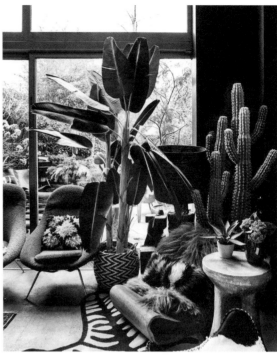

CONSERVATORY
*The double-height glass wall extends the space inside and out.
"I wanted the garden to be overgrown and forest-like and create our own
little private enclosed space," says Abigail. "Plants immediately add
the wow factor. I like to supersize them to make the space feel
even grander than it really is. I like mixing up shapes with golden balls
with taller cacti to create intriguing focal points."*

WINTERGARTEN
*Die Glasfront in zweifacher Raumhöhe lässt den Innen- und
Außenbereich ineinander übergehen. „Ich wollte einen völlig
überwucherten Garten, der fast wie ein Wald wirkt und
zu unserem kleinen privaten Geheimversteck wird", sagt Abigail.
„Pflanzen haben sofort einen Wow-Effekt. Ich bevorzuge Riesengewächse,
die den Raum noch prächtiger erscheinen lassen. Und ich setze gern
unterschiedliche Formen wie goldene Kugeln und hohe Kakteen
nebeneinander, um faszinierende Blickpunkte zu erzeugen."*

JARDIN D'HIVER
*Une immense baie vitrée s'élève jusqu'au premier étage,
prolongeant l'espace intérieur. « Mon jardin, je l'ai voulu luxuriant,
comme un petit coin de forêt, explique Abigail. Les plantes sont un plus.
Je les préfère surdimensionnées, pour donner une impression
de grandeur que l'espace, en réalité, n'a pas. J'aime mélanger
les silhouettes pour attirer le regard, comme des plantes à boules dorées
avec de hauts cactus. »*

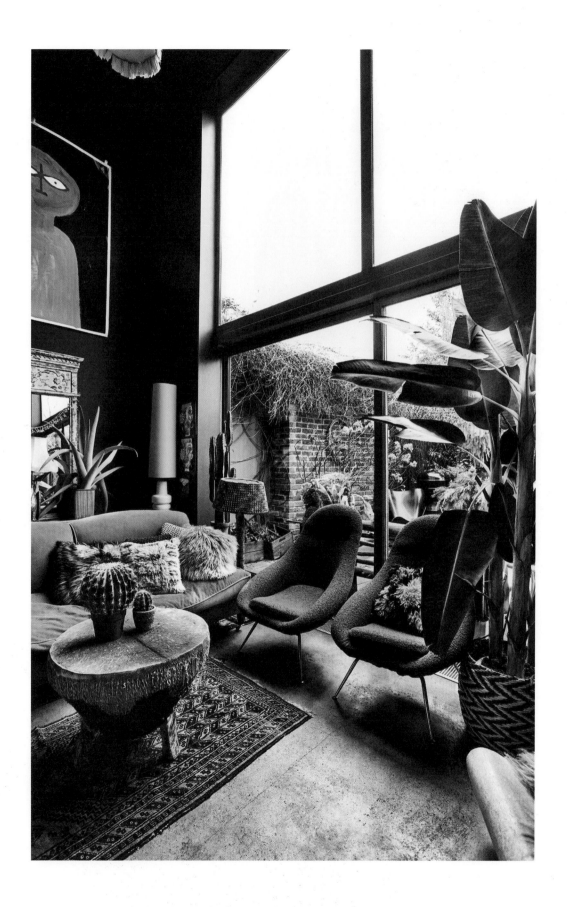

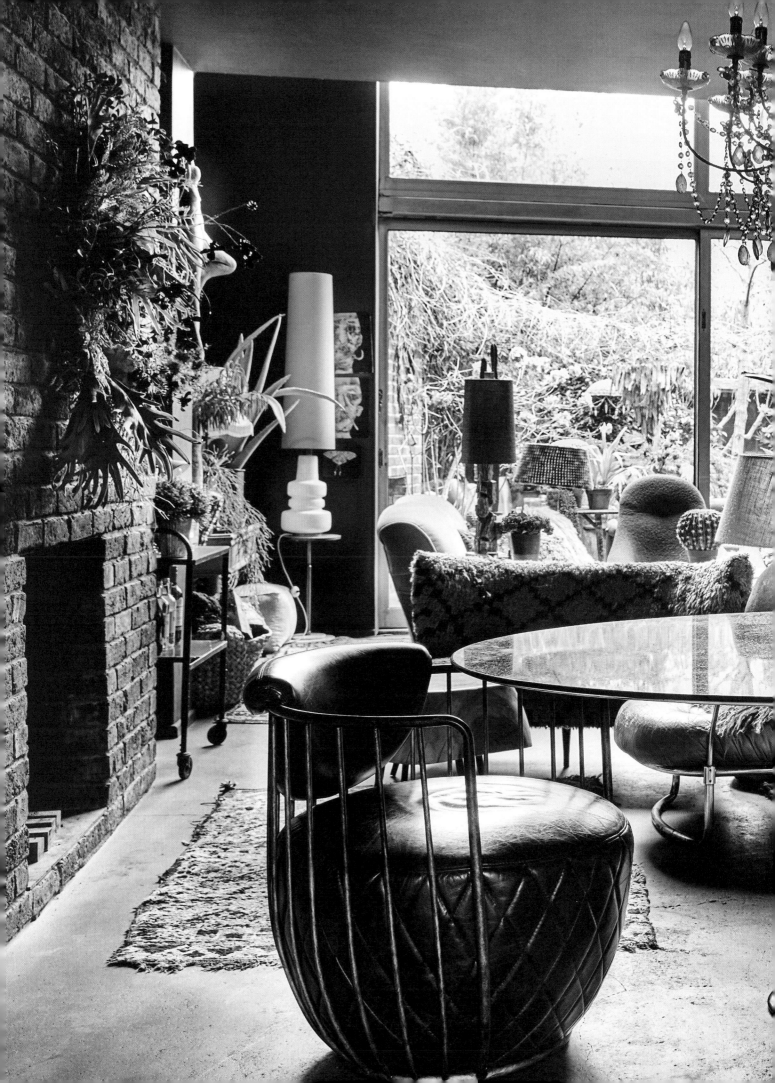

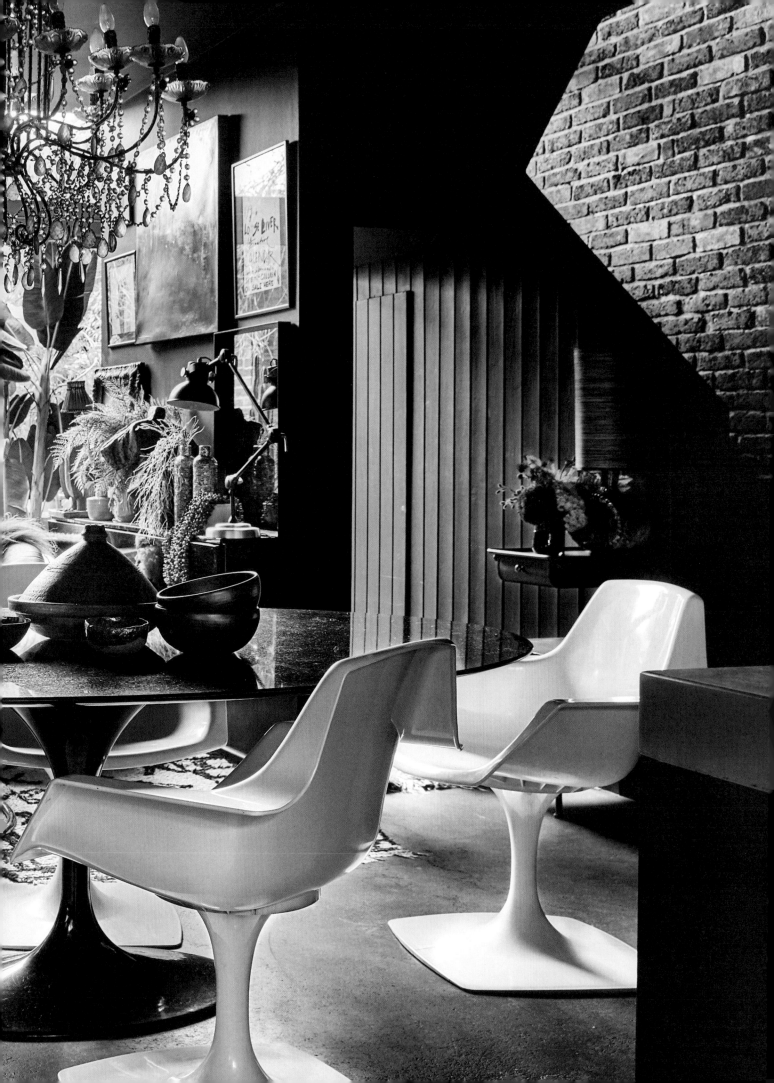

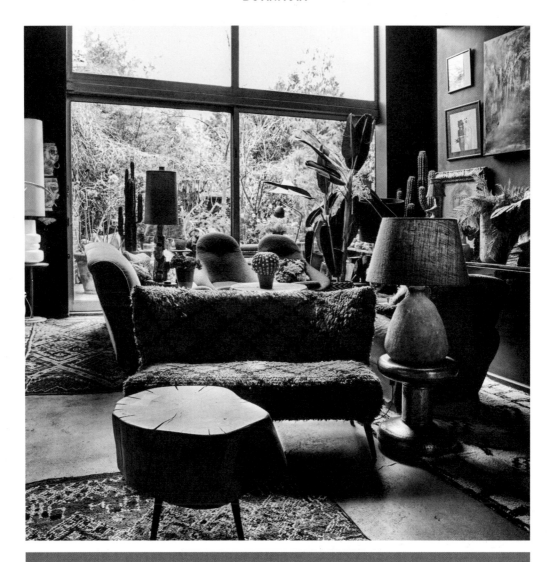

LIVING ROOM
*The living room features teal chairs, which are flea market finds,
covered in a fabric by Tom Dixon for Bute. "I love mixing textiles,
so I married marble with concrete, leather with sheepskin, wool with leather—
the trick is to combine as many materials as possible that makes a space
feel really tantalizing, cozy, and enticing."*

WOHNZIMMER
*Die petrolfarbenen Stühle vom Flohmarkt sind mit einem von Tom Dixon
für die Firma Bute entworfenen Stoff bezogen. „Ich liebe es, Materialien
zu mischen", sagt Abigail. „Deshalb kombinierte ich Marmor mit Beton,
Leder mit Schafsfell, Wolle mit Leder. Der Trick besteht darin,
so viele unterschiedliche Materialien wie möglich miteinander zu verbinden –
dadurch wirkt der Raum einladend, gemütlich und verführerisch."*

SALON
*Dans le salon, les chaises bleu sarcelle ont été chinées aux puces et habillées
d'un tissu Bute signé Tom Dixon. « J'adore marier les textiles et les matières.
J'associe le marbre et le béton, le cuir et la peau de mouton, la laine et le cuir.
L'astuce, c'est de combiner le maximum de matériaux susceptibles de rendre
un espace douillet et accueillant. »*

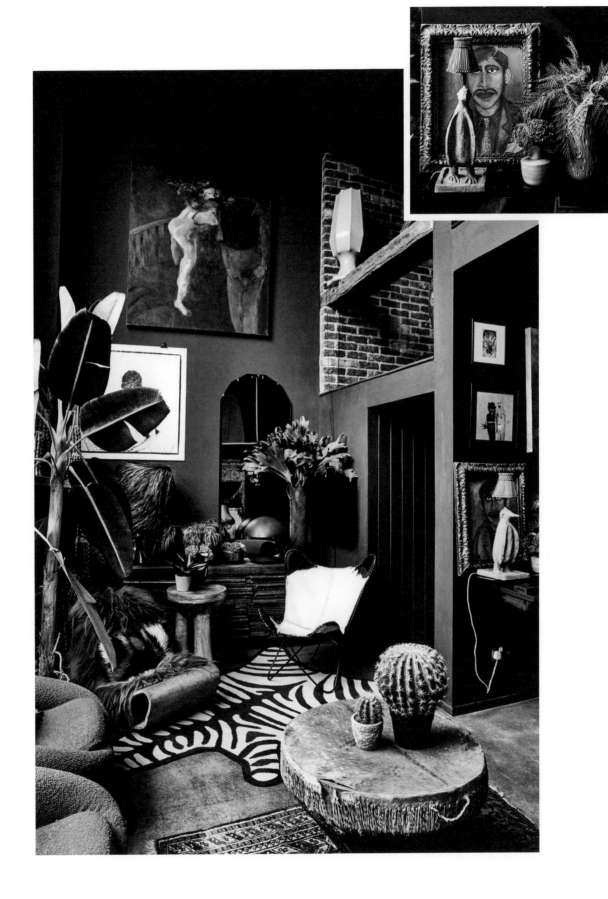

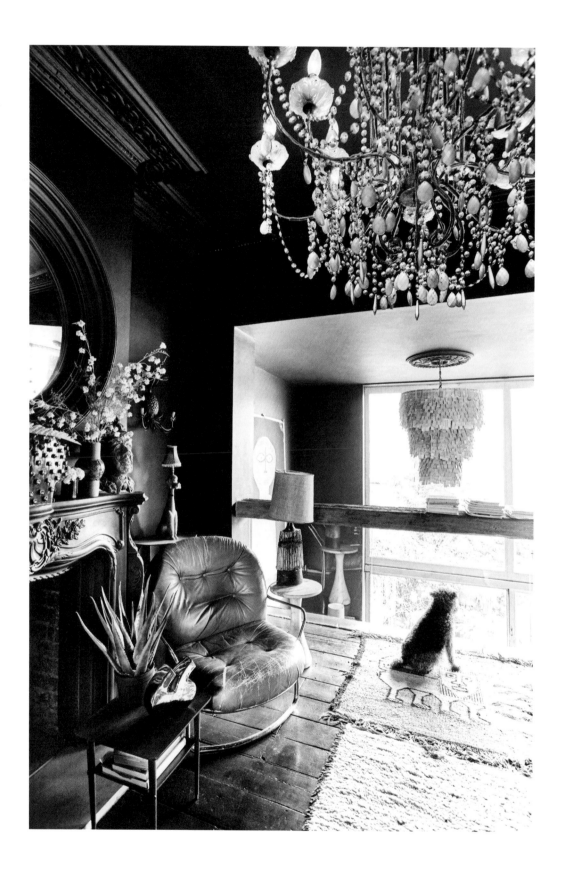

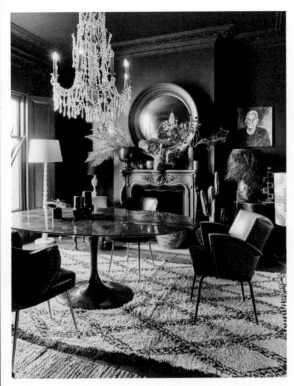

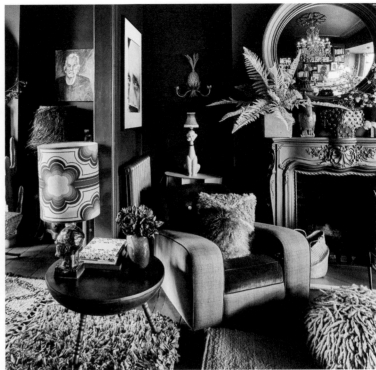

DINING ROOM
The greenery stands out against the dark walls, as does the opulent lighting, from the supersized porcelain chandelier in the mezzanine to the vintage-looking Lazzaro chandelier in the dining room.

ESSZIMMER
Die Pflanzen kontrastieren mit den dunklen Wänden, genau wie die opulente Beleuchtung – vom XXL-Kronleuchter aus Porzellan im Zwischengeschoss bis hin zum Lazzaro-Lüster im Vintage-Look, der über dem Esstisch hängt.

SALLE À MANGER
Les végétaux se détachent sur le gris des murs, de même que les luminaires XXL, de la suspension en porcelaine surdimensionnée de la mezzanine au lustre Lazzaro vintage de la salle à manger.

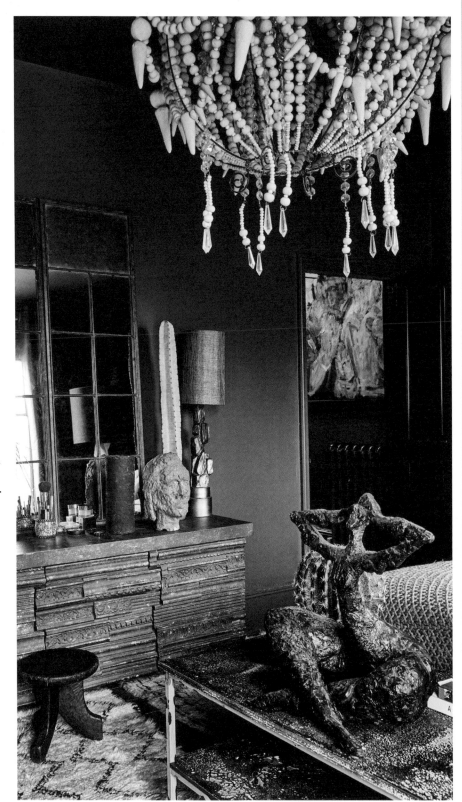

BEDROOM

In the bedroom, there is an abundance of texture. Planks of wood line the wall, Abigail's beaded chandelier takes center space, grounded by the Maroc Tribal rugs and beautifully buxom cacti.

SCHLAFZIMMER

Im Schlafzimmer bestimmen unterschiedliche Texturen das Bild. Die Wände sind mit Holzplanken getäfelt. Abigails Perlenkronleuchter bildet den Mittelpunkt des Raums und wird durch Teppiche von Maroc Tribal und wunderbar dralle Kakteen geerdet.

CHAMBRE À COUCHER

La chambre à coucher recèle une myriade de textures. Les murs sont habillés de bois, les sols recouverts de tapis de la société Maroc Tribal, et la suspension en perles recentre l'espace ponctué de cactus aux formes rebondies.

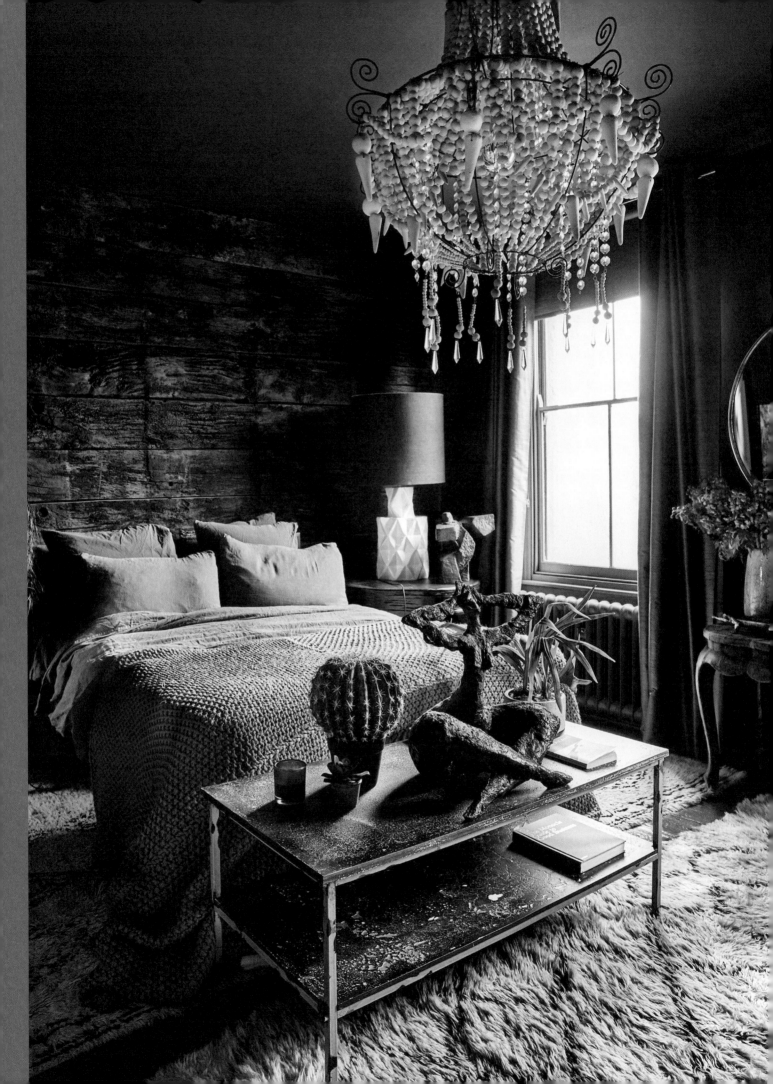

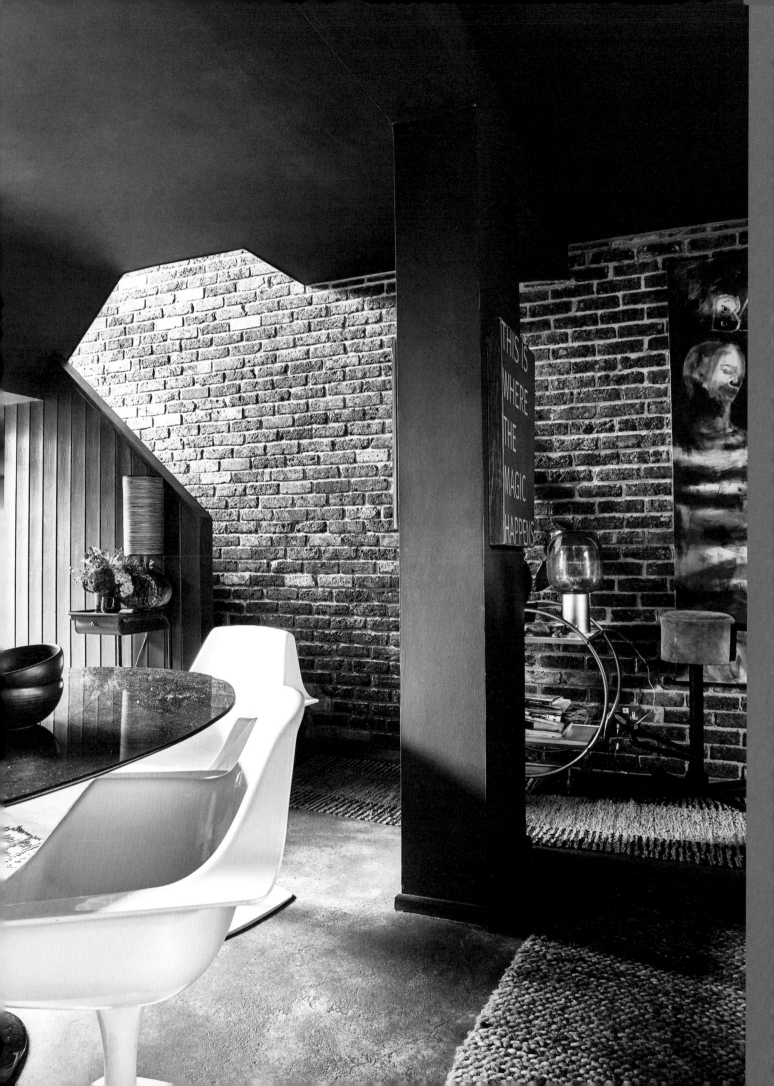

FURNITURE
A medley of different eras and styles, there's a modern retro feel to the interior. "Taste wise I merge toward glam with grit and boho sophistication. When choosing furniture, I plump toward '50s style, and quite classic masculine pieces."

MÖBLIERUNG
Dank eines Medleys aus verschiedenen Jahrgängen und Stilen verströmt das Interieur einen modernen Retro-Vibe. „Ich neige zu einem unkonventionell-künstlerischen Glamour Style mit Elementen von Shabby Chic", so Abigail über ihren Stil. „Beim Mobiliar gefallen mir Stücke aus den 1950er-Jahren und klassische maskuline Sachen."

MOBILIER
Méli-mélo de styles, d'époques, l'intérieur d'Abigail brille par sa modernité à tendance rétro. « Mon goût me porte vers le glamour et le bohème chic. Pour le mobilier, je pioche dans le vivier des années 1950, des pièces classiques aux lignes masculines. »

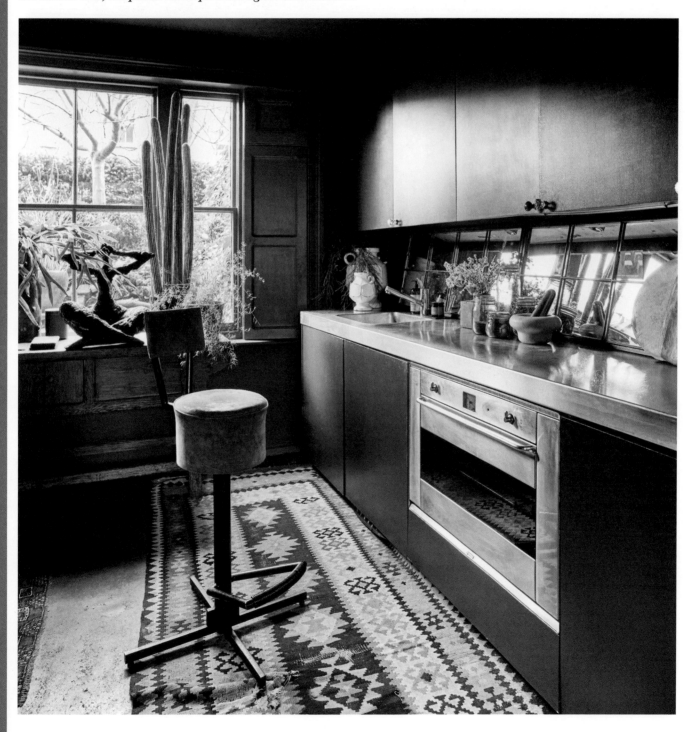

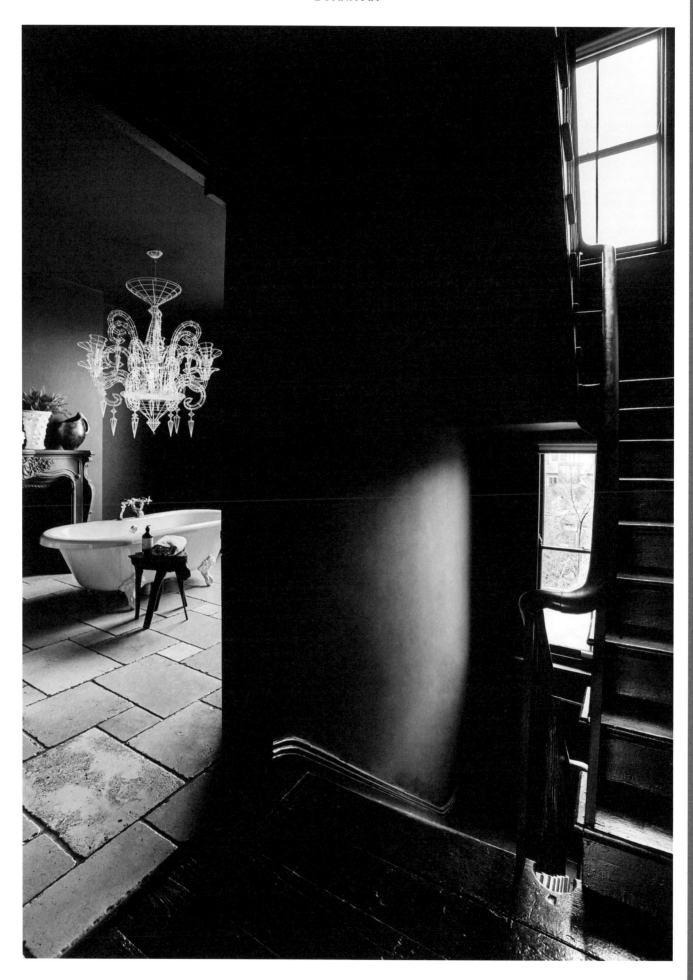

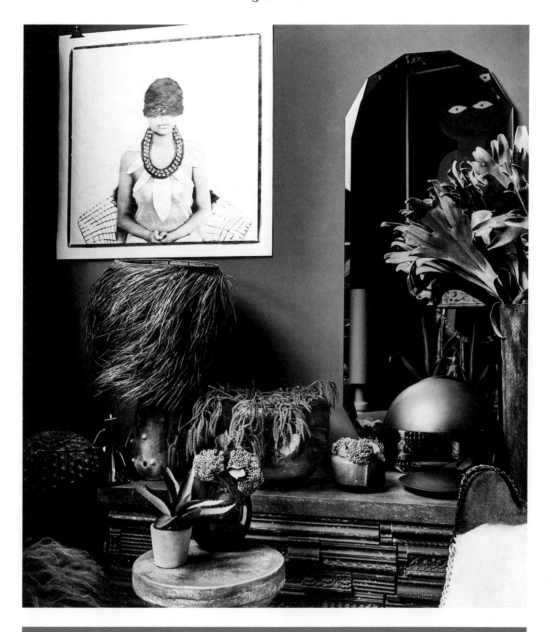

PALETTE

*"I design a room based on how I want it to feel," says Abigail.
"I like to feel cocooned, which might sound a little odd, but I choose materials
and colors that make me feel immediately comfortable and relaxed."*

FARBPALETTE

*„Bevor ich ihn einrichte, überlege ich mir, wie sich ein Raum anfühlen soll",
verrät Abigail. „Ich fühle mich gern wie in einem Kokon, was sich vielleicht
etwas seltsam anhört. Ich wähle Materialien und Farben aus, die Gemütlichkeit
ausstrahlen und mit denen ich mich sofort wohlfühle."*

PALETTE DES COULEURS

*« Pour la décoration de chaque pièce, je suis partie de l'ambiance que je voulais
y trouver, dit Abigail. J'aime me sentir à l'abri dans mon nid, alors je choisis
des matériaux et des couleurs qui évoquent le confort et la détente. »*

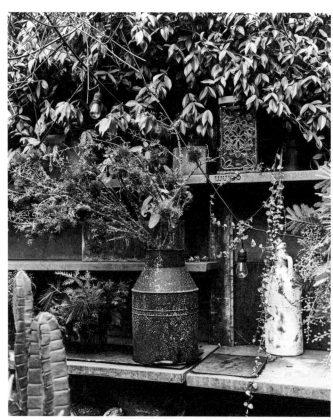

GARDEN

*"I would describe my gardening style as jungly,"
states Abigail. "I've filled the garden with
massive trees, scented jasmine, mimosa, lilac,
and all sorts of herbs. It's super lush and green
most of the year round."*

GARTEN

*„Meinen Gartenstil würde ich als urwaldig
bezeichnen", sagt Abigail. „Ich habe den Garten
mit massiven Bäumen, duftendem Jasmin,
Mimosen, Flieder und allen möglichen Kräutern
bepflanzt. Er ist fast das ganze Jahr über
üppig bewachsen und grün."*

JARDIN

*« J'aime les jardins qui ressemblent à des jungles,
affirme Abigail. J'ai planté de gros arbres,
du mimosa, du lilas, du jasmin et des herbes
aromatiques. Cela donne un ensemble
luxuriant qui reste vert toute l'année,
ou presque. »*

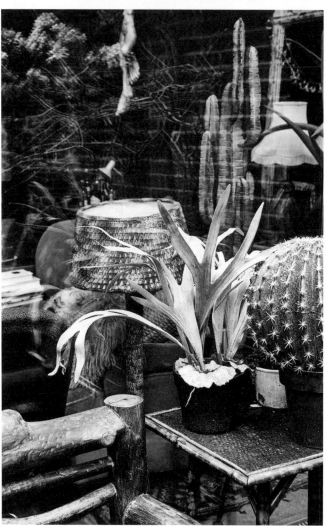

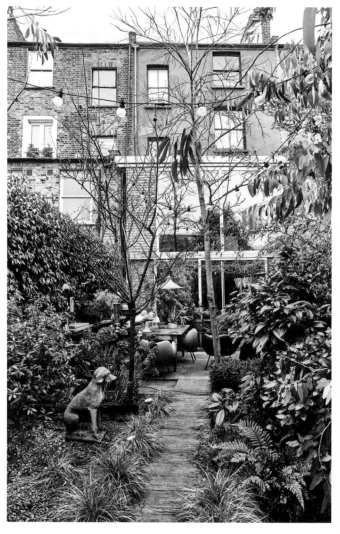

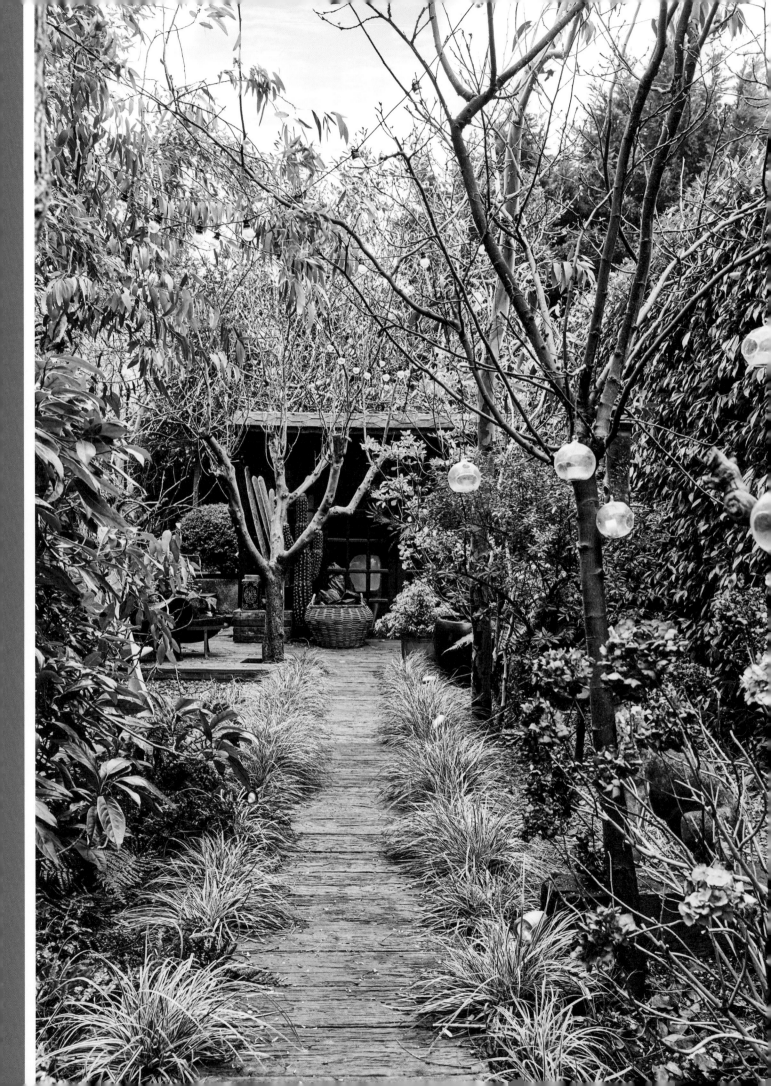

BOTANICAL ART

GIVE NEW LIFE TO SOMETHING YOU'VE GROWN WITH THE TRADITIONAL ART
OF FLOWER PRESSING—BUT WITH A TWIST.

PFLANZENKUNST: DIE TRADITIONELLE KUNST DES BLUMENPRESSENS
NEU INTERPRETIERT. SCHENKEN SIE IHREN PFLANZEN EWIGES LEBEN.

L'ART DES PLANCHES BOTANIQUES : UNE NOUVELLE VIE POUR LES VÉGÉTAUX
SÉCHÉS SOUS PRESSE DANS LES RÈGLES DE L'ART, AVEC UN PETIT PLUS !

FOR PRESSED FLOWERS AND PLANTS WITH A DIFFERENCE, LAY THEM ON GLASS

To begin with, choose your plants. Combine a selection of flower shapes from giant poppy petals to dainty forget-me-knots, or stick to a greener look with sculptural-shaped nasturtium leaves or feathery ferns. Joyful-looking flowers such as pansies, birds of paradise, or tall irises all make a pretty scene. Using the picture frame as a guide, cut plants to size, arranging them into different patterns—random or in an orderly fashion—to see how they look. Once you are happy with the arrangement, carefully sandwich the leaves between two sheets of glass. This allows light to filter through, defining shapes and revealing beautiful transparencies. Flowers and leaves need to be pressed first, as described on page 117.

GRÜNE KUNST FÜR DIE WÄNDE, PRÄSENTIEREN SIE IHRE PFLANZEN HINTER GLAS

Wählen Sie zuerst die Pflanzen aus. Kombinieren Sie verschiedene Blütenformen – vom Mohn bis zum Vergissmeinnicht – oder entscheiden Sie sich z. B. mit skulpturalen Brunnenkresseblättern oder fedrigen Farnen für einen grüneren Look. Fröhliche Blumen wie Stiefmütterchen, Paradiesvogelblumen oder schlanke Schwertlilien ergeben ein hübsches Ensemble. Schneiden Sie die Pflanzen unter Beachtung der Bildrahmengröße zurecht und legen Sie sie in verschiedenen Mustern aus, um auszuprobieren, was Ihnen am besten gefällt. Wenn Sie mit dem Arrangement zufrieden sind, platzieren Sie die Blätter vorsichtig zwischen zwei Glasplatten. So kann das Licht durch das zarte Gewebe hindurchschimmern. Blumen müssen zuerst gepresst werden, wie in der Anleitung auf Seite 117 beschrieben.

DE MERVEILLEUSES FLEURS ET PLANTES SÉCHÉES SOUS VERRE

Pour commencer, sélectionnez les fleurs. Vous pouvez marier des formes variées (du coquelicot géant au minuscule myosotis), vous en tenir à un look entièrement vert (feuilles de capucines aux formes sculpturales ou frondes de fougères aux allures de plumes), ou choisir des fleurs aux couleurs gaies (pensées, strelitzias, grands iris…). En fonction du cadre, coupez les végétaux à la taille adéquate, disposez-les de façon à former différents motifs – ordonnés ou aléatoires. Une fois que vous avez trouvé l'agencement qui vous convient, insérez les végétaux avec précaution entre deux plaques de verre, qui laissent filtrer la lumière, soulignent les formes et révèlent les transparences. Les fleurs doivent d'abord être séchées sous presse selon la méthode expliquée p. 117.

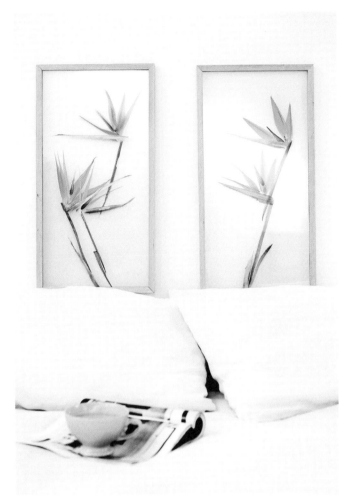

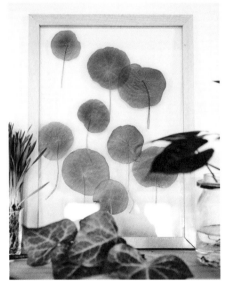

In this bedroom, a pair of strelitzias have been dissected, then pressed to preserve their shape. The display makes for an alternative headboard.

In diesem Schlafzimmer wurden Strelitzien zwischen Glasplatten verewigt. Die Glasbilder sind eine schöne Alternative für ein Kopfgestell.

Dans cette chambre à coucher, deux strelitzias disséqués ont été mis sous presse pour figer leurs silhouettes. Une tête de lit originale !

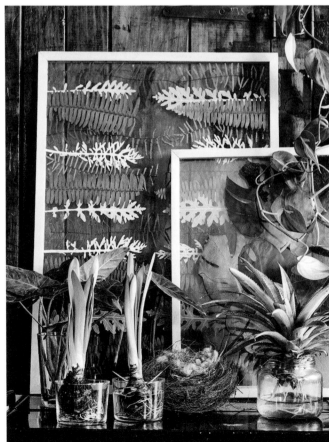

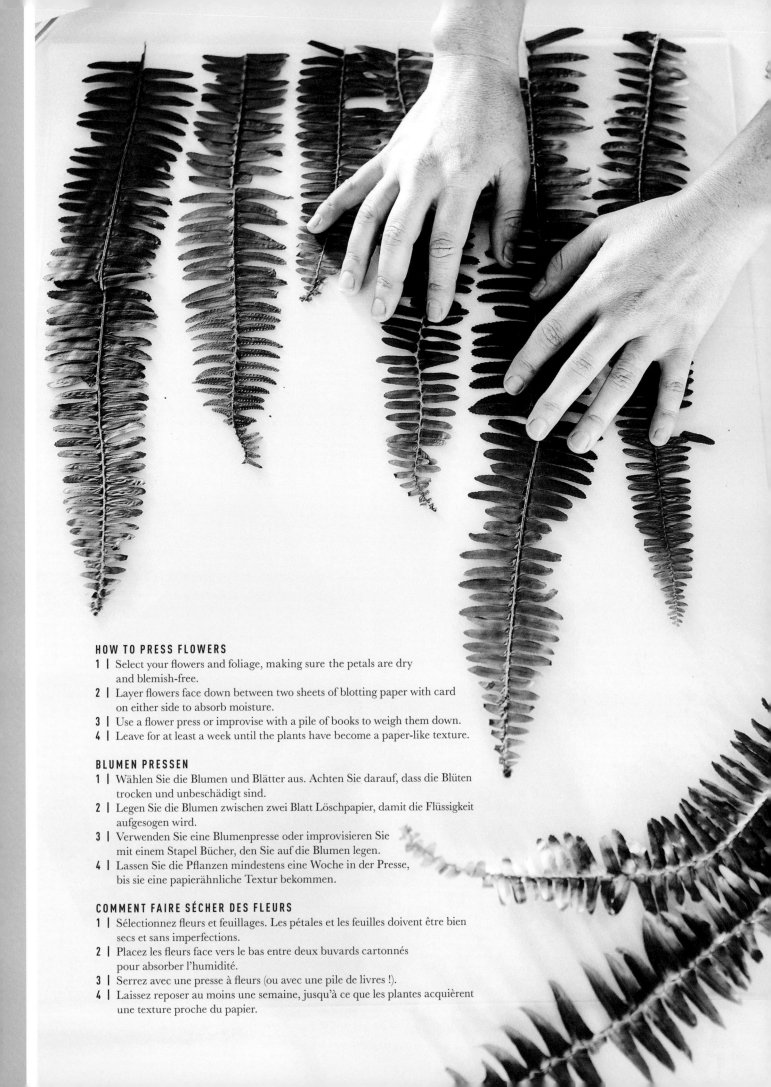

HOW TO PRESS FLOWERS

1 | Select your flowers and foliage, making sure the petals are dry
 and blemish-free.
2 | Layer flowers face down between two sheets of blotting paper with card
 on either side to absorb moisture.
3 | Use a flower press or improvise with a pile of books to weigh them down.
4 | Leave for at least a week until the plants have become a paper-like texture.

BLUMEN PRESSEN

1 | Wählen Sie die Blumen und Blätter aus. Achten Sie darauf, dass die Blüten
 trocken und unbeschädigt sind.
2 | Legen Sie die Blumen zwischen zwei Blatt Löschpapier, damit die Flüssigkeit
 aufgesogen wird.
3 | Verwenden Sie eine Blumenpresse oder improvisieren Sie
 mit einem Stapel Bücher, den Sie auf die Blumen legen.
4 | Lassen Sie die Pflanzen mindestens eine Woche in der Presse,
 bis sie eine papierähnliche Textur bekommen.

COMMENT FAIRE SÉCHER DES FLEURS

1 | Sélectionnez fleurs et feuillages. Les pétales et les feuilles doivent être bien
 secs et sans imperfections.
2 | Placez les fleurs face vers le bas entre deux buvards cartonnés
 pour absorber l'humidité.
3 | Serrez avec une presse à fleurs (ou avec une pile de livres !).
4 | Laissez reposer au moins une semaine, jusqu'à ce que les plantes acquièrent
 une texture proche du papier.

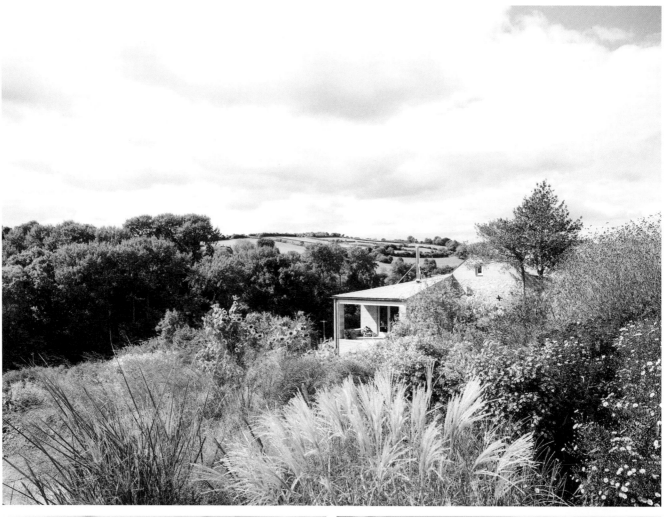

DAN PEARSON

FAMOUS FOR CREATING HARMONIOUS OUTDOOR SPACES, DAN PEARSON'S PASSION FOR NATURALISTIC PLANTING KNOWS NO BOUNDS.

DER LANDSCHAFTSGÄRTNER UND NATURFORSCHER IST BERÜHMT FÜR SEINE HARMONISCHEN DESIGNS. SEINE LEIDENSCHAFT FÜR EINE NATÜRLICH WIRKENDE BEPFLANZUNG KENNT KEINE GRENZEN.

RÉPUTÉ POUR SON TALENT À CRÉER DES ESPACES EXTÉRIEURS HARMONIEUX, DAN EST ANIMÉ D'UNE PASSION POUR LE JARDIN AU NATUREL.

MY WORK is all about identifying the inherent mood of a place, and then intensifying it to create emotional resonance.

I WOULD SUM UP MY STYLE as naturalistic but bold. I don't aim to ape nature, but use it as a springboard for an intense reinterpretation.

MY LOVE OF PLANTING was sparked by a hippeastrum (amaryllis) bulb I was given as a Christmas present at the age of five.

MY BEST FLORAL MOMENT is always the one just before the buds burst on any flowering plant. The anticipation and promise of all that potential is exhilarating.

MY FAVORITE COLOR COMBINATION is lime green and rusty orange.

MY BIGGEST GUILTY PLEASURE is ordering too many plants.

THE BOOKS that have influenced me most are Beth Chatto's *The Damp Garden* and *The Dry Garden*.

MY BEST SKILL is imagining spaces that don't exist yet.

MY PERSONAL MOTTO is "Keep up momentum."

IN MEINER ARBEIT GEHT ES DARUM, die einem Ort innewohnende Stimmung zu erkennen und diese dann zu intensivieren, um eine emotionale Resonanz zu erzeugen.

MEINEN STYLE WÜRDE ICH SO BEZEICHNEN: Naturalistisch, aber auffällig. Ich will die Natur nicht kopieren, sondern sie als Sprungbrett für eine intensive Neuinterpretation nutzen.

MEINE LIEBE ZU BLUMEN wurde geweckt durch eine Ritterstern-Zwiebel, die ich mit fünf Jahren zu Weihnachten geschenkt bekam.

MEIN BESTER FLORALER MOMENT: Kurz bevor die Knospen an einer blühenden Pflanze aufgehen. Die Vorfreude und das Versprechen, das darin steckt, sind berauschend.

MEINE LIEBLINGSFARBKOMBINATION: Limettengrün und Rostorange

MEIN GRÖSSTES HEIMLICHES VERGNÜGEN: Zu viele Pflanzen bestellen.

DIE BÜCHER, DIE MICH AM MEISTEN BEEINFLUSST HABEN: *The Damp Garden* und *The Dry Garden* von Beth Chatto

MEINE BESTE FÄHIGKEIT: Mir Räume vorzustellen, die noch nicht existieren.

MEIN PERSÖNLICHES MOTTO: Das Momentum bewahren!

MON TRAVAIL, C'EST AVANT TOUT cerner l'atmosphère inhérente à un lieu et la valoriser en suscitant une résonance émotionnelle.

JE QUALIFIERAIS MON STYLE de naturaliste et audacieux. Je ne cherche pas à singer la nature ; je la considère comme la matière d'une réinterprétation en profondeur.

MON AMOUR DES FLEURS me vient d'un bulbe d'amaryllis que l'on m'a offert quand j'avais cinq ans.

MON PLUS BEL INSTANT FLORAL, c'est celui où un bourgeon est sur le point d'éclore, quelle que soit la fleur. L'anticipation et les promesses qu'il recèle me transportent.

MON ASSOCIATION DE COULEURS PRÉFÉRÉE, c'est vert tilleul et orange brûlée.

MON PETIT PLAISIR COUPABLE, c'est de commander trop de plants.

LES LIVRES QUI M'ONT LE PLUS MARQUÉ sont *The Damp Garden* et *The Dry Garden* de Beth Chatto.

MA QUALITÉ PREMIÈRE est d'imaginer des espaces qui n'existent pas encore.

MA DEVISE est « Ne lâche rien. »

CONCRETE JUNGLE

MODERNER DSCHUNGEL
JUNGLE DE BÉTON

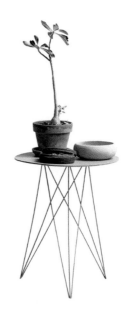

"**THIS HOUSE** has a feeling of living in a greenhouse," says Antonino Sciortino of his über-contemporary home and atelier in Milan. Antonino, a Sicilian metalwork artist who shapes iron into wonderful, sculptural designs, converted this former workshop in an old industrial part of Milan, now well and truly gentrified. "Our building was the kitchen and dining room of the industrial complex," Antonino says, "the first floor was the men's changing room." Since moving in, the house has had a complete overhaul. Antonino exploited the high-ceilings and masses of light to create a serene home with polished concrete floors, a suspended iron staircase, and a studio that overlooks the garden outside. "I was lucky to have a big garden with old trees," says Antonino. His passion for plants continues indoors with the giant potted succulents that punctuate the space.
"It all started from an old man I used to know in Sicily," Antonino recalls. "He gave me cuttings from his beautiful garden and it's a miracle but twenty years later they are still going strong." The plants lend a vitality to the space that is otherwise pared-back and calm. On being asked how to add warmth to a contemporary, minimal space, Antonino replies: "With lots and lots of love."

„**ES FÜHLT SICH AN,** als würde man in einem Gewächshaus leben", sagt Antonino Sciortino über sein hypermodern eingerichtetes Haus plus Atelier in Mailand. Der sizilianische Metallbildhauer, der Eisen zu wunderbaren Skulpturen formt, sanierte diese frühere Werkstatt in einem (inzwischen völlig gentrifizierten) ehemaligen alten Industrieviertel von Milano. „Im Erdgeschoss unseres Gebäudes war die Küche und der Speisesaal der Industrieanlage", sagt Antonino. „Im ersten Stock befand sich die Umkleidekabine für Männer." Das Haus wurde komplett umgebaut. Antonino nutzte die hohen Decken und die Helligkeit der Räume, um ein entspanntes Zuhause zu schaffen: mit polierten Betonböden, einer eisernen Wendeltreppe und einem Atelier, das auf den Garten blickt. „Ich hatte Glück, einen großen Garten mit alten Bäumen zu bekommen", sagt Antonino. Seine Leidenschaft für Pflanzen setzt sich aber auch innen fort – mit riesigen Sukkulenten als Blickfang.
„Alles fing mit diesem alten Mann an, den ich in Sizilien kannte", erzählt Antonino. „Er gab mir Ableger aus seinem wunderschönen Garten. Es ist wie ein Wunder, aber heute, 20 Jahre später, wachsen und gedeihen diese immer noch." Die Pflanzen geben dem ansonsten sehr reduziert und ruhig eingerichteten Wohnraum einen Schuss Vitalität. Auf die Frage, wie man einem modernen, minimalistischen Design Wärme verleiht, antwortet Antonino: „Mit sehr viel Liebe."

« **VIVRE DANS CETTE MAISON,** c'est un peu comme vivre dans une serre », dit Antonino Sciortino de son intérieur, un lieu hyper-contemporain, qui est aussi son atelier. Artiste ferronnier, Antonino façonne le fer en de merveilleuses formes sculpturales. Dans un ancien quartier industriel de Milan transformé par la gentrification, il a reconverti une usine en habitation. « Notre maison abritait jadis la cuisine et la cantine du complexe industriel, explique Antonino. Au premier, il y avait le vestiaire des hommes. »
Antonino a exploité la hauteur de plafond et la lumière qui entre à flots pour créer un intérieur paisible avec des sols en béton ciré et un escalier en métal suspendu. L'atelier, lui, donne sur les jardins.
« J'avais la chance d'avoir un grand jardin planté de vieux arbres », explique Antonino. À l'intérieur, sa passion pour les plantes s'exprime sous la forme d'immenses plantes grasses en pot qui ponctuent l'espace.
« Tout a commencé avec un vieil homme, en Sicile, se souvient Antonino. Il me donnait des boutures qui venaient de son jardin. Vingt ans plus tard, elles prospèrent encore. » Ce sont les plantes qui insufflent sa vitalité à un espace qui, sinon, resterait atone et minimaliste. Quand on lui demande comment rendre chaleureux un espace épuré et contemporain, Antonino réplique : « Avec beaucoup, beaucoup d'amour. »

LIVING ROOM
*Antonino has styled his home using large succulents as pieces
of art to create a focal point in a space. Big or small, succulents
come in many shapes and sizes, there are infinite
ways to use them—and anything green brings nature indoors.*

WOHNZIMMER
*Große Sukkulenten wurden hier wie Kunstwerke eingesetzt,
um Mittelpunkte zu schaffen. Diese Pflanzen gibt es in vielen Größen
und Formen und sie lassen sich vielfältig ins Einrichtungskonzept
einbinden – alles, was grün ist, bringt die Natur ins Haus.*

SALON
*Telles des d'œuvres d'art, d'immenses plantes grasses créent
des axes qui structurent l'espace. Il existe toutes sortes
de plantes grasses – et autant de possibilités de les mettre en œuvre
pour faire entrer la nature à l'intérieur.*

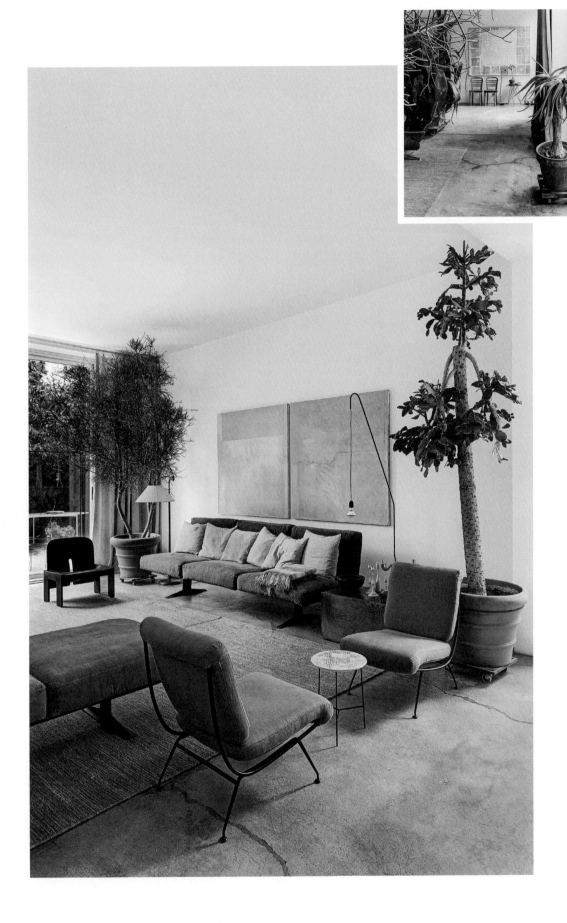

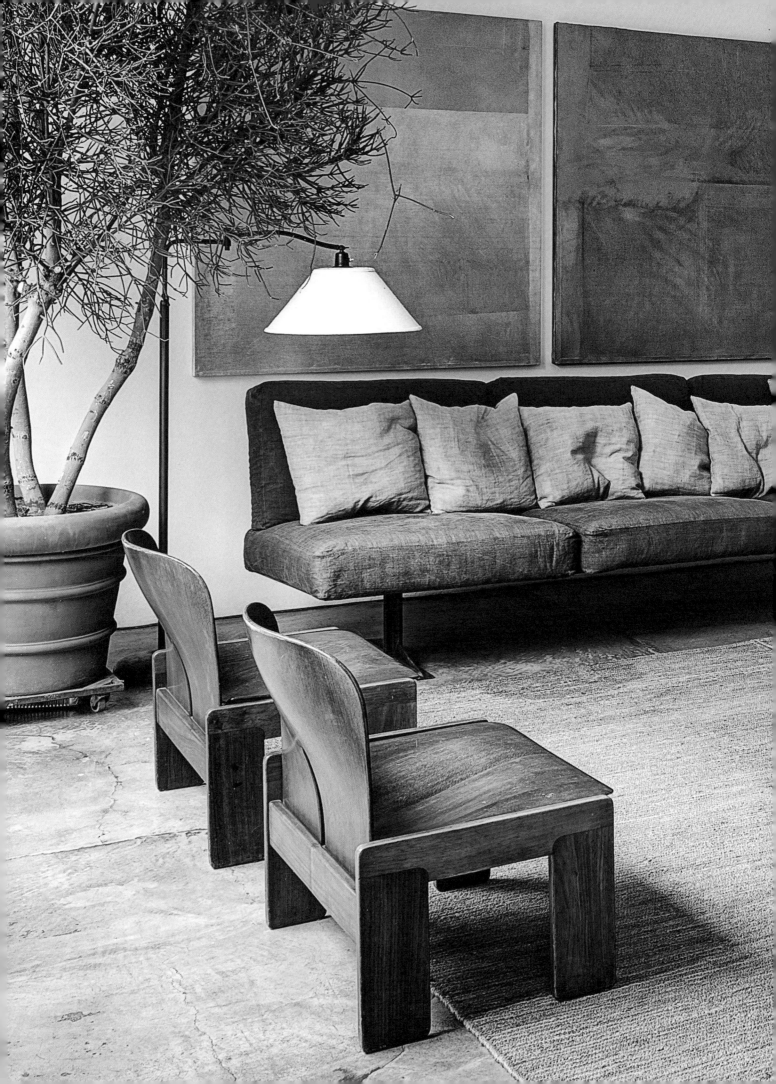

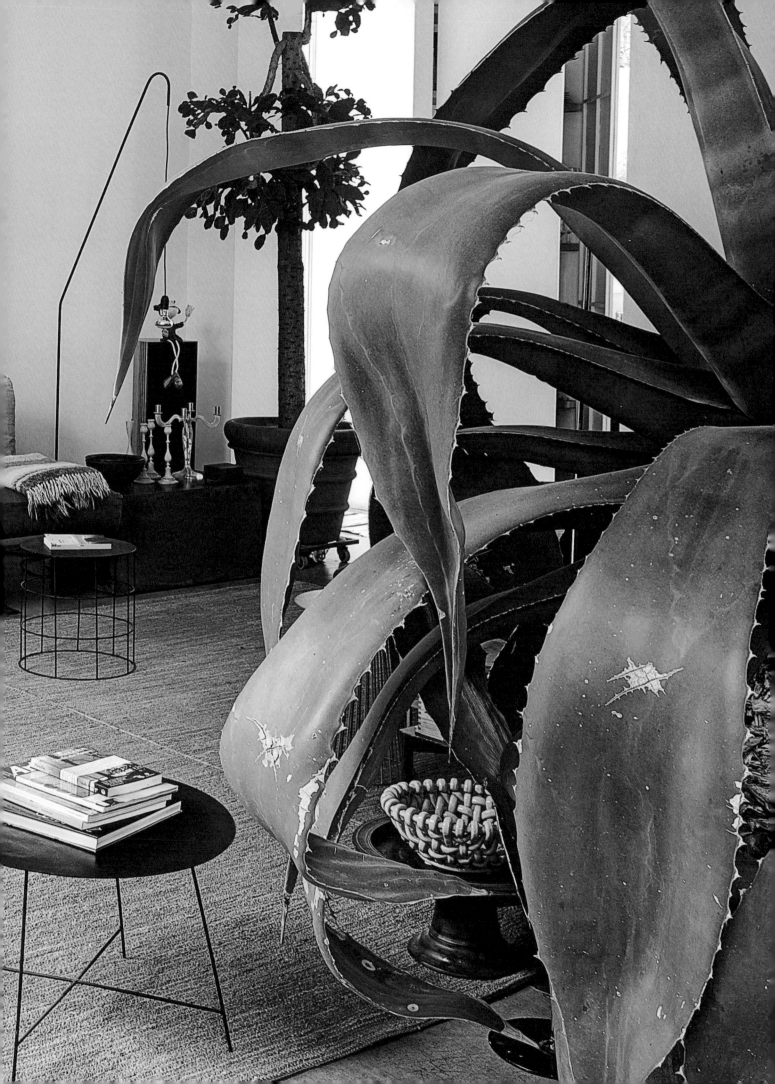

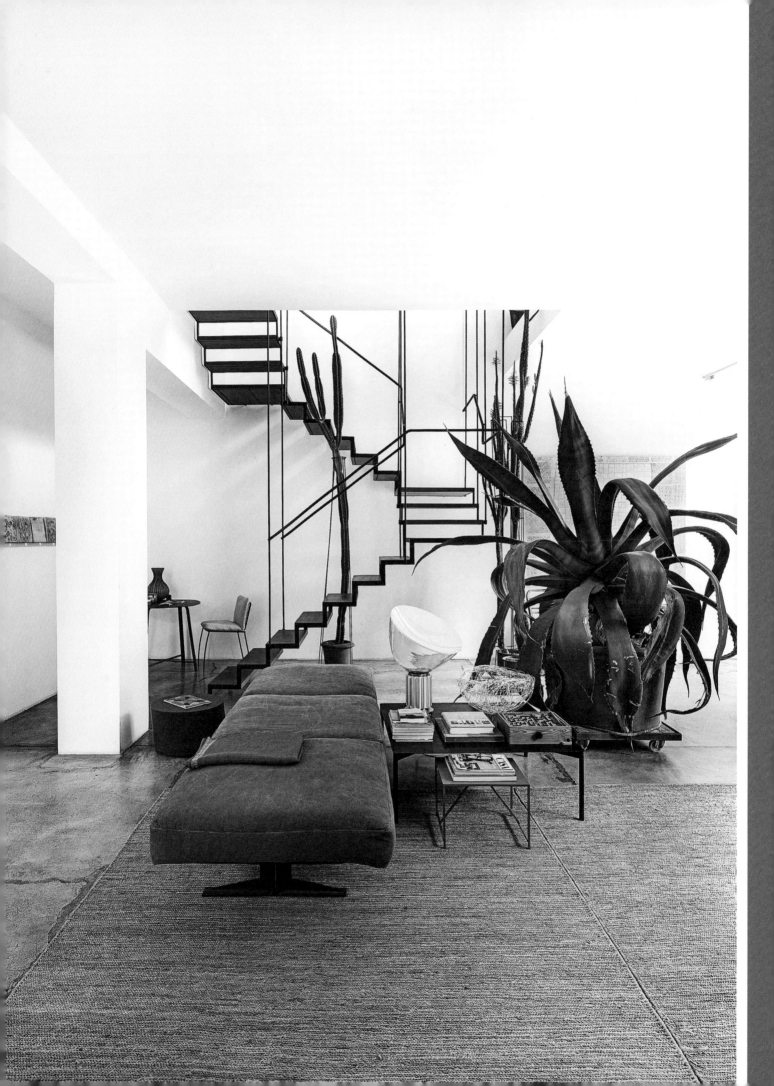

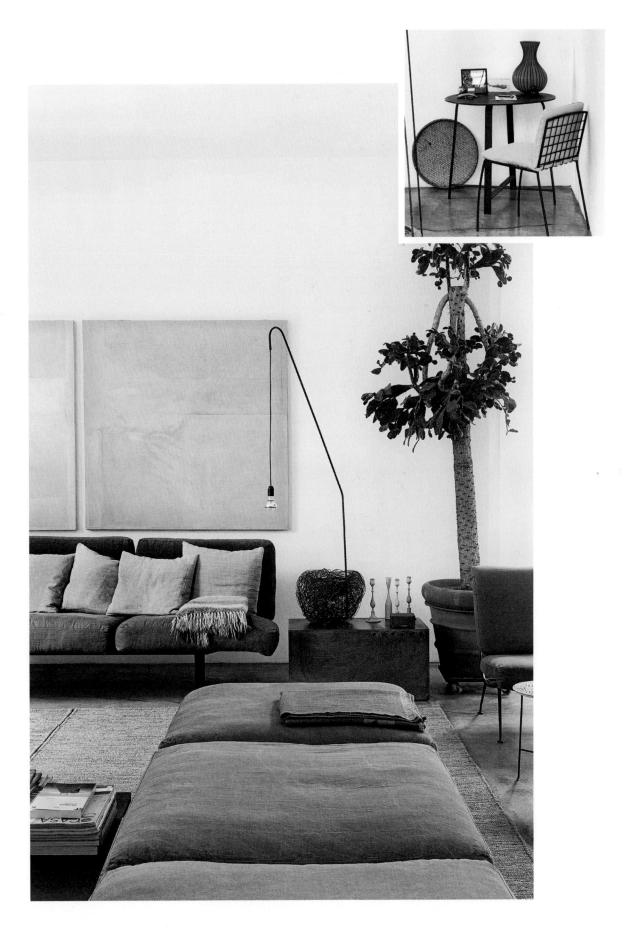

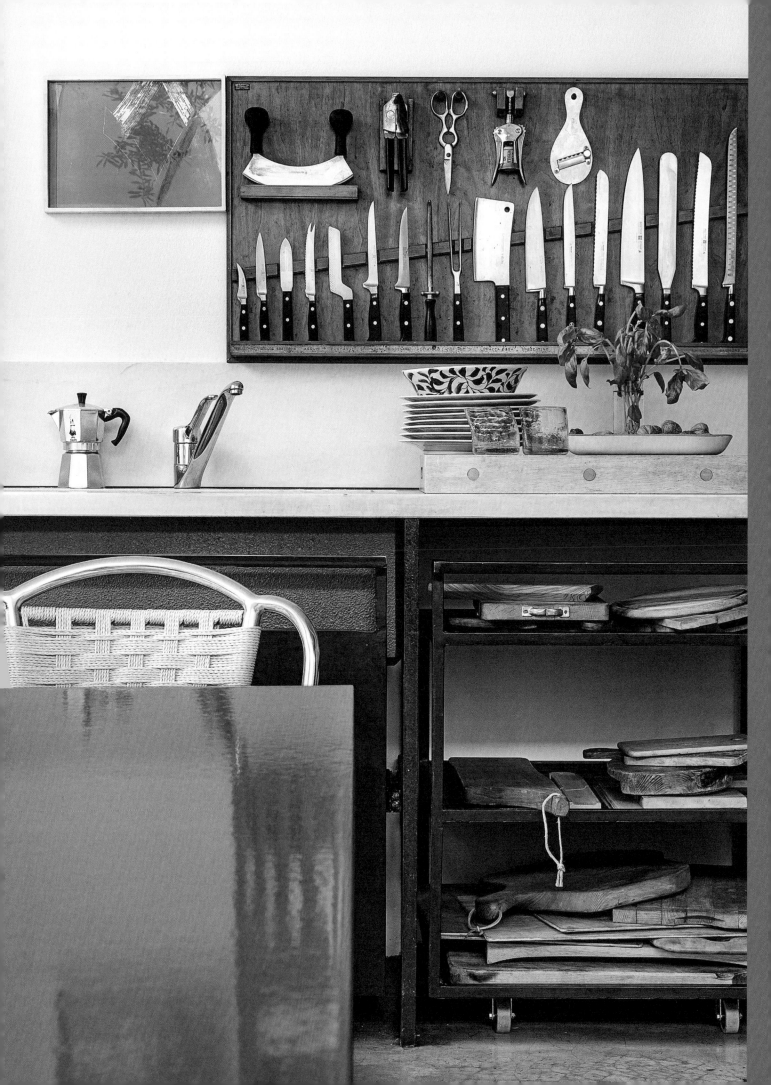

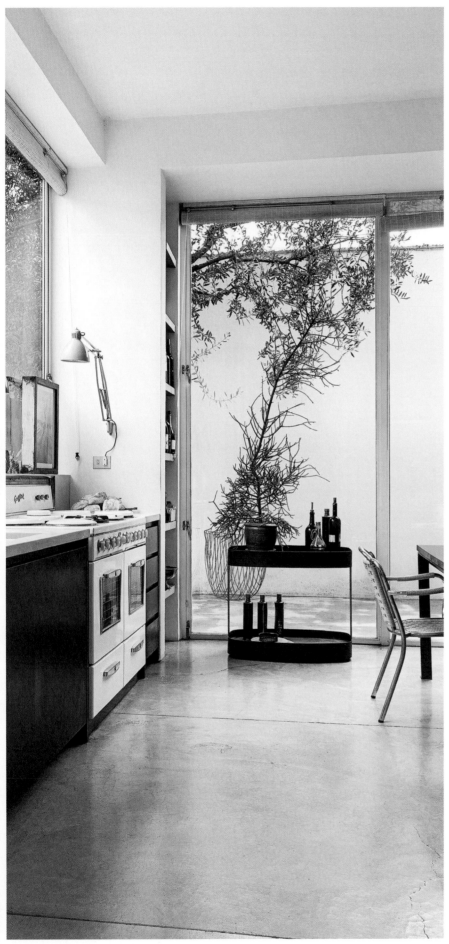

KITCHEN

Antonino has kept his industrial-looking kitchen streamlined by stowing utensils on movable trolleys under the work surface and by mounting workshop-inspired "tool tidies" on the walls. Anglepoise lamps are mounted to the wall for precision lighting.

KÜCHE

Die Küche im Industrial Style ist dank der Schubladenelemente auf Rollen unter der Arbeitsplatte und der Bretter für Küchengerätschaften an den Wänden immer aufgeräumt. Lampen von Anglepoise wurden für eine gezielte Beleuchtung an die Wand montiert.

CUISINE

Pour préserver les lignes épurées de sa cuisine au look industriel, Antonino range ses ustensiles sur des chariots à roulettes escamotés sous le plan de travail, ou sur un cadre accroché au mur, façon atelier. Des lampes d'architecte assurent la précision de l'éclairage.

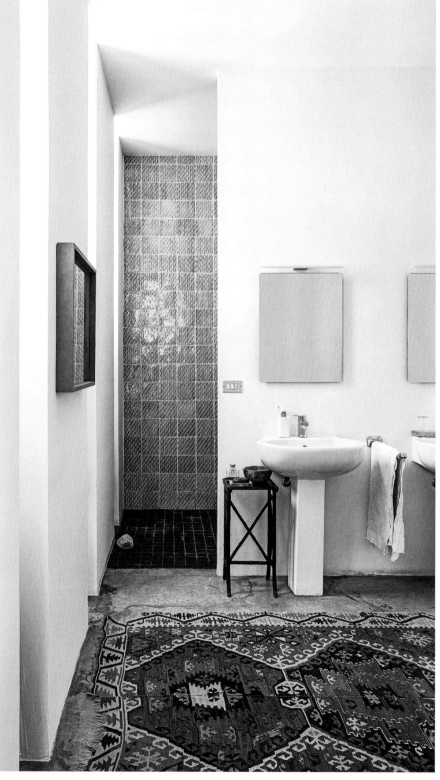

BEDROOM & BATHROOM

A vintage Persian rug and linen curtain warms the concrete floor of the bedroom and bathroom. Color has been used boldly in the walk-in shower, providing a Sicilian-inspired contrast to the pale gray and white.

SCHLAFZIMMER
& BADEZIMMER

Alte Perserteppiche wärmen den Betonboden des Schlafzimmers. Leinenvorhänge sorgen für Behaglichkeit. In der begehbaren Dusche bilden die blauen Kacheln einen Kontrast zu den blassen Grau- und Weißtönen des Schlafzimmers.

CHAMBRE À COUCHER
& SALLE DE BAIN

Tapis persans anciens et rideaux de lin réchauffent les sols en béton de la chambre à coucher et de la salle de bain. La douche italienne fait un usage audacieux des couleurs, dans un contraste très sicilien.

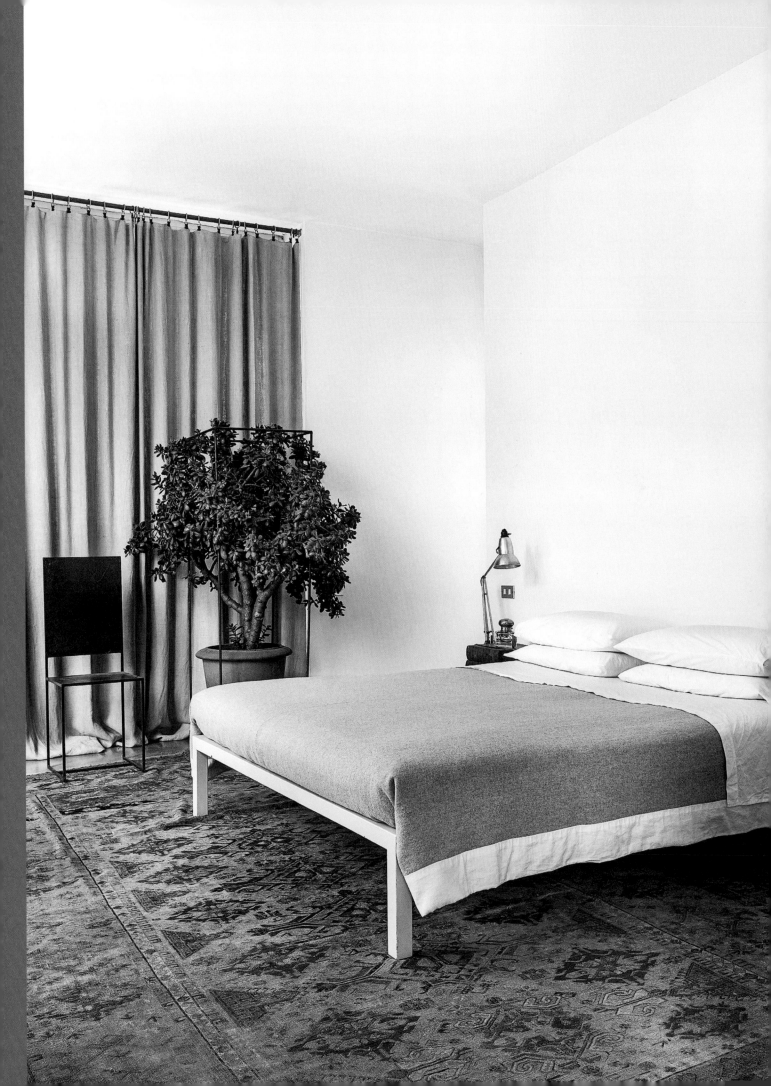

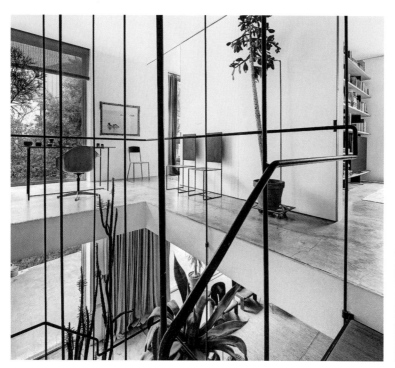

STAIRCASE
*Antonino's towering steel-framed staircase leads from
the living room and kitchen to the mezzanine floor above.
Its long-limbed silhouette is matched by the tall cacti.*

TREPPE
*Die Treppe mit Stahlgerüst führt vom Wohnzimmer und
der Küche ins obere Zwischengeschoss. Ihre langgestreckte Silhouette
wird von hohen Kakteen flankiert.*

ESCALIER
*Un imposant escalier en fer forgé mène de l'espace à vivre
au premier étage. De hauts cactus accompagnent le mouvement
de sa silhouette élancée.*

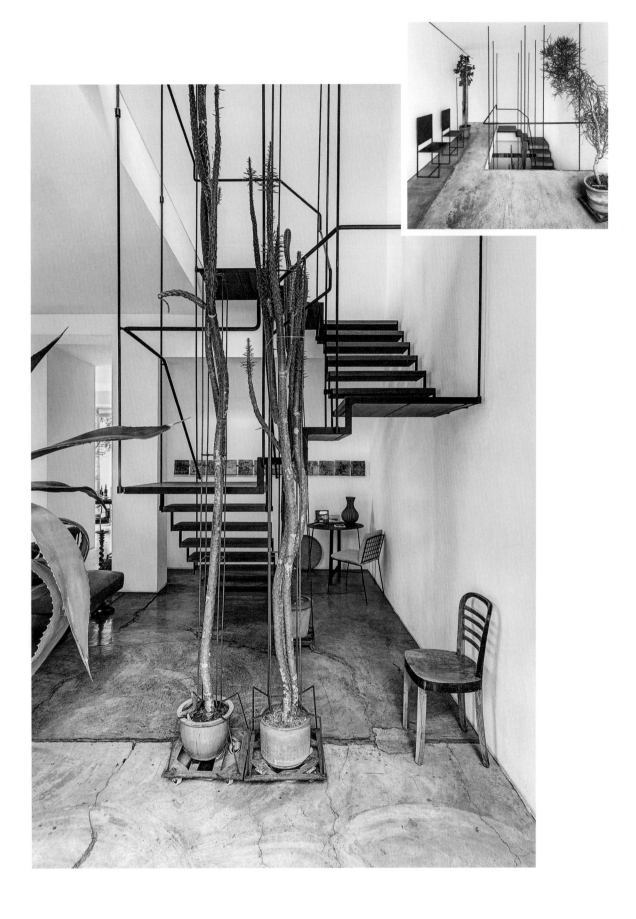

SIMPLE CHRISTMAS

STILL TWINKLY AND LOOK-AT-ME, THIS COOL COPENHAGEN APARTMENT
SHOWS THAT LESS IS MORE.

SCHLICHTE WEIHNACHTEN: DAS PRINZIP „WENIGER IST MEHR" LÄSST SICH SOGAR
AN WEIHNACHTEN ANWENDEN – UND ZWAR DURCHAUS MIT FESTLICHER WIRKUNG.

NOËL, TOUT SIMPLEMENT : SANS RENONCER À L'ESPRIT DE NOËL,
CET APPARTEMENT DE COPENHAGUE EST UN EXEMPLE DE MINIMALISME RÉUSSI.

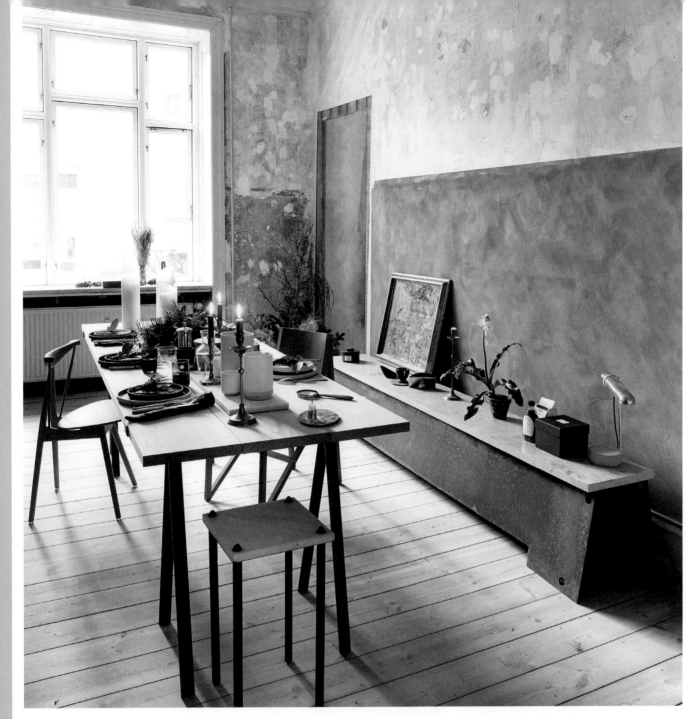

**CHRISTMAS BRINGS WITH
IT A TIME OF PREPARATION,
CLEARING OUT, AND TIDYING—**
almost as much as spring, so what better
reason to keep the decorations simple?
Niels Strøyer Christophersen, cofounder
of the Danish furniture brand Frama,
has stuck to an elemental philosophy when
deciding on how to decorate his home for
the festive season: nature. "I like to use
natural materials and simple shapes,"
he says. "I don't have a box of Christmas
decorations that I open each year. I craft
new ones every time." On Niels's dining
table, he keeps things tablecloth-free and
combines vintage cutlery with candlesticks
and simple ceramic plates. Blue linen
napkins and a few sprigs tied with twine
complete the natural look.

**WEIHNACHTEN IST AUCH EINE
ZEIT DER VORBEREITUNGEN, DES
PUTZENS UND AUSMISTENS –**
fast so wie im Frühling. Da liegt es nahe,
die Dekorationen nicht ausufern zu lassen,
sondern auf Schlichtheit zu setzen.
Niels Strøyer Christophersen, Mitbegründer
der dänischen Möbelmarke Frama, hält
sich beim Dekorieren seines Zuhauses für
die festlichen Tage an ein paar elementare
Regeln: „Ich arbeite mit natürlichen
Materialien und einfachen Formen", sagt er.
„Außerdem besitze ich keinen Karton mit
Weihnachtsdeko, aus dem ich mich jedes
Jahr bediene, sondern bastle jedes Mal
neue." Auf Niels' tischdeckenfreiem Esstisch
wird Vintage-Besteck mit Kerzen und
einfachen Keramiktellern kombiniert.
Blaue Stoffservietten und ein paar mit
Zwirn zusammengebundene dekorative
Zweige vollenden den natürlichen Look.

**LORSQUE NOËL ARRIVE,
AU MOMENT DE PARER
SON INTÉRIEUR DE SES ATOURS
DE FIN D'ANNÉE,**
Niels Strøyer Christophersen, cofondateur
de la ligne de meubles danoise Frama, s'en
tient à un principe élémentaire : le naturel.
« J'aime les matériaux bruts et les lignes
pures, dit-il. Je n'ai pas de boîte remplie
de boules et de guirlandes que je rouvre
tous les ans. À chaque fois, je fabrique
de nouvelles décorations. » Dans la salle
à manger, Niels n'a pas de nappe sur
la table, mais il la décore de bougeoirs et la
dresse de couverts vintage et d'assiettes
en céramique toutes simples. Des serviettes
en lin bleu et de petits bouquets de brindilles
noués avec de la ficelle viennent parfaire
ce look naturel.

Free from unfussy layers, this homemade circular wreath is more eye-catching for its simplicity.

Dieser selbstgemachte Kranz ist gerade wegen seiner Schlichtheit ein absoluter Blickfang.

Réduite à sa plus simple expression, cette couronne de Noël attire le regard par sa simplicité.

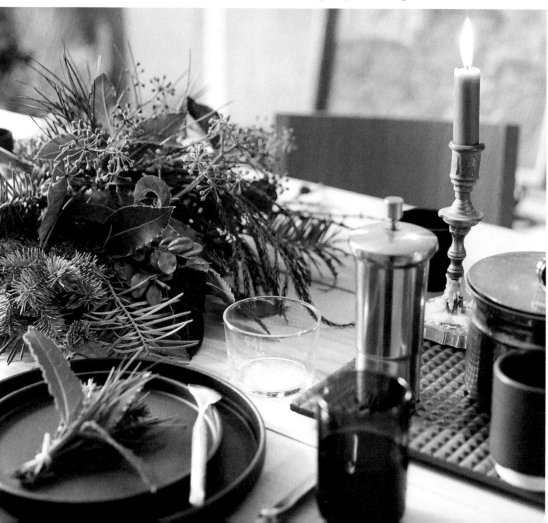

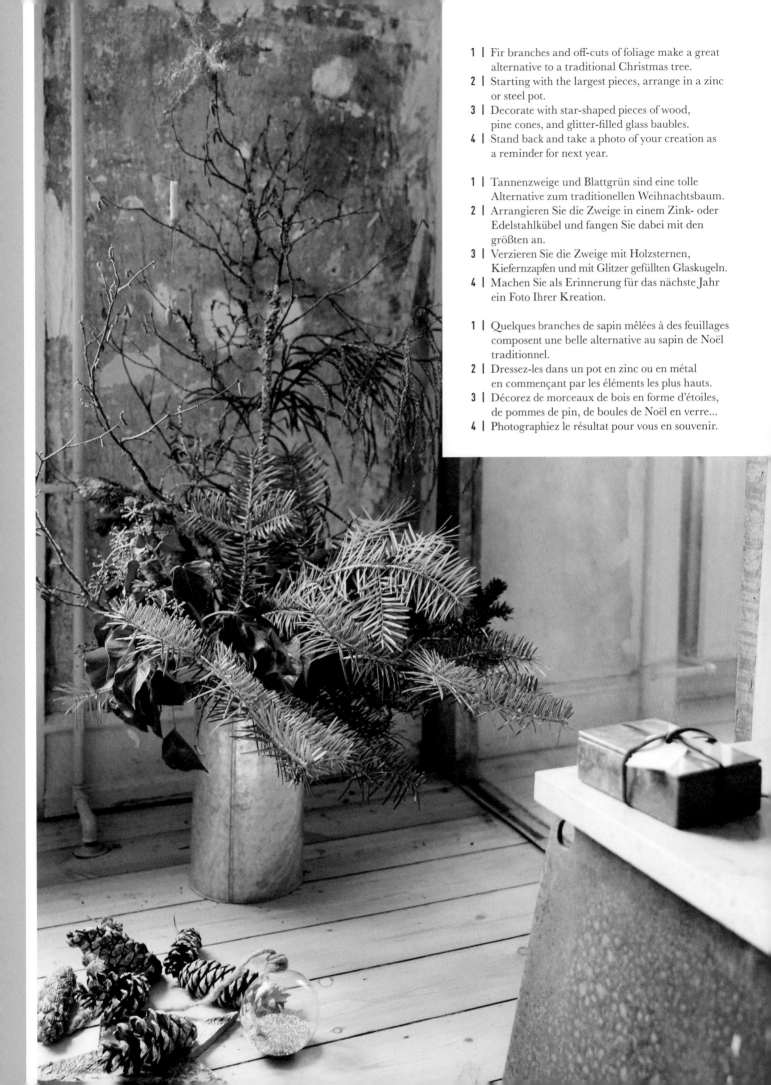

1 | Fir branches and off-cuts of foliage make a great alternative to a traditional Christmas tree.
2 | Starting with the largest pieces, arrange in a zinc or steel pot.
3 | Decorate with star-shaped pieces of wood, pine cones, and glitter-filled glass baubles.
4 | Stand back and take a photo of your creation as a reminder for next year.

1 | Tannenzweige und Blattgrün sind eine tolle Alternative zum traditionellen Weihnachtsbaum.
2 | Arrangieren Sie die Zweige in einem Zink- oder Edelstahlkübel und fangen Sie dabei mit den größten an.
3 | Verzieren Sie die Zweige mit Holzsternen, Kiefernzapfen und mit Glitzer gefüllten Glaskugeln.
4 | Machen Sie als Erinnerung für das nächste Jahr ein Foto Ihrer Kreation.

1 | Quelques branches de sapin mêlées à des feuillages composent une belle alternative au sapin de Noël traditionnel.
2 | Dressez-les dans un pot en zinc ou en métal en commençant par les éléments les plus hauts.
3 | Décorez de morceaux de bois en forme d'étoiles, de pommes de pin, de boules de Noël en verre...
4 | Photographiez le résultat pour vous en souvenir.

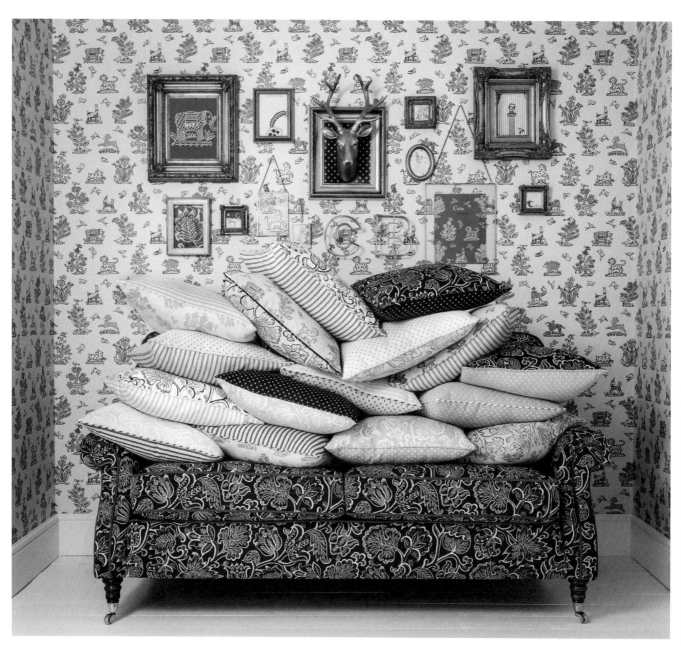

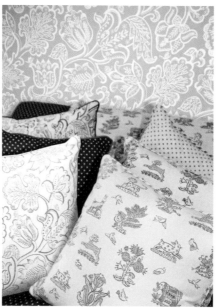

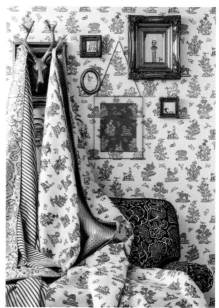

CELIA BIRTWELL

MARRIED TO OSSIE CLARK AND IMMORTALIZED BY DAVID HOCKNEY, THE TEXTILE ARTIST CELIA BIRTWELL CREATES BOLD, ROMANTIC, AND FEMININE PRINTS, FOR EXAMPLE IN COOPERATION WITH BLENDWORTH.

DIE MIT OSSIE CLARK VERHEIRATETE UND VON DAVID HOCKNEY IM BILD VEREWIGTE TEXTILDESIGNERIN KREIERT VERWEGENE, ROMANTISCHE UND FEMININE STOFFDESIGNS, U.A. FÜR BLENDWORTH.

MARIÉE À OSSIE CLARK, ET IMMORTALISÉE PAR DAVID HOCKNEY, LA CRÉATRICE TEXTILE CELIA BIRTWELL IMAGINE DES IMPRIMÉS AUDACIEUX, ROMANTIQUES ET FÉMININS, NOTAMMENT POUR BLENDWORTH.

MY WORK is all about trying to express my love of nature through design.

THE BEST THING ABOUT IT is looking at nature's magic and this beautiful world.

I WOULD SUM UP MY STYLE as personal, bohemian, and fun.

MY LOVE OF FLOWERS was sparked by my father, who was a keen gardener. He inspired me from an early age to look at the natural world.

MY BEST FLORAL MOMENT is bringing spring flowers into the house for the first time of the year.

I LIKE TO USE PLANTS at home by keeping fresh-cut flowers. They are a must, and if they have a perfume, that's a double bonus.

MY BIGGEST GUILTY PLEASURE is dark chocolate rose and violet creams from Fortnum & Mason.

MY FAVORITE SEASON is the one coming next. I love the changes and surprises of each season.

MY FAVORITE FILM is David Lean's *Great Expectations*.

MY BEST SKILL is making a pretty home and garden.

MY PERSONAL MOTTO is "It's a beautiful world—try and enjoy it."

IN MEINER ARBEIT GEHT ES DARUM, meine Liebe zur Natur durch Design auszudrücken.

DAS BESTE DARAN: Die Magie der Natur und diese wunderschöne Welt zu betrachten.

MEINEN STYLE WÜRDE ICH SO BEZEICHNEN: persönlich, künstlerisch und mit viel Spaß verbunden

MEINE LIEBE ZU BLUMEN hat mein Vater, ein leidenschaftlicher Gärtner, in mir geweckt. Er hat mich von klein auf dazu inspiriert, die natürliche Welt zu betrachten.

MEIN BESTER FLORALER MOMENT: Zum ersten Mal im Jahr Frühlingsblumen mit nach Hause bringen.

INNEN DEKORIERE ICH FLORAL mit Schnittblumen. Sie sind ein absolutes Muss, und wenn sie auch noch duften, ist das ein doppelter Bonus.

MEIN GRÖSSTES HEIMLICHES VERGNÜGEN: die Pralinensorte Rose & Violet Creams mit dunkler Schokolade von Fortnum & Mason

MEINE LIEBLINGSJAHRESZEIT: Immer die, die als Nächstes kommt. Ich liebe die Veränderungen und Überraschungen, die jede Jahreszeit mit sich bringt.

MEIN LIEBLINGSFILM: David Leans *Geheimnisvolle Erbschaft*

MEINE BESTE FÄHIGKEIT: Häuser und Gärten hübsch einrichten.

MEIN PERSÖNLICHES MOTTO: Die Welt ist schön – versuche, sie zu genießen.

MON TRAVAIL, C'EST AVANT TOUT une tentative d'exprimer mon amour pour la nature à travers le design.

CE QUE J'AIME LE PLUS DANS MON TRAVAIL, c'est ce regard sur la magie de la nature et notre monde merveilleux.

JE QUALIFIERAIS MON STYLE de personnel, bohème et fun.

MON AMOUR DES FLEURS me vient de mon père, qui était passionné de jardinage. Il m'a appris à observer la nature quand j'étais toute petite.

MON PLUS BEL INSTANT FLORAL, c'est celui des premières fleurs de printemps qui entrent à la maison.

J'AIME FLEURIR MON CHEZ MOI et décorer mon intérieur de fleurs coupées. Je ne peux pas m'en passer, et si elles sont parfumées, c'est encore mieux.

MON PETIT PLAISIR COUPABLE, ce sont les chocolats noirs fourrés à la crème de rose et de violette de chez Fortnum & Mason.

MA SAISON PRÉFÉRÉE, c'est la prochaine. J'adore les changements et les surprises qu'apporte chaque saison.

MON FILM PRÉFÉRÉ est *Les Grandes Espérances* de David Lean.

MA QUALITÉ PREMIÈRE est de savoir composer de beaux jardins et intérieurs.

MA DEVISE est « Le monde est merveilleux, faites un effort pour en profiter. »

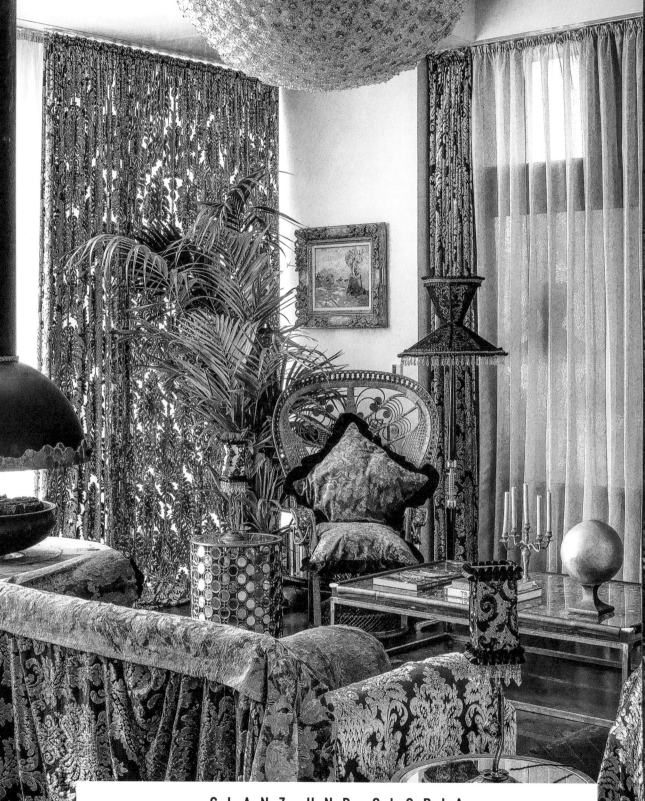

Botanical

GOLDEN GLOW

GLANZ UND GLORIA
REFLETS DORÉS

Shanyan Koder

WHAT DOES the word "bohemian" mean to you? Embroidery and jewels are good. With an eye for drapery, velvets, fringes, tassels, and festoons of plants, there's a flair for vintage that all adds up to deliciously covetable design. Elegant with more than a bohemian touch, it's impossible not to fall in love with the interiors of Sera Hersham-Loftus. The silhouettes are loose and light, combining voluminous fabrics in a glamorous palette of green, gold, and peony pink.

For this project, Sera converted an old artist's studio in the swish area of Chelsea in London, introducing a style that is floral, yet with no floral prints as such. "My client, art dealer Shanyan Koder, wanted something that was very easy to live in, very human with lots of plants," says Sera. "People come to me for my sense of style. It's a certain look." All very romantic, imagine layers of devoré-patterned velvet, transparent organza, and trims of satin. "It's sexy in the way a woman would dress," Sera explains. "I like my lace and fabrics that you can see through."

The relaxed, cocktail-in-hand attitude of the decoration stretches from the shiny, mirrored dining room to the majestic four-poster bed—but it's at night when the real magic happens. Discreetly lit up with amber-colored bulbs, the clusters of plants come to life after dark, casting shadows on the walls and adding to the glow.

STICKEREIEN, GLITZERNDE PRETIOSEN, Samt und Seide, Drapierungen, Troddeln und überbordende Blumenarrangements: In dieser herrschaftlichen Wohnung waltet ein ungezügelter Vintage-Flair, der einen überwältigenden Gesamteindruck vermittelt. Es ist schier unmöglich, sich nicht in die eleganten und künstlerisch angehauchten Interieurs von Sera Hersham-Loftus zu verlieben. Die Silhouetten sind licht und luftig, voluminöse Stoffe verführen in einem glamourösen Farbenspiel aus Grün, Gold und Pfingstrosenpink.

Für dieses Projekt baute Sera im edlen Londoner Stadtteil Chelsea ein altes Künstleratelier um und führte einen Stil ein, der zwar floral ist, aber völlig ohne florale Muster auskommt. „Meine Kundin, die Kunsthändlerin Shanyan Koder, wollte etwas, in dem es sich entspannt leben lässt, sehr human, mit vielen Pflanzen", sagt Sera. „Menschen engagieren mich wegen meines Stilgefühls. Es ist ein ganz bestimmter Look." Das Gesamtkonzept ist sehr romantisch: Man stelle sich Samt mit Ausbrenner-Muster, transparenten Organza-Stoff und Satinborten vor. „Es ist sexy – wie ein Frau sich kleiden würde", erklärt Sera. „Ich mag Spitze und durchsichtige Stoffe."

Die lockere Cocktail-Atmosphäre reicht vom spiegelglänzenden Esszimmer bis zum majestätischen Himmelbett – doch erst nachts setzt der wahre Zauber ein: Die mit bernsteinfarbenen Glühbirnen diskret beleuchteten Pflanzengruppen erwachen nach Einbruch der Dunkelheit zum Leben und werfen geheimnisvolle Schatten.

BIJOUX ET BRODERIES, mais aussi draperies et velours, ainsi que franges, pompons et festons. Impossible de ne pas tomber amoureux de la décoration de Sera Hersham-Loftus : élégante, toute en silhouettes légères et déliées, en étoffes volumineuses, à l'éblouissante palette de verts, d'ors et de rose pivoine et avec cette touche résolument bohème, qui, mâtinée d'une touche vintage, compose un ensemble délicieusement sexy.

Le projet de Sera consistait à convertir en habitation un ancien atelier d'artiste dans le quartier chic de Chelsea, à Londres. Sans introduire aucun motif de fleur, elle a réussi à lui insuffler un style résolument floral. « Ma client, la marchande d'art Shanyan Koder, voulait un intérieur facile à vivre, quelque chose de très humain avec beaucoup de plantes, explique Sera. Les gens s'adressent à moi pour retrouver un certain style. » Imaginez des pans de velours dévoré, des voilages d'organdi transparent et des festons de satin. Romantique en diable. « Tout cela est sexy de la même manière que le sont des vêtements de femme. Ce que je préfère, ce sont les dentelles et les tissus qui laissent voir à travers. »

De la salle à manger qui scintille de mille feux, au majestueux lit à baldaquin de la chambre à coucher, l'effet est saisissant. Mais c'est surtout le soir que la magie opère. Discrètement éclairées par des ampoules couleur ambre, les plantes prennent vie à la nuit tombée, projetant sur les murs des ombres qui soulignent l'éclat des lieux.

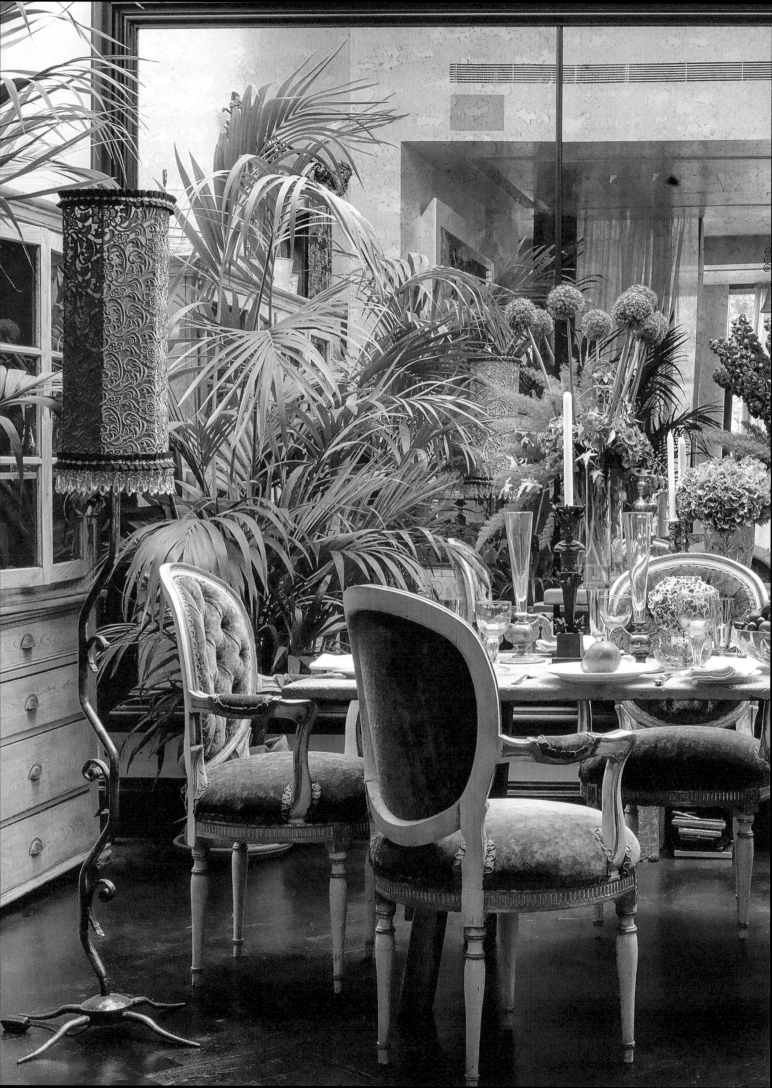

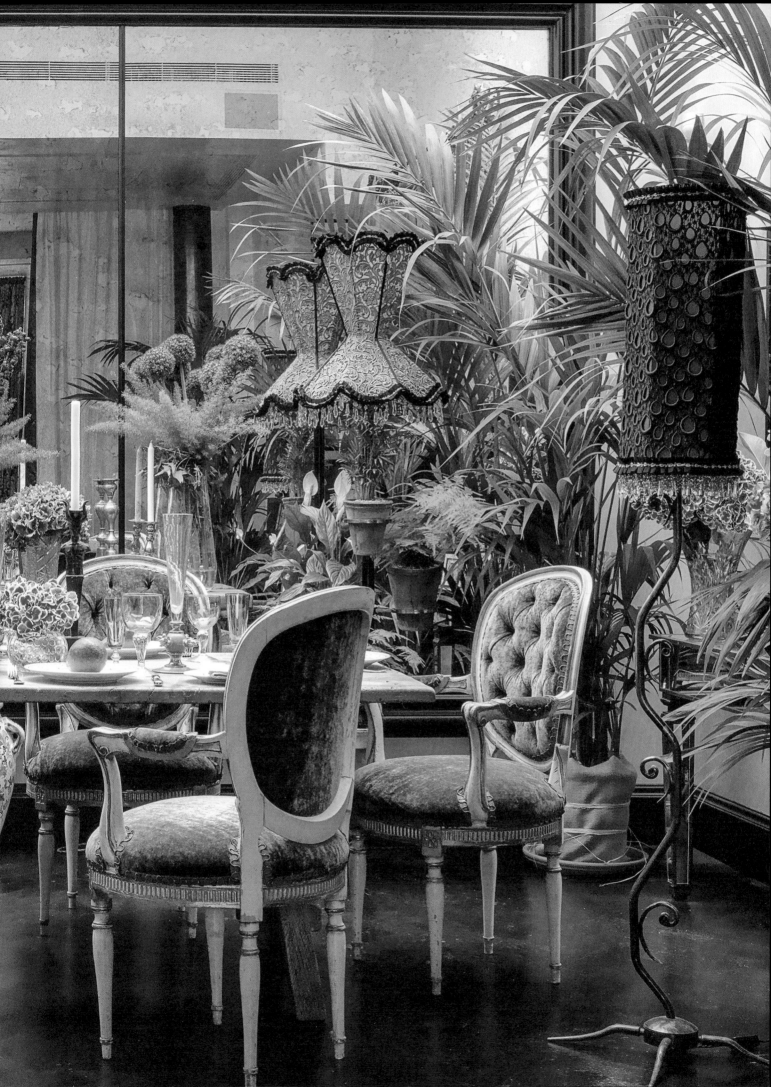

DINING ROOM

*Receiving the star treatment, in the dining room we're talking
velvet-upholstered seating, glossy black parquet floors, and a mirrored wall
that reflects the plant-filled space so it looks like a never-ending garden.
Even the plant pots are dolled up with hessian and tied with string.
The sunny, serene spirit of the green and gold interior is the ultimate
in feel-good decoration.*

ESSZIMMER

*Glamour pur: Hier beeindrucken samtgepolsterte Stühle,
ein glänzend schwarzer Parkettboden und eine Spiegelwand,
die den mit Pflanzen gefüllten Raum so reflektiert, dass man sich
wie in einem unendlichen Garten vorkommt. Sogar die Pflanzenkübel
wurden aufgebrezelt: Sie sind mit Sackleinen und Bastschnur verkleidet.
Die vorherrschende Farbpalette aus Grün und Gold erzeugt
eine sonnig-elegante Wohlfühlatmosphäre.*

SALLE À MANGER

*Reçus comme des stars dans la salle à manger, nous parlons
fauteuils capitonnés de velours et parquet noir brillant.
Au mur, un grand miroir reflète un espace foisonnant de plantes,
tel un jardin qui s'étendrait à l'infini. Les pots sont habillés de toile
de jute maintenue par un ruban de raphia. L'esprit joyeux et ensoleillé
créé par les tons vert et or frise la perfection en matière
de décoration bien-être.*

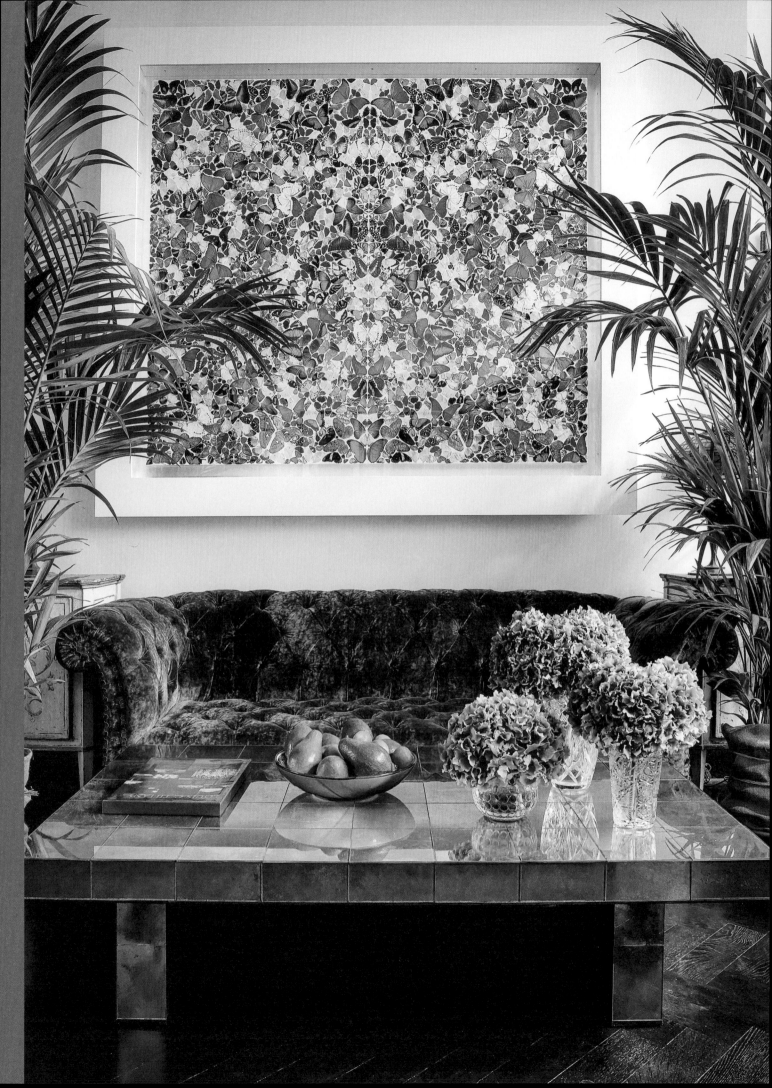

LIVING ROOM

"It's really a garden room," explains Sera. "We wanted to bring the outdoors in so that the garden is part of the room." The '70s peacock cane chair adds to the conservatory feel, dressed up with a lovely fringed cushion. Choosing fabrics that feel good and look special, cut velvet is thrown over old, comfy sofas to vamp up the glamour. It's the kaftan equivalent for the home.

WOHNZIMMER

„Das ist eigentlich ein Gartenzimmer", erklärt Sera. „Wir wollten den Außenbereich ins Interieur übertragen, sodass das Zimmer wie ein Wintergarten wirkt." Der mit einem wunderschönen Fransenkissen belegte 1970er-Jahre-Pfauensessel aus Korb trägt zu diesem Ambiente bei. Ein Chiffonstoff mit Samtmuster wurde über die alten bequemen Sofas geworfen, um sie wieder mehr als vorzeigbar zu machen – das Äquivalent eines Kaftans für Möbel.

PETIT SALON

« Cette pièce est dédiée au jardin, explique Sera. Nous voulions lui faire une place à l'intérieur, qu'il vienne se perdre dans ce petit salon. » Le fauteuil paon en rotin, très années 1970, accentue le côté jardin d'hiver. Le choix des étoffes mise sur un look original et un toucher sensuel, avec des pans de velours jetés sur d'anciens canapés douillets – l'équivalent déco du caftan.

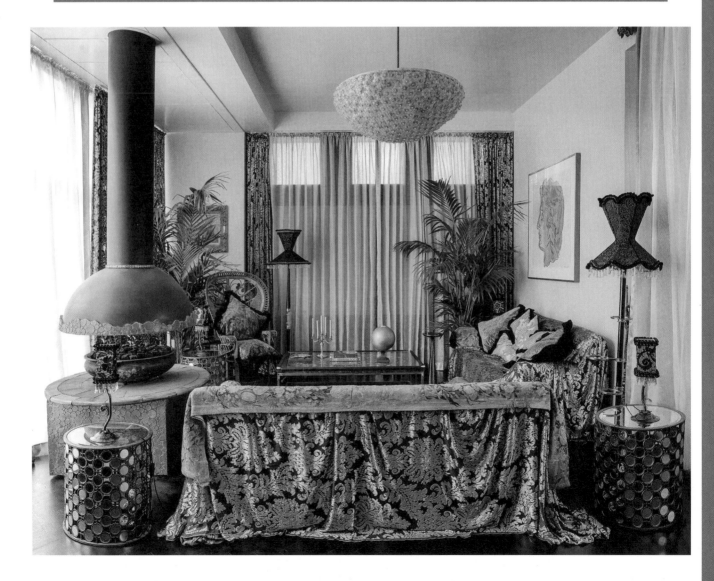

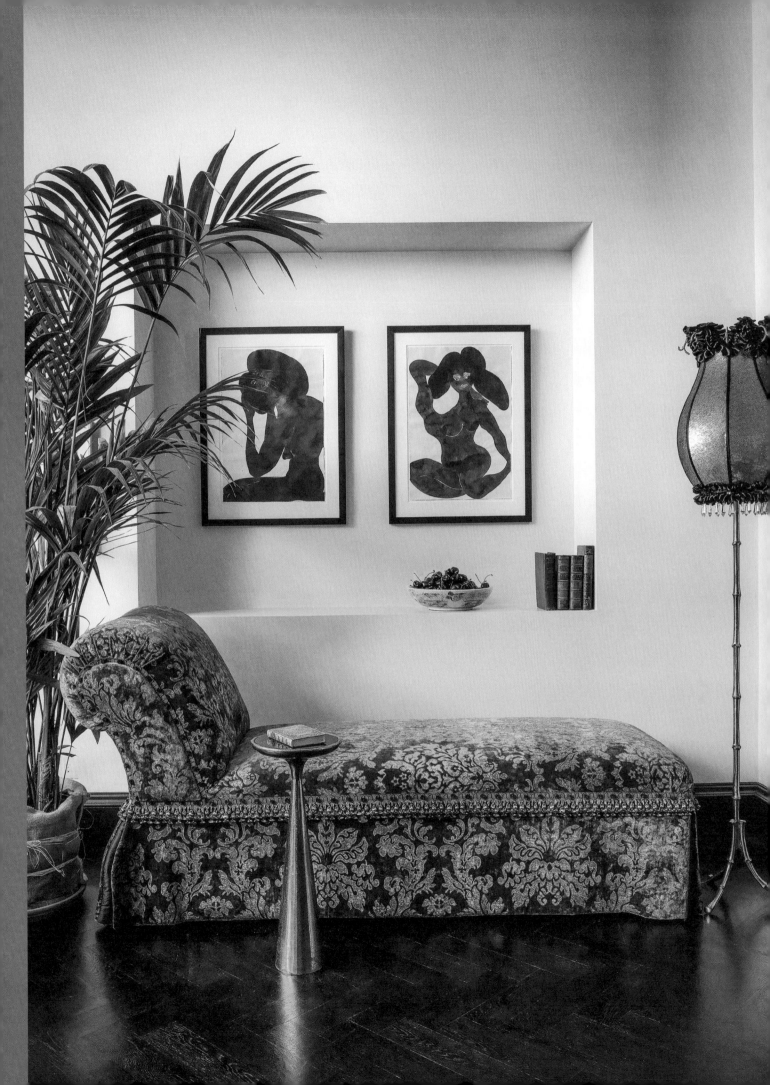

BEDROOM

*A four-poster bed is one of those things that transcends fashion.
It's part of a princess bedroom look, in the expensive boutique-hotel sense.
This oversized bed is the centerpiece of the room, draped in linen
and scallop-edged pillows. To hide the TV, a raffia fringe slides back
like a theater curtain and in contrast to the dining room,
the pale floor gives a peaceful feel.*

SCHLAFZIMMER

*Himmelbetten gehören zu den Dingen, die Mode transzendieren.
Sie sind Teil des Prinzessinnen-Looks – in der teuren Boutiquehotel-
Ausführung. Dieses mit Muschelkissen dekorierte XXL-Bett bildet
den Mittelpunkt des Raums. Der Fernseher wird hinter einem Vorhang
aus Raffia-Bast versteckt. Im Gegensatz zum Esszimmer
ist der Boden hier hell und strahlt Ruhe aus.*

CHAMBRE À COUCHER

*Le lit à baldaquin est un incontournable dans une chambre à coucher
de princesse façon hôtel de caractère. Ce lit surdimensionné
est au cœur de la pièce, drapé de lin et garni de coussins.
La télévision se cache derrière un rideau de raphia qui s'ouvre
comme au théâtre. Contrastant avec le sol sombre de la salle à manger,
la teinte claire du plancher diffuse une ambiance sereine.*

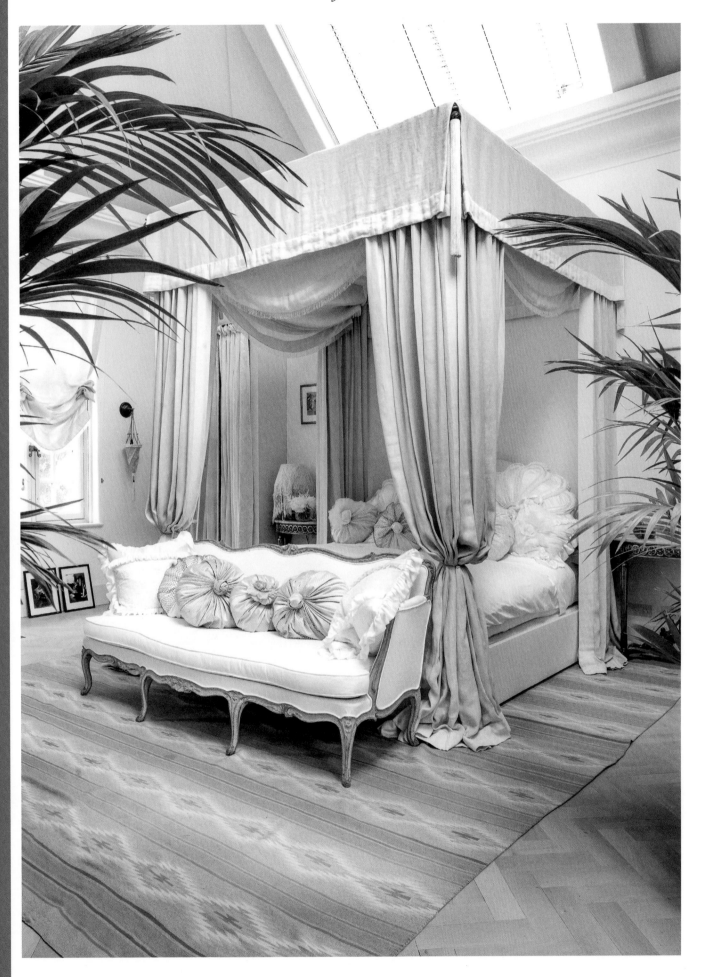

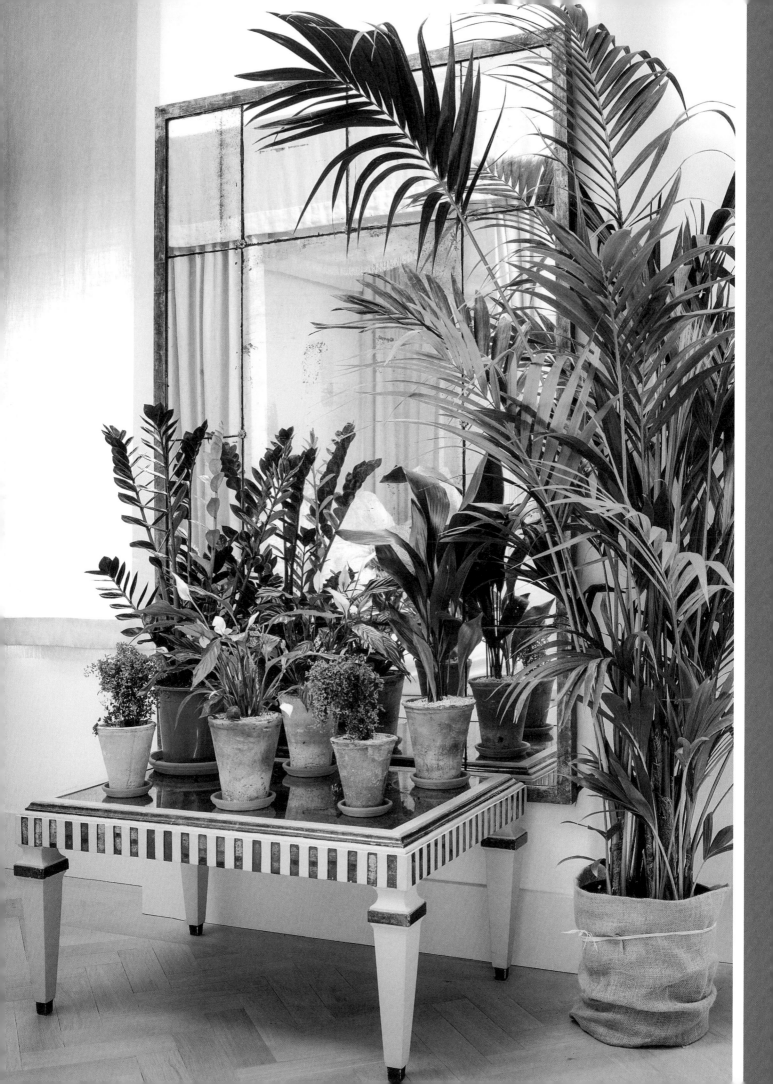



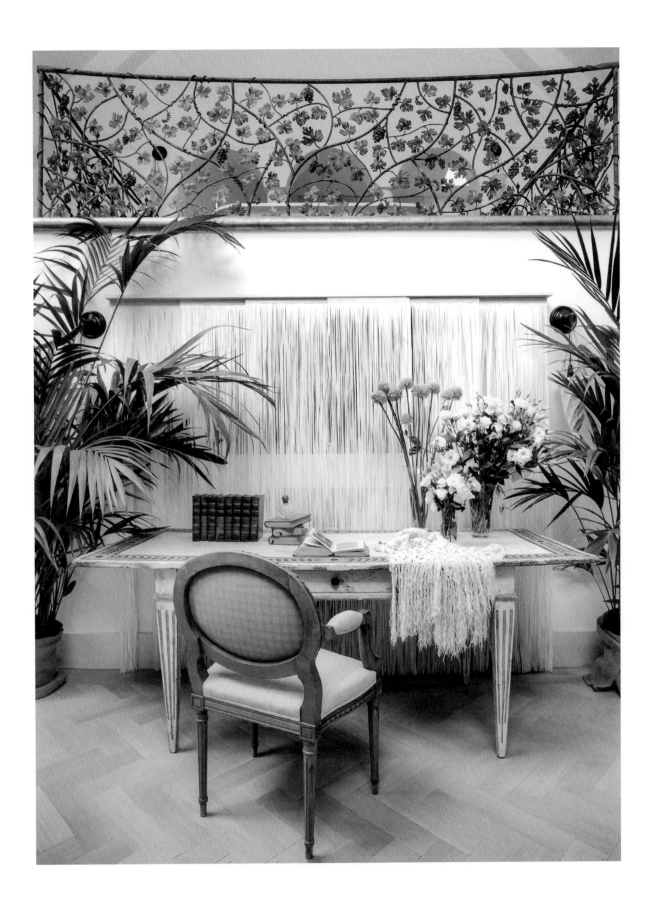

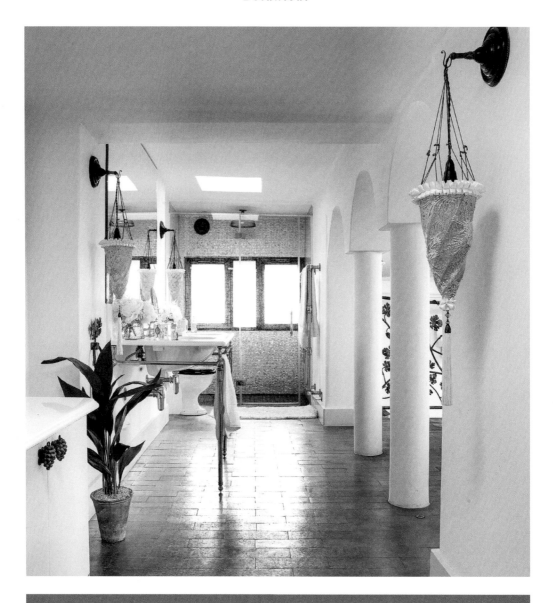

BATHROOM
Filled with vintage pieces, the classic white and silver bathroom sits on a mezzanine level above the bedroom, separated by a leaf-patterned balustrade by Andrew Finlay. It's dripping with Moorish features: hanging lanterns, mosaic tiles, and arched columns. The floor-to-ceiling shower screen and large mirrors add a modern touch.

BADEZIMMER
Das in klassischem Weiß und Silber gehaltene Bad befindet sich auf einem Zwischengeschoss über dem Schlafzimmer und wird von einer blattmustrigen Balustrade von Andrew Finlay begrenzt. Die Einrichtung mit hängenden Laternen, Mosaikfliesen und Säulenbögen mutet maurisch an, ein raumhoher Duschvorhang und große Spiegel verleihen dem Ganzen einen modernen Touch.

SALLE DE BAIN
La salle de bain est installée en mezzanine, au-dessus de la chambre à coucher. Bordée par une balustrade à motifs de feuillage signée Andrew Finlay, elle foisonne de clins d'œil à l'Orient : lanternes suspendues, carreaux de mosaïque, arches et colonnes. De grands miroirs, ainsi que l'écran de douche qui va du sol au plafond, assurent la touche moderne.

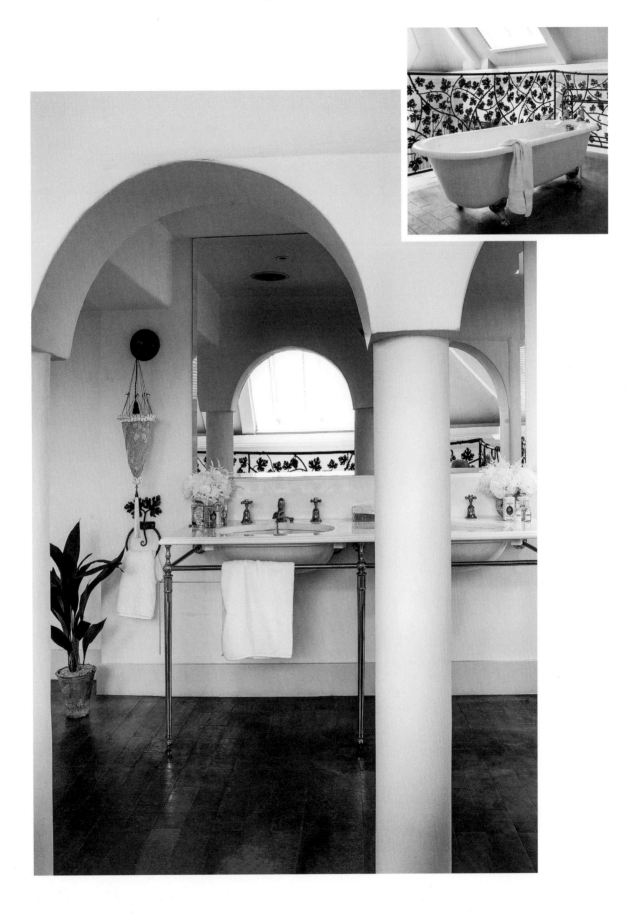

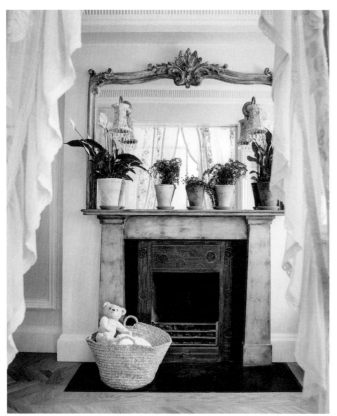

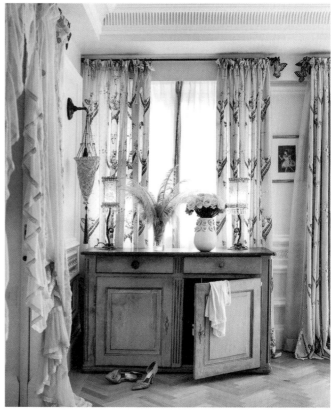

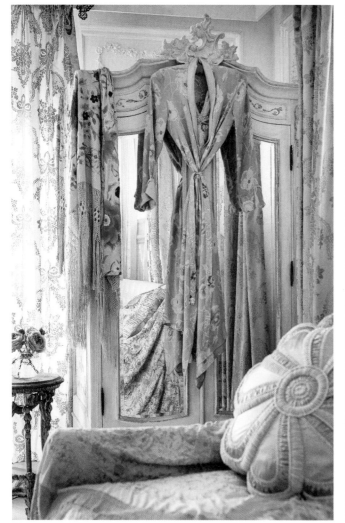

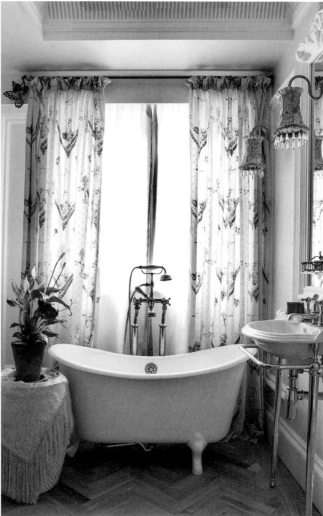

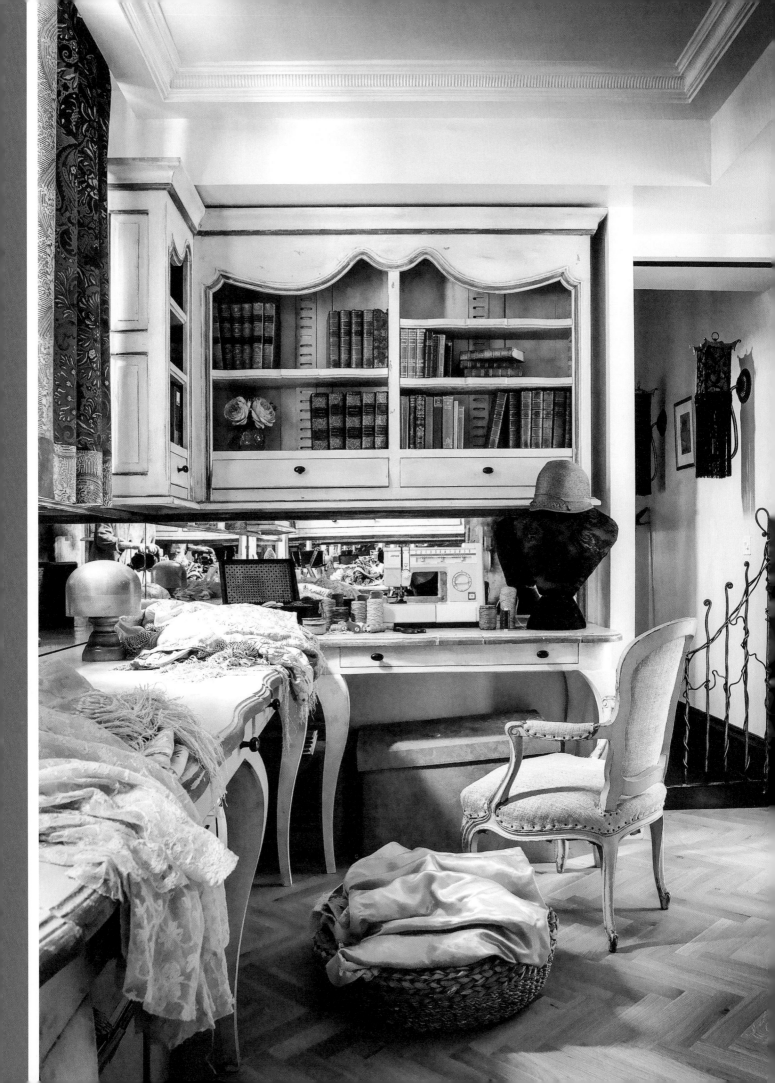

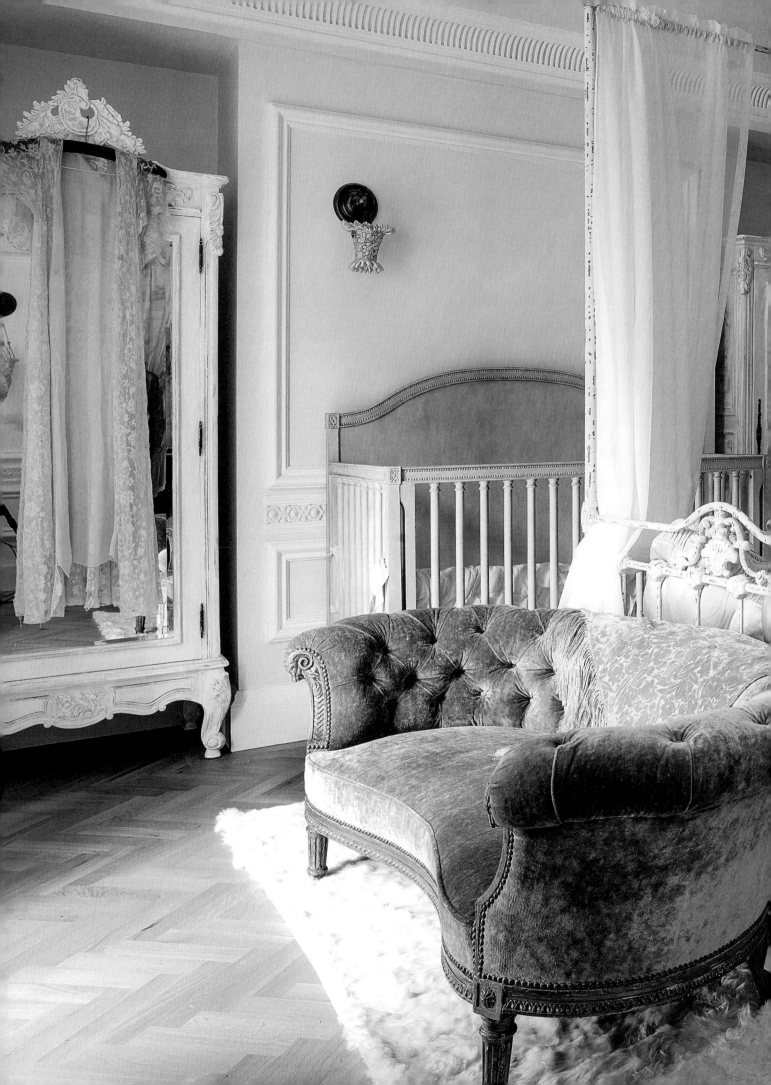

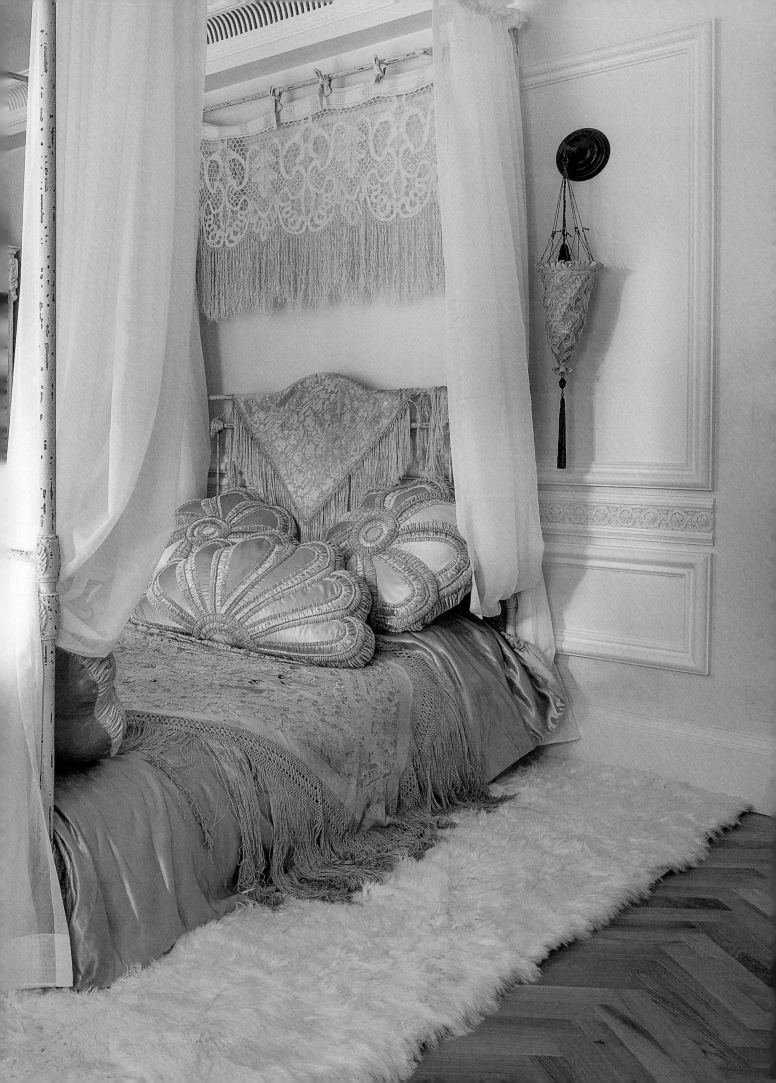

LUKE EDWARD HALL

THE WUNDERKIND LONDON ILLUSTRATOR AND INTERIOR DESIGNER ON HIS PASSION FOR DECORATING AND THE GREAT OUTDOORS.

DER BLUTJUNGE LONDONER ILLUSTRATOR, STYLIST UND INTERIOR DESIGNER ÜBER SEINE LEIDENSCHAFT FÜR DEKORATION UND DIE FREIE NATUR.

ENFANT PRODIGE DE L'ILLUSTRATION ET DU DESIGN D'INTÉRIEUR, LE CRÉATEUR LONDONIEN PARLE DE SA PASSION POUR LA DÉCORATION.

MY WORK is all about color, pattern, optimism, and fun.

I WOULD SUM UP MY STYLE as Greco-Roman meets crumbling English country house with a dash of Palm Springs.

I'VE ALWAYS BEEN INSPIRED by nature. It is the original source of fantastic colors; a tulip's spring green stem and dusky pink petals, for example.

IF I WERE A FLOWER, I'd be something big, bright, and blousy.

MY FAVORITE COLORS are odd, clashing combinations like red with pink or orange and brown.

MY FAVORITE DESTINATION is Italy, always.

I LIKE TO USE plants at home by planting bulbs in glass dishes and bowls.

I'M HAPPIEST when I'm drawing.

THE BOOK that's influenced me most is the American interior designer Miles Redd's *The Big Book of Chic*.

MY FAVORITE QUOTE is from a house in Dorset, which has "COÛTE QUE COÛTE" above its entrance. It translates as: "Costs what it costs."

IN MEINER ARBEIT GEHT ES UM Farben, Muster, Optimismus, Spaß.

MEINEN STYLE WÜRDE ICH SO BEZEICHNEN: Griechisch-römisch trifft auf verfallenes englisches Landhaus mit einem Schuss Palm Springs.

DIE NATUR HAT MEINE ARBEIT BEEINFLUSST, weil sie der Ursprung fantastischer Farben ist. Man denke z. B. an das Frühlingsgrün eines Tulpenstängels und das Altrosa der Blütenblätter.

ALS BLUME WÄRE ICH etwas Großes und Leuchtendes mit üppigen Blüten.

MEINE LIEBLINGSFARBEN: schräge Kombinationen wie Rot und Pink oder Orange und Braun

MEIN LIEBLINGSREISEZIEL: immer Italien

INNEN DEKORIERE ICH MIT PFLANZEN, indem ich Blumenzwiebeln in Glasgefäße einpflanze.

AM GLÜCKLICHSTEN BIN ICH, wenn ich zeichne.

DAS BUCH, DAS MICH AM MEISTEN BEEINFLUSST HAT: *The Big Book of Chic* des amerikanischen Interior Designers Miles Redd

MEIN LIEBLINGSZITAT steht über der Eingangstür eines Hauses in Dorset: „COÛTE QUE COÛTE", was soviel bedeutet wie „Es kostet, was es kostet".

MON TRAVAIL, C'EST AVANT TOUT la couleur, la composition, l'optimisme et le plaisir.

JE QUALIFIERAIS MON STYLE comme la rencontre du gréco-romain et d'une maison de campagne anglaise un peu décrépite, avec une touche de Palm Springs.

J'AI TOUJOURS PUISÉ MON INSPIRATION dans la nature. Elle est la source originelle de splendides couleurs – la tige vert printemps d'une tulipe aux pétales vieux rose, par exemple.

SI J'ÉTAIS UNE FLEUR, je serais une grosse fleur aux amples pétales de couleur vive.

MES COULEURS PRÉFÉRÉES sont faites de combinaisons improbables qui détonnent, comme le rouge et le rose ou l'orange et le brun.

MA DESTINATION PRÉFÉRÉE est toujours l'Italie.

POUR FAIRE ENTRER LES FLEURS CHEZ MOI, je plante des bulbes dans des bols et des saladiers en verre.

MON BONHEUR, je le trouve dans le dessin.

LE LIVRE QUI M'A LE PLUS MARQUÉ est *The Big Book of Chic* du designer d'intérieur américain Miles Redd.

MA CITATION PRÉFÉRÉE, je l'ai trouvée sur une maison dans le Dorset, en Angleterre, qui affichait « coûte que coûte » en français au-dessus de la porte.

SITTING PRETTY

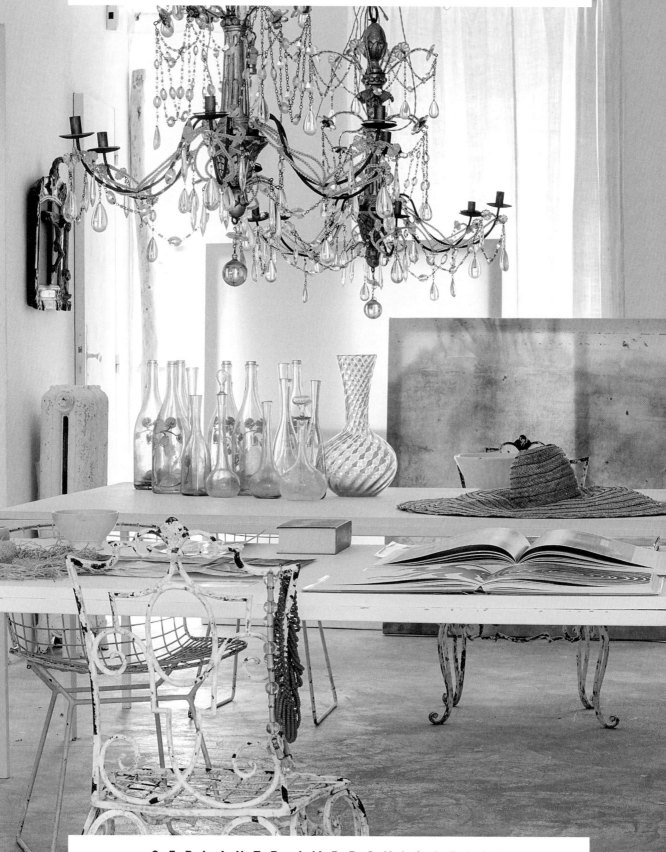

GEPLANTE IMPROVISATION
LA PART BELLE

ARTIST AND ART DIRECTOR

Carolyn Quartermaine says she is happiest when she is picking, photographing, and painting flowers. Just a look at her Instagram feed and you are flung into a world that is so florally immersive, you know it's going to smell good, too.

Her home in the South of France doesn't disappoint. A grown-up playground—vintage gilded furniture, crystal chandeliers, and Oriental-inspired patterns add romance to the contemporary, all-white interior. Floral pinks and juicy blues inject the color. It's a heady mix. Every piece of trailing ivy, every photograph casually taped to the wall, every display of styled objects that decorate the tables and shelves—her home is a window into her mind. Every petal counts.

"I've always created for myself and my homes," Carolyn explains. "I'm an artist, so painting, collaging, photography, and art directing all merge into my exhibitions or special interior projects. I source, collect, and mix to create new looks and rare combinations. It's all about the mark making—the tiny splashes of color, the hidden layers. The historical references are deeply embedded, pulling together stories from the 18th century to now."

When it comes to interiors, she explains that it's never about filling a space. "It's about looking at a chair as you would a painting," she says. "I can't bear 'girlie-pretty' so I would put a stronger object like a rock next to the chair." With a certain look-at-me factor, while it is soft and feminine, this is a home with superpowers. It has a can-do energy, which is just what you need to get the creative juices flowing.

DIE KÜNSTLERIN UND ART-DIREKTORIN Carolyn Quartermaine sagt, sie sei am glücklichsten, wenn sie Blumen pflückt, fotografiert und malt. Man braucht nur auf ihren Instagram-Account zu gehen, um in eine florale Welt einzutauchen, die so intensiv ist, dass man meint, ihren Duft riechen zu können.

Ihr Haus in Südfrankreich ist ein Spielplatz für Erwachsene, in dem vergoldete Vintage-Möbel, Kristallleuchter und Orient-Muster dem modernen, weißen Interieur einen Hauch Romantik verleihen. Florale Pinkschattierungen und kräftige Blautöne setzen Farbakzente. Die bunte Mischung mag improvisiert wirken, ist aber genau durchdacht – jeder herabhängende Efeustrang, jedes scheinbar spontan an die Wand gepinnte Foto. Carolyns Zuhause ist ein Fenster in ihre Seele.

„Ich war schon immer für mich selbst und meine Wohnstätten kreativ", erklärt Carolyn. „Ich bin eine Künstlerin; Malerei, Collagen, Fotografie und Art-Direktion fließen in meine Ausstellungen oder Designprojekte ein. Ich suche, sammle und mische, um neue Looks und seltene Kombinationen zu kreieren. Es geht um Statements – winzige Farbtupfer, verborgene Schichten, inklusive historischer Referenzen." Beim Einrichten geht es ihr nie nur darum, einen Raum zu füllen. „Ich betrachte einen Stuhl wie ein Gemälde", erklärt sie. „ ‚Hübsch und niedlich' kann ich nicht ausstehen, also würde ich ein stärkeres Objekt wie zum Beispiel einen Stein neben den Stuhl setzen." Dieses Zuhause hat einen gewissen „Schau mich an"-Faktor, ist aber zugleich weich und feminin. Es besitzt Superkräfte, eine positive Energie – genau das Richtige, um die Kreativität zu fördern.

C'EST QUAND ELLE CUEILLE DES FLEURS, qu'elle les peint ou les photographie que l'artiste et directrice artistique Carolyn Quartermaine dit trouver son bonheur. Un simple coup d'œil à son flux Instagram, et nous voilà projetés en immersion totale dans un univers intensément floral.

Dans le sud de la France, elle s'est créé un intérieur à la hauteur de ces promesses. Meubles vintage à dorures, suspensions en cristal et motifs d'inspiration orientale ajoutent une touche romantique à cet intérieur contemporain tout blanc, tandis qu'un rose pétale ou un bleu myrtille font éclater la couleur. Un sarment de lierre rampant, une photo négligemment collée au mur, un objet de style posé sur une table. Son décor est le miroir de son âme.

« J'ai toujours été créative, explique Carolyn. Je suis une artiste. La peinture, les collages, la photographie, la direction artistique fusionnent dans mes expositions ou mes projets d'intérieur. Je repère et j'assemble pour créer de nouveaux looks et des associations inattendues. Tout est dans les repères que je pose – d'infimes éclats de couleurs, des couches que l'on devine sous la surface... Les références historiques, du XVIIIe siècle à nos jours, sont nombreuses. » En décoration, explique-t-elle, il ne s'agit jamais de combler un vide. « Il s'agit de poser sur une chaise le même regard que sur un tableau. Puis j'installerais, auprès de la chaise, un objet fort, minéral. » Non dénué d'un brin de séduction assumée, car il reste doux et féminin, cet intérieur irradie l'énergie et l'optimisme.

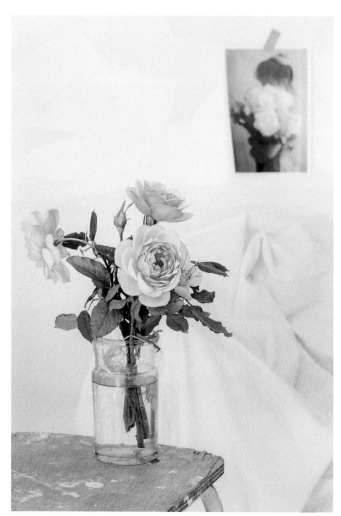

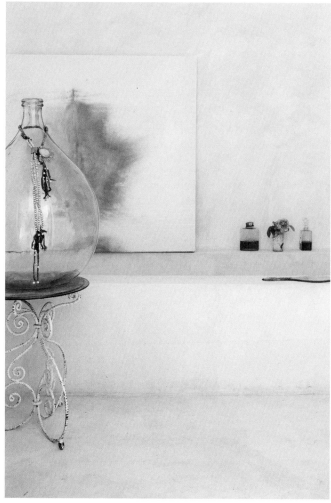

LIVING AREA & STUDIO
*With a lifelong passion for art, Carolyn's home is brimming with
inspirational objects, from flowers to glassware to photography
and books. Gilded furniture, stone surfaces, and loopy crystal
chandeliers add to the romantic feel in this modern space.*

WOHNBEREICH & ATELIER
*Aufgrund ihrer lebenslangen Leidenschaft für Kunst steckt
Carolyns Wohnung voller inspirierender Dinge – von Blumen und
Glasobjekten bis hin zu Fotos und Büchern. Vergoldete Möbel,
Steinoberflächen und gewundene Kristallleuchter verleihen
der modernen Umgebung ein romantisches Flair.*

ESPACE À VIVRE & ATELIER
*Animée d'une passion de toujours pour l'art, Carolyn s'entoure
d'objets qui l'inspirent, comme les fleurs, les verres, les livres et
les photos. Meubles à dorures, surfaces de pierre et lustres en cristal
donnent un ton romantique à cet espace aux lignes modernes.*

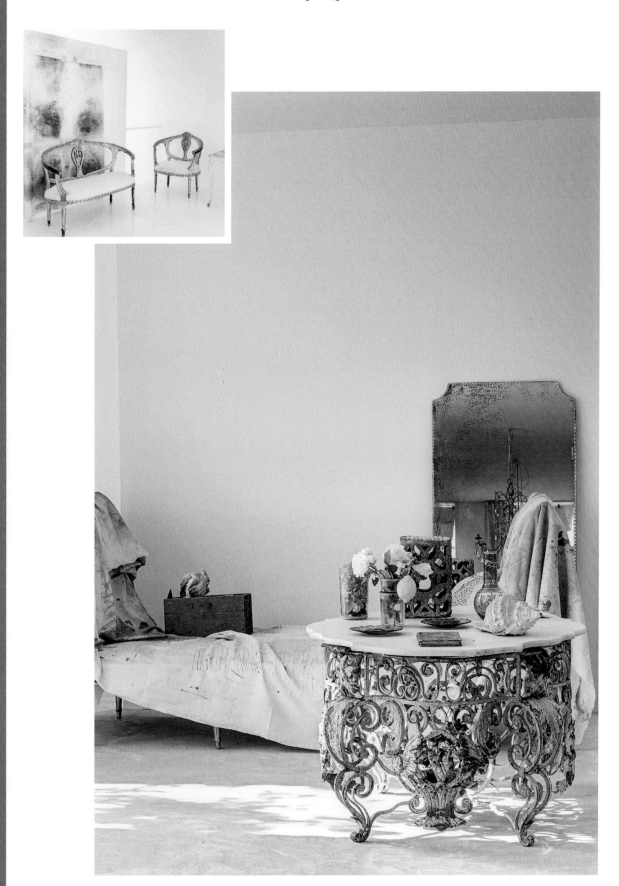

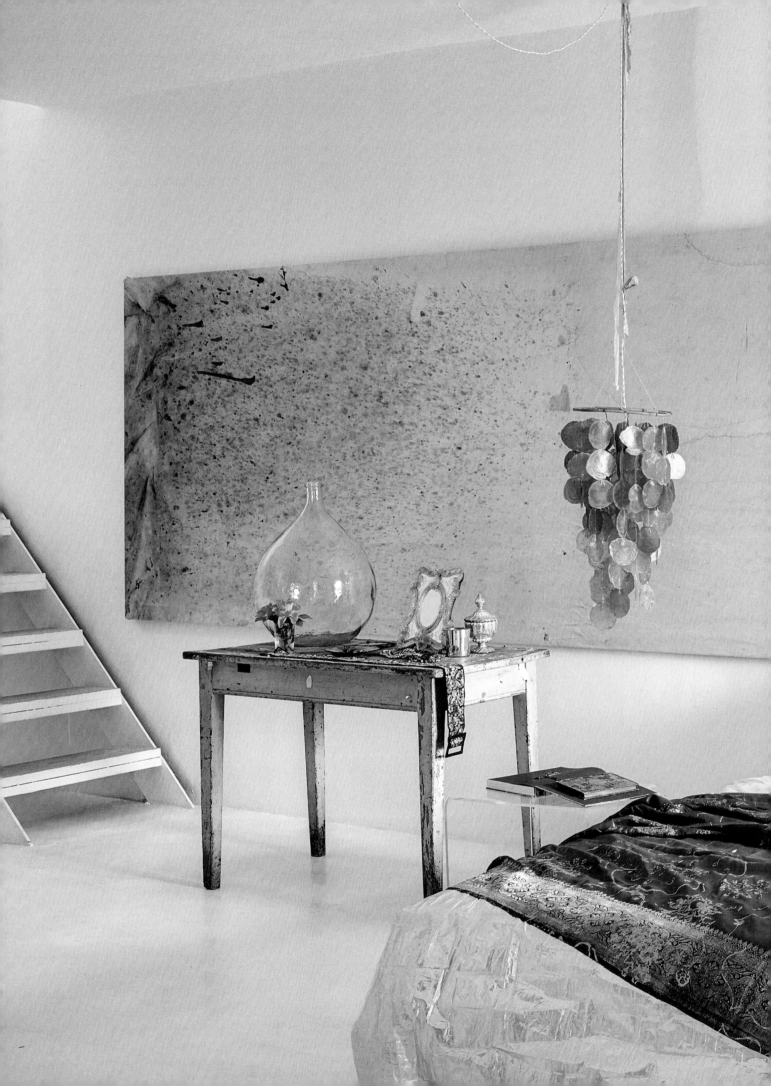

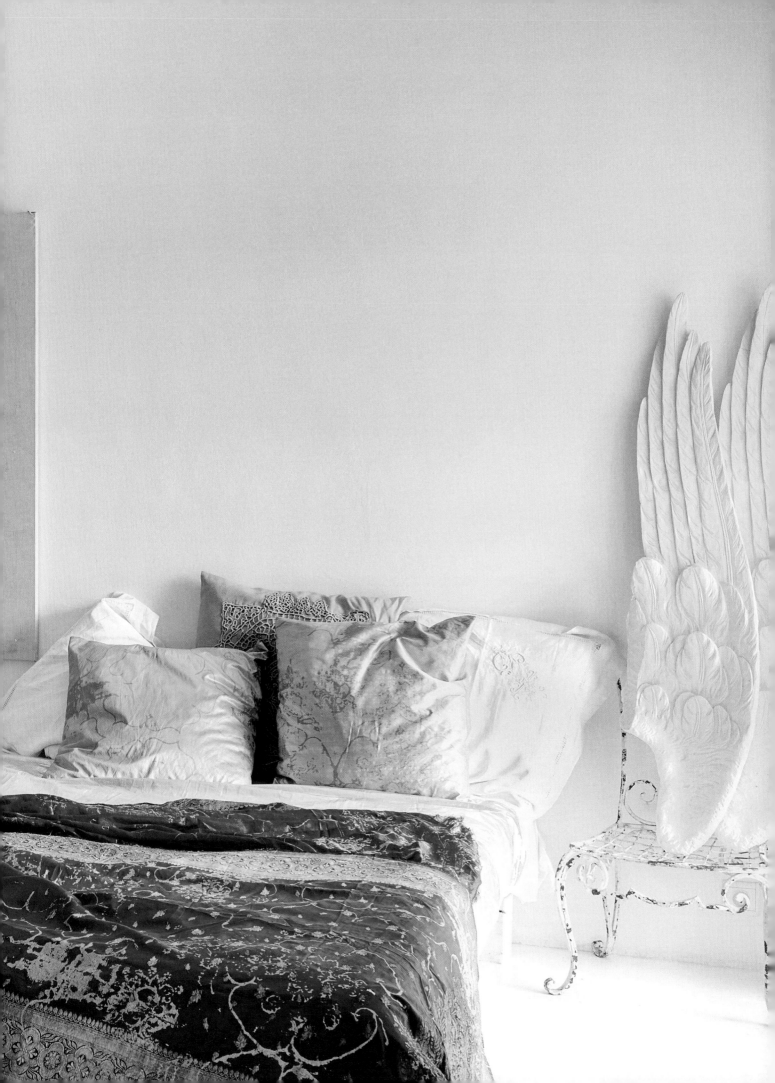

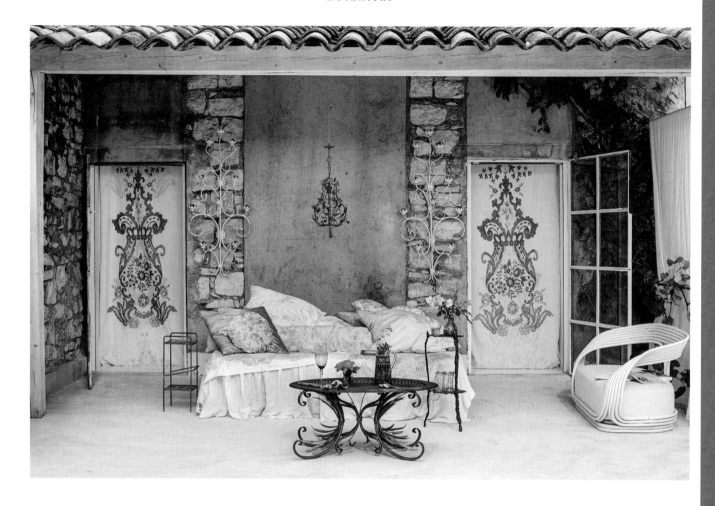

BEDROOM (PREVIOUS PAGE) & TERRACE

In the bedroom, Carolyn's large abstract splash painting and
vintage silk aubergine sari, as well as a blue shell light from Patmos, Greece
add color and character to the space. Opt for XXL artworks that group all
the pieces of furniture together. Semi-transparent white cotton panels
hang at the doors of the terrace.
A daybed is strewn with hand-painted pillows and a design piece
by Bonacina contrasts with decorative ironwork.

SCHLAFZIMMER (VORHERIGE SEITE) & TERRASSE

Ein von Carolyn kreiertes Gemälde, der Vintage-Seidenüberwurf in Aubergine
sowie eine blaue Leuchte aus Patmos, geben dem Raum Farbe und Charakter.
XXL-Kunstwerke eignen sich gut dazu, einzelne Möbelstücke zu gruppieren.
Semitransparente Baumwollbahnen verhängen die Türen zur Terrasse.
Die Schlafcouch ist mit handbemalten Kissen drapiert und ein Designobjekt
von Bonacina kontrastiert mit dekorativer Schmiedeeisenarbeit.

CHAMBRE À COUCHER (PAGE PRÉCÉDENTE) & TERRASSE

Dans la chambre à coucher, un grand tableau abstrait peint par Carolyn, un sari
vintage en soie aubergine et une lampe bleue de Patmos en Grèce insufflent
à l'espace couleur et caractère. Carolyn a opté pour des œuvres d'art XXL qui
font le lien entre tous les meubles de la pièce. Sur la terrasse, des panneaux
de coton blanc, un lit de repos agrémenté de coussins peints à la main et
une pièce design de Bonacina contrastent avec le fer forgé.

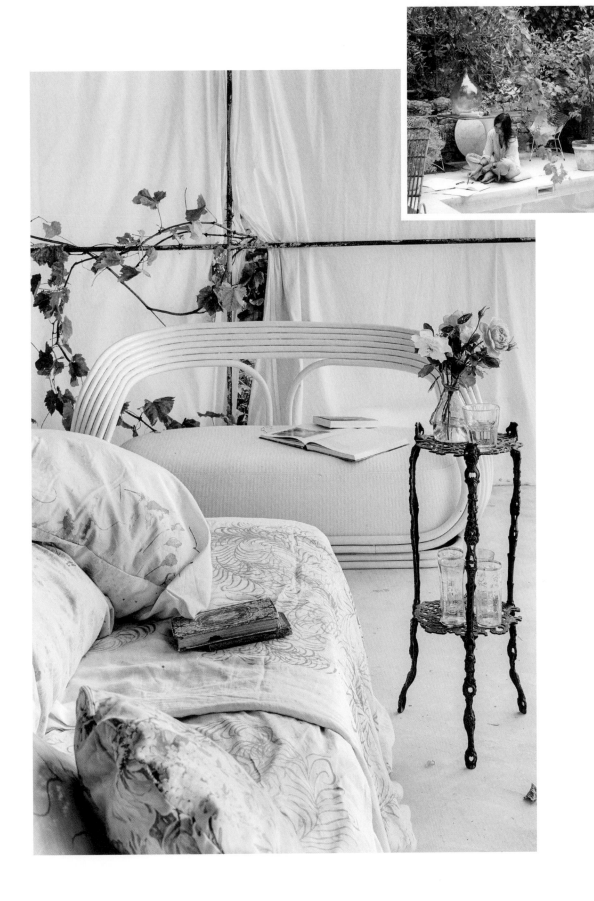

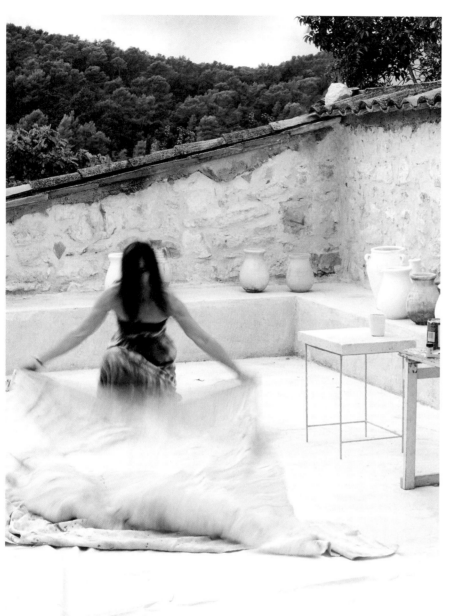

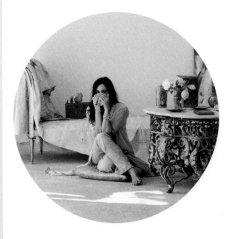

CAROLYN QUARTERMAINE

ARTIST CAROLYN QUARTERMAINE HAS BECOME KNOWN FOR HER ROMANTIC PIECES—HAND-PAINTED TEXTILES AND FURNITURE THAT MAKE YOU WANT TO TWIRL AWAY TO A MAGICAL FARAWAY LAND.

DIE KÜNSTLERIN IST FÜR IHRE ROMANTISCHEN KREATIONEN BEKANNT – HANDBEMALTE STOFFE UND MÖBEL, DIE EINEN IN EINE MAGISCHE FANTASIEWELT ENTFÜHREN.

L'ARTISTE CAROLYN QUARTERMAINE S'EST FAIT CONNAÎTRE AVEC SES CRÉATIONS ROMANTIQUES : DES TEXTILES ET DES MEUBLES QUI DONNENT ENVIE DE S'ENVOLER VERS UN PAYS MAGIQUE, FORT LOINTAIN.

MY WORK is all about history combined with a modern twist. Layers, color, and passion.

THE BEST THING ABOUT IT is those ahhh moments when elements piece together to create a new look. I'm nomadic at heart, so travel is exhilarating, too.

I WOULD SUM UP MY STYLE as hugely personal. It's all about the mise-en-scène.

MY LOVE OF FLOWERS was sparked by bluebell woods in the Forest of Dean; also, my Swiss great-uncle used to pick mountain flowers for me to press in books.

MY BEST FLORAL MOMENTS are heady combinations. There is a secret garden in Grasse that looks like a Bonnard painting, which I love.

IF I WERE A FLOWER, I'd be a rose.

MY FAVORITE COLOR COMBINATION is gray, lilacs, and pinks.

MY FAVORITE DESTINATIONS include Tokyo for blossom, Istanbul for roses.

MY FAVORITE FILM could be *Picnic at Hanging Rock* or maybe *Rebecca*.

THE BOOK that's influenced me most is *The Secret Garden* and all those by Edith Nesbit.

I'D SPEND MY LAST DECORATIVE DOLLAR on a château. Or throwing flower seeds everywhere, imagine . . .

IN MEINER ARBEIT GEHT ES UM Geschichte mit einem modernen Dreh. Schichten, Farben und Leidenschaft.

DAS BESTE DARAN: Diese „Ahhh"-Momente, wenn die einzelnen Elemente sich zu einem neuen Look zusammenfügen. Ich bin im Herzen eine Nomadin, das Reisen ist also auch aufregend.

MEINEN STYLE WÜRDE ICH SO BEZEICHNEN: Sehr persönlich. Alles dreht sich um die Inszenierung.

MEINE LIEBE ZU BLUMEN entstand durch Lichtungen voller Blauglöckchen im Forest of Dean. Und mein Schweizer Groß-onkel pflückte für mich immer Bergblumen, zum Pressen zwischen Büchern.

MEINE BESTEN FLORALEN MOMENTE: Aufregende Kombinationen. In Grasse gibt es einen geheimen Garten, der wie ein Gemälde von Bonnard aussieht.

ALS BLUME WÄRE ICH eine Rose.

MEINE LIEBLINGSFARBKOMBINATION: Grau mit Lila- und Pinktönen

MEINE LIEBLINGSREISEZIELE: Tokio zur Kirschbaumblüte, Istanbul zur Rosenblüte

MEIN LIEBLINGSFILM: Entweder *Picknick am Valentinstag* oder *Rebecca*

DAS BUCH, DAS MICH AM MEISTEN BEEINFLUSST HAT: *Der geheime Garten* von Frances Hodgson Burnett und alles von Edith Nesbit

MEINEN LETZTEN CENT würde ich für ein Château ausgeben. Oder dafür, überall Blumensamen zu verstreuen. Man stelle sich das mal vor …

MON TRAVAIL, C'EST AVANT TOUT relever l'histoire d'une touche de modernité. Plusieurs strates, des couleurs et de la passion.

CE QUE J'AIME LE PLUS DANS MON TRAVAIL, ce sont ces moments où tous les éléments s'assemblent en quelque chose de nouveau. Je suis nomade de cœur, alors les voyages aussi me transportent.

JE QUALIFIERAIS MON STYLE d'immensément personnel. Tout est dans la mise en scène.

MON AMOUR DES FLEURS me vient des tapis de jacinthes dans la forêt de Dean et de mon grand-oncle suisse, qui me cueillait des fleurs que je faisais sécher entre les feuilles d'un livre.

MON PLUS BEL INSTANT FLORAL, c'est quand se mêlent des parfums entêtants. Il y a, à Grasse, un jardin secret qui ressemble à un tableau de Bonnard, et que j'adore.

SI J'ÉTAIS UNE FLEUR, je serais une rose.

MON ASSOCIATION DE COULEURS PRÉFÉRÉE allie le gris, le lilas et le rose.

MES DESTINATIONS PRÉFÉRÉES sont Tokyo pour les cerisiers en fleurs et Istanbul pour les roses.

MON FILM PRÉFÉRÉ pourrait être *Pique-nique à Hanging Rock* ou peut-être *Rebecca*.

LE LIVRE QUI M'A LE PLUS MARQUÉE est *Le Jardin secret* et tous les livres d'Edith Nesbit.

JE DÉPENSERAIS MON DERNIER DOLLAR pour acheter un château. Ou pour semer des graines de fleurs à tous vents, j'imagine…

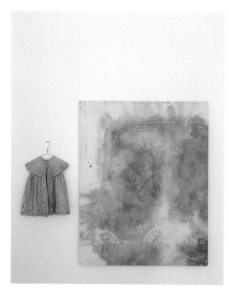

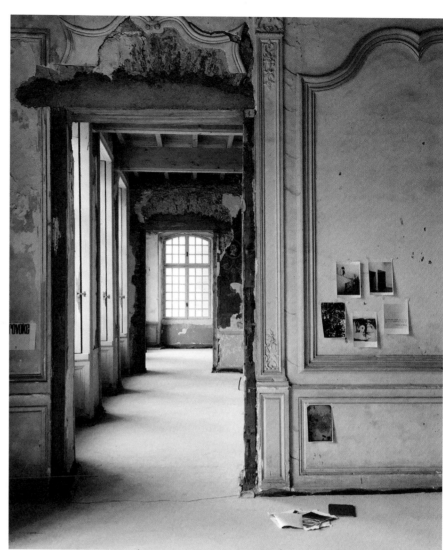

WHERE FLOWERS DREAM

Carolyn's work includes hand-painted textiles, crystal paperweights for Baccarat, and installations at the Musée Fragonard in Grasse, one of France's oldest fragrance houses. For the London bar and restaurant The Glade at Sketch, Carolyn created a huge decoupage forest, where flowers hung from the ceiling and blossom trees decked the walls.

WO BLUMEN TRÄUMEN

Zu Carolyns Arbeiten gehören handbemalte Textilien, Briefbeschwerer aus Kristallglas für Baccarat und Installationen im Duftmuseum Musée Fragonard in Grasse. Für das Londoner Restaurant The Glade at Sketch schuf Carolyn einen gigantischen Decoupage-Wald, wo Blumen von der Decke hängen und Bäume die Wände bedecken.

RÊVES DE FLEURS

Parmi les réalisations de Carolyn, des textiles peints à la main, des presse-papiers en cristal pour Baccarat et des installations au musée Fragonard de Grasse. Pour le The Glade at Sketch, un bar-restaurant tendance, à Londres, Carolyn a créé, en découpages, une immense forêt : les fleurs sont suspendues au plafond et les arbres habillent les murs.

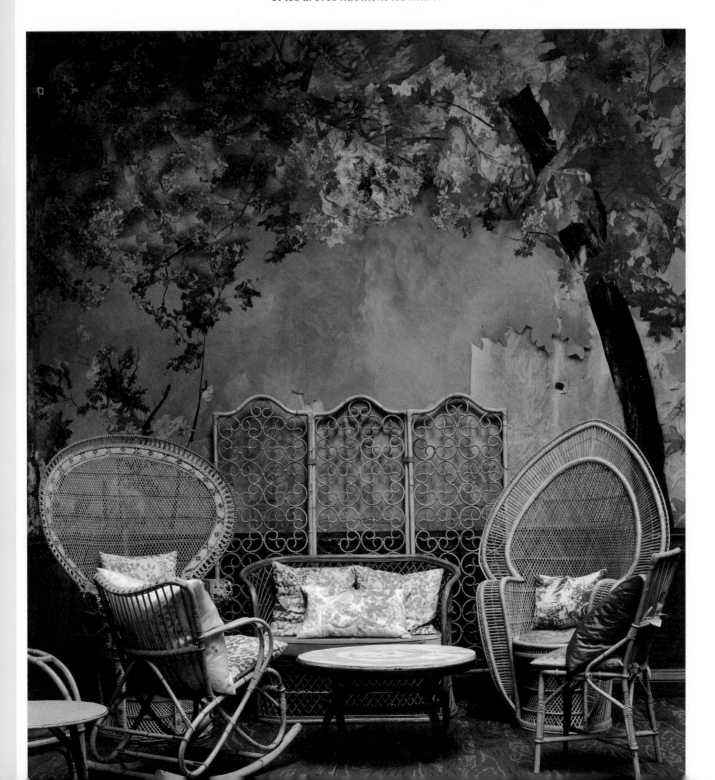

INDEX

PHOTO CREDITS
BILDNACHWEISE | CRÉDITS PHOTOGRAPHIQUES

TEXT CREDITS

IMPRINT

IMPRESSUM | MENTIONS LÉGALES

© 2017 *teNeues Media GmbH & Co. KG*, Kempen
All rights reserved.

Words/Texte/Textes *Claire Bingham*
Copy editing/Lektorat/Révision *Victorine Lamothe* (English),
Nadine Weinhold (Deutsch), *Caroline Fait* (Français)
Translation/Übersetzung/Traduction *Ronit Jariv*,
derschönstesatz (Deutsch), *Liliane Charrier* (Français)
Editorial management/Projektmanagement/Coordination
éditoriale *Nadine Weinhold*
Design & Layout/Maquette et mise en pages *Christin Steirat*
Typesetting/Satz/Composition *Sophie Franke*
Production/Herstellung/Fabrication *Alwine Krebber*
Imaging & proofing/Bildbearbeitung & Proofing/Photogravure
Jens Grundei

Published by *teNeues Publishing Group*

teNeues Media GmbH & Co. KG
Am Selder 37, 47906 Kempen, Germany
Phone: +49 (0)2152 916 0
Fax: +49 (0)2152 916 111
e-mail: books@teneues.com

Press department: Andrea Rehn
Phone: +49 (0)2152 916 202
e-mail: arehn@teneues.com

teNeues Publishing Company
7 West 18th Street, New York, NY 10011, USA
Phone: +1 212 627 9090
Fax: +1 212 627 9511

teNeues Publishing UK Ltd.
12 Ferndene Road, London SE24 0AQ, UK
Phone: +44 (0)20 3542 8997

teNeues France S.A.R.L.
39, rue des Billets, 18250 Henrichemont, France
Phone: +33 (0)2 48 26 93 48
Fax: +33 (0)1 70 72 34 82

www.teneues.com

English Edition
ISBN 978-3-96171-010-2
Library of Congress Control Number: 2017942011
Deutsche Ausgabe
ISBN 978-3-96171-011-9
Édition française
ISBN 978-3-96171-012-6

Printed in the Czech Republic

The Deutsche Nationalbibliothek lists this publication in
the Deutsche Nationalbibliografie; detailed bibliographic
data are available on the Internet at *http://dnb.dnb.de*.